# CREEPiGURUMi

## 14 Kawaii Amigurumi Creatures to Crochet

### Madelenón-Soledad Iglesias Silva

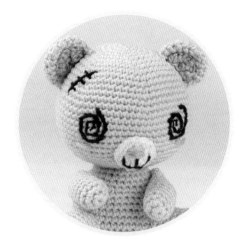

DOVER PUBLICATIONS
Garden City, New York

*Creepigurumi: 14 Kawaii Amigurumi Creatures to Crochet* is a new work,
first published by Dover Publications in 2024.

*ISBN-13: 978-0-486-85329-1*
*ISBN-10: 0-486-85329-2*

Publisher: Betina Cochran
Acquisitions Editor: Allyson D'Antonio
Managing Editorial Supervisor: Susan Rattiner
Production Editor: Gregory Koutrouby
Cover Designer: Peter Donahue
Creative Manager: Marie Zaczkiewicz
Interior Designer: Jennifer Becker
Production: Pam Weston, Tammi McKenna, Ayse Yilmaz

Manufactured in China
85329201    2024
www.doverpublications.com

# TABLE OF CONTENTS

## Projects

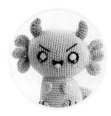

**Axolotl**

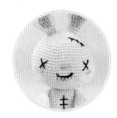

**Creepy Rabbit**

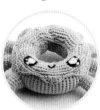

**Spider Donut**

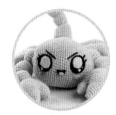

**Sinister Scorpion**

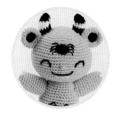

**Green Devil Bear**

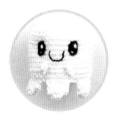

**Morbid Marshmallows**

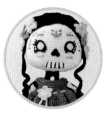

**La Catrina**

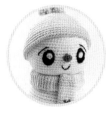

**Snow-Ghost**

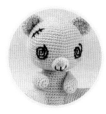

**Creepy Bear**

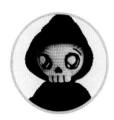

**Grim Reaper**

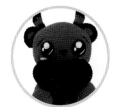

**Red Devil Bear**

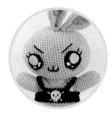

**Octobunny**

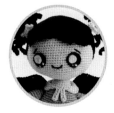

**Vampire Girl**

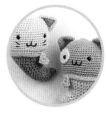

**Ghost Kitties**

# Introduction

When Dover Publications asked me to create 14 new crochet designs based on characters that appear in their *Creepy Cute Kawaii Coloring Book*, at first I thought it was too tall a task. However, to my great joy, we achieved our goal, and I am very happy with the results!

We were able to capture the friendliness and sweetness of Mary Eakin's creepy cute characters, and now you will be able to crochet them in a practical and easy way.

I guarantee that you will have a fun time creating this spooky collection of crochet friends.

Happy crocheting!

—SOLEDAD

# Abbreviations List

| | |
|---|---|
| **beg:** | begin(ning) |
| **beg-ch:** | beginning chain |
| **BL:** | back loop |
| **BL sc:** | back loop single crochet |
| **ch:** | chain(s) |
| **dc:** | double crochet |
| **dec:** | decrease |
| **FL:** | front loop |
| **FL dc:** | front loop double crochet |
| **FL hdc:** | front loop half double crochet |
| **FL sc:** | front loop single crochet |
| **hdc:** | half double crochet |
| **inc:** | increase |
| **rnd(s):** | round(s) |
| **sc:** | single crochet |
| **sc2tog:** | single crochet 2 together |
| **sl st:** | slip stitch |
| **st(s):** | stitch(es) |
| **tr:** | triple crochet |

## Basic Stitches

### Chain (ch)

Make a loop and pull the yarn up through the loop. Pull the loop up until tight. Wrap the yarn over the hook from back to front. Pull the hook, carrying the yarn, through the loop already on your hook. Repeat these steps as many times as indicated.

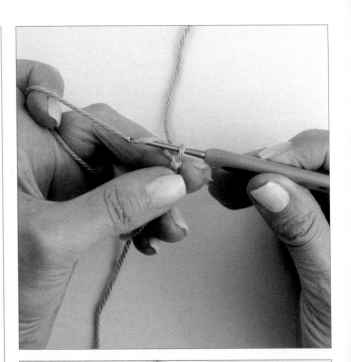

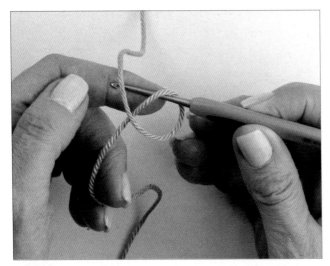

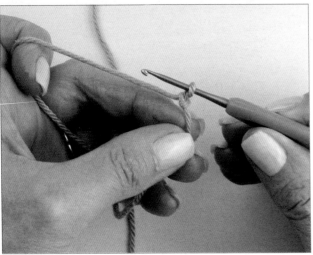

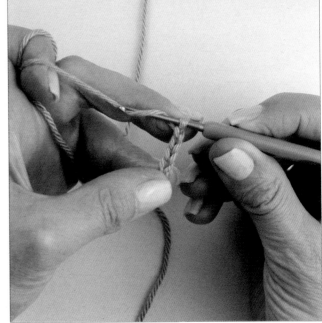

## Slip Stitch (sl st)

Insert hook in indicated stitch, yarn over and pull through both loops on hook.

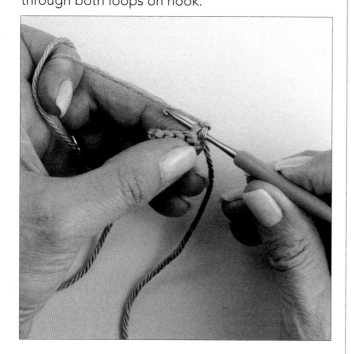

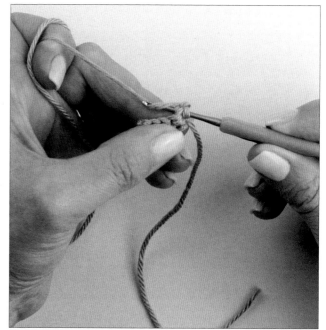

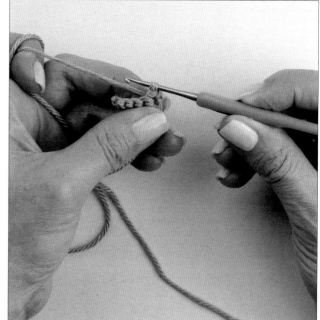

## Single Crochet (sc)

Insert hook in indicated stitch, yarn over and pull through loop, yarn over and pull through both loops on hook.

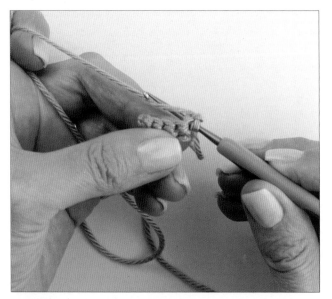

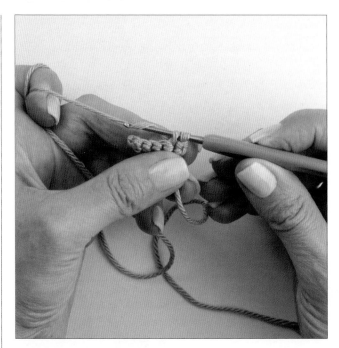

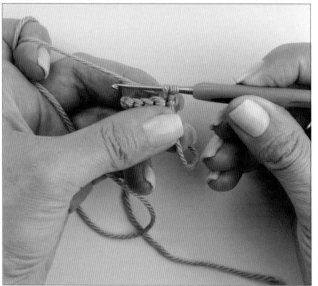

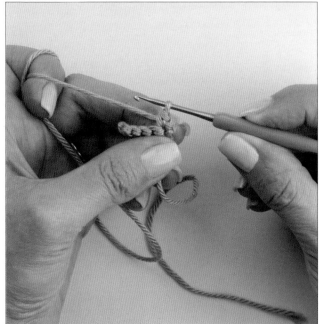

## Increase (inc)

Make 2 single crochet stitches in the same stitch.

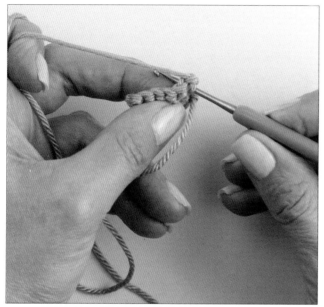

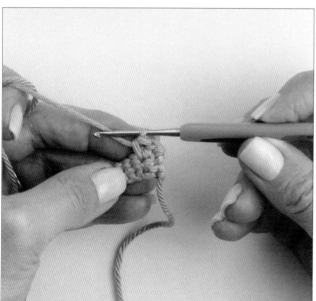

## Decrease (dec)

Insert hook into only the front loop of the indicated stitch, and into only the front loop of the next stitch; yarn over and pull through both front loops; yarn over and pull through both loops on hook.

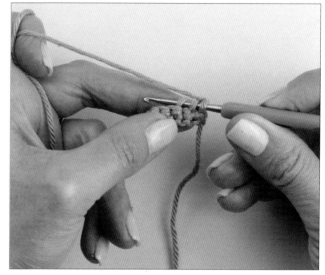

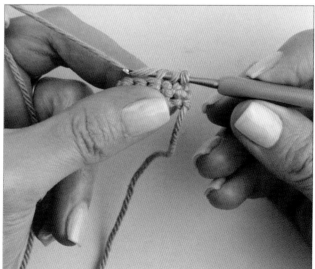

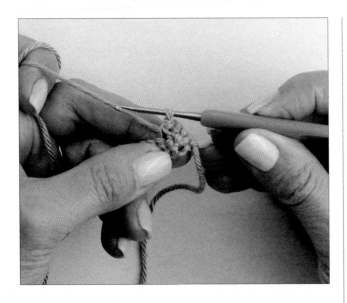

## Magic Ring

Make a loop with your hook, but don't pull it tight. Hold the circle with your index finger and thumb and wrap the working yarn over your middle finger. Make a chain stitch. Insert the hook into the loop and underneath the tail. Yarn over the hook and draw a loop; yarn over again and pull through both loops on hook. Repeat steps 6, 7, and 8 as many times as indicated. Now grab the yarn tail and pull to draw the center of the ring tightly closed.

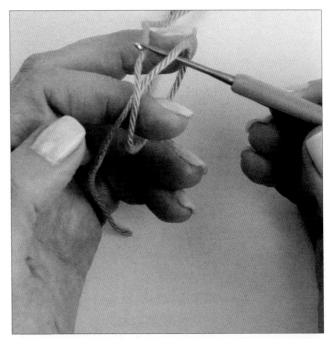

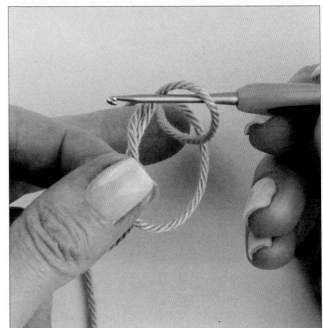

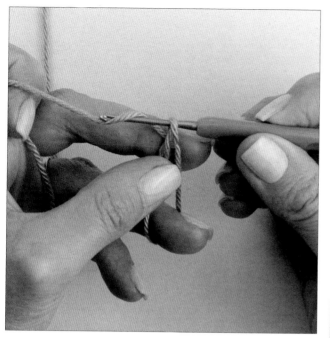 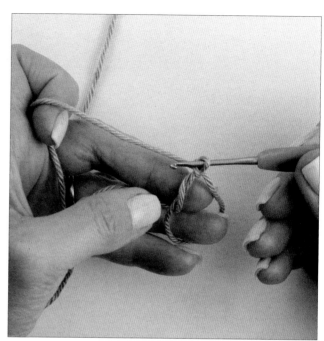

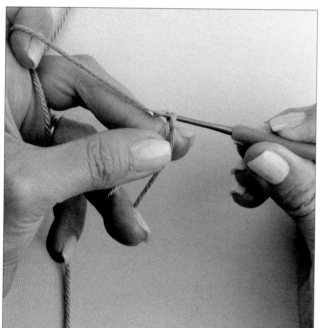 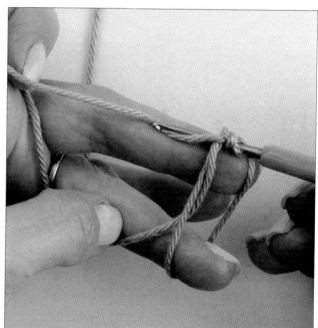

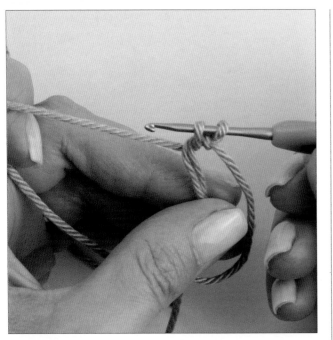
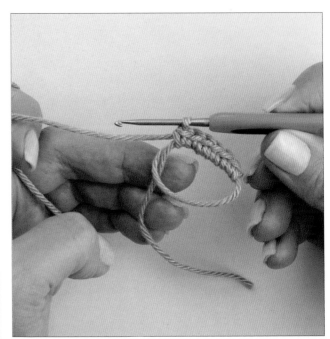
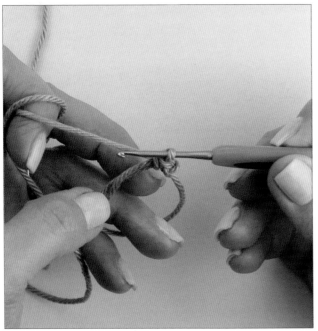
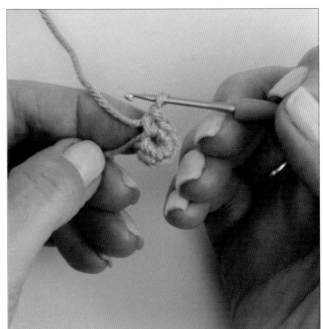

# Half Double Crochet (hdc)

Yarn over and insert hook in indicated stitch; yarn over and pull through loop; yarn over and pull through all 3 loops on hook.

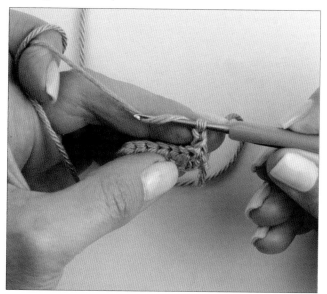

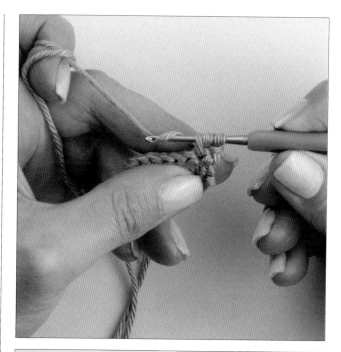

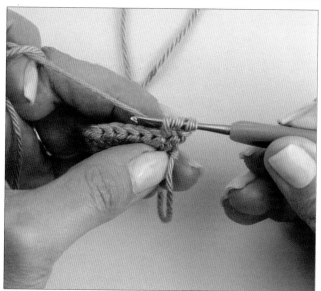

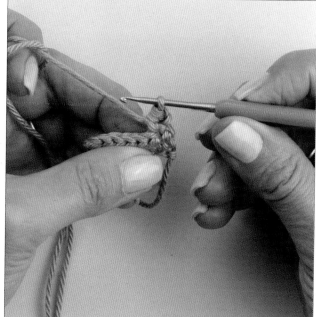

## Double Crochet (dc)

Yarn over; insert hook in indicated stitch; yarn over and pull through loop; yarn over and pull through 2 loops twice.

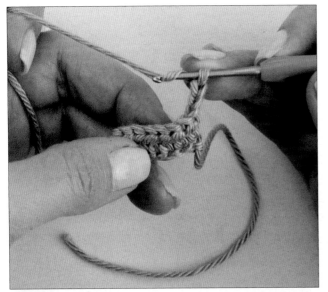

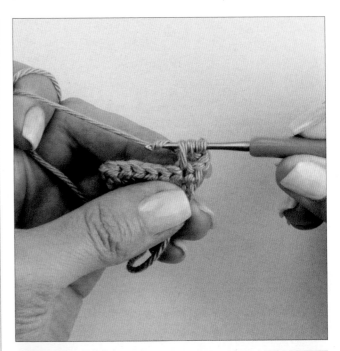

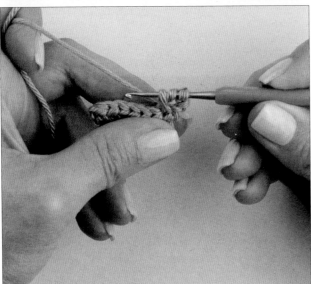

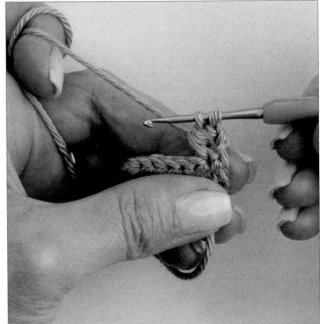

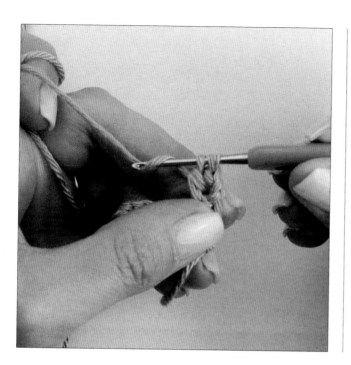
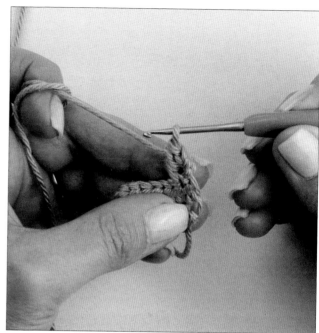

## Pro Tip!

Stuffing soft toys and decorations can be tricky. No matter how good your shaping is on a crochet piece, the way that you stuff it will be crucial in determining the finished shape. Putting in small amounts of stuffing and building up a shape works better than pushing in a large wad all at once.

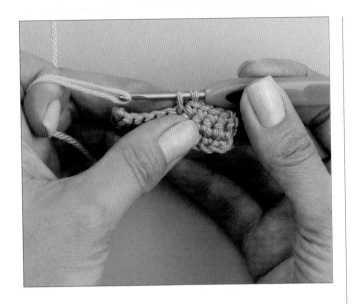

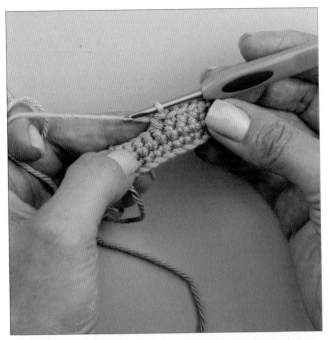

## Invisible Color Change

When you want to switch from one color to another, work to within 2 stitches before making the color change. Make the next stitch as usual, but don't pull the final loop through. Instead, wrap the new color of yarn around your hook and pull it through the remaining loops. To make a neat color change, you can make the first stitch in the new color a slip stitch instead of a single crochet. (Don't pull the slip stitch too tight or it will be difficult to crochet into the next round.) Next, tie the loose tails in a knot and leave them on the inside.

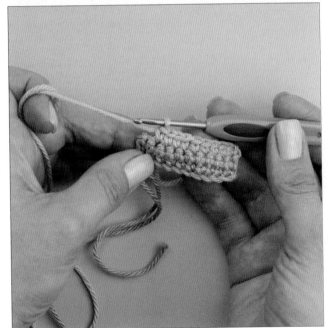

# CREEPiGURUMi

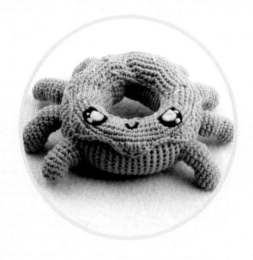

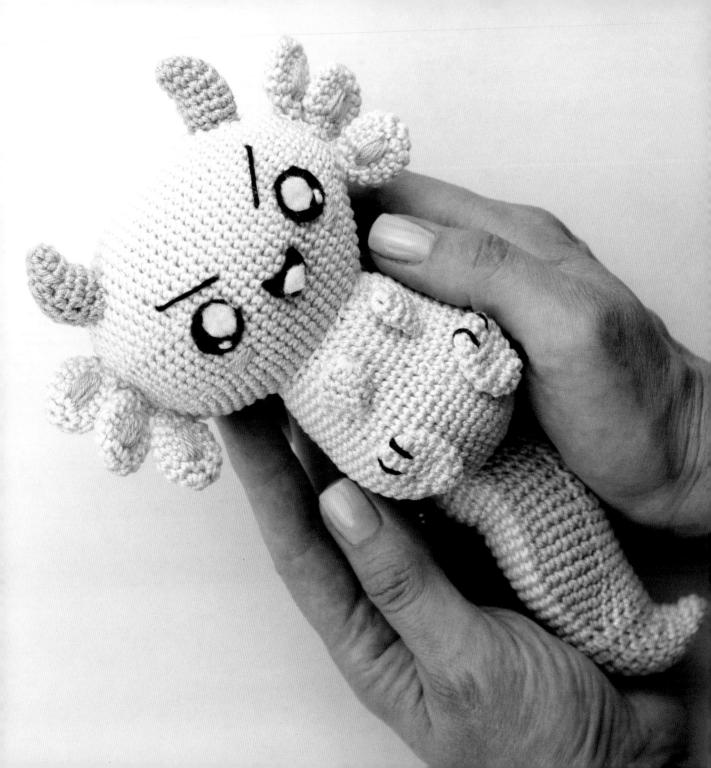

# AXOLOTL

## MATERIALS

Yarn and Colors® 100% mercerized cotton (sport weight yarn)

1.75oz (50g); 137yds (125m)

### Colors:

Jade Gravel (073) 137yds (125m)

Glass (072) 28yds (25.5m)

Cotton Candy (037) (leftover)

White (001) (leftover)

Black (100) (leftover)

- Size 2mm crochet hook
- Felt fabric (black and white)
- Fiberfill
- Tapestry needle
- Stitch marker
- Scissors
- Glue
- Black and white thread and sewing needle
- Pins

### Gauge:

7 sts and 7 rnds = 1in/2.54cm in sc

## Let's Begin!

### Head

**Rnd 1:** With Jade Gravel, work 6 sc in a magic ring—6 sts.

**Rnd 2:** 2 sc in each st—12 sts.

**Rnd 3:** *Sc in the next st, 2 sc in the next st; repeat from * 5 more times—18 sts.

**Rnd 4:** *Sc in the next 2 sts, 2 sc in the next st; repeat from * 5 more times—24 sts.

**Rnd 5:** *Sc in the next 5 sts, 2 sc in the next st; repeat from * 3 more times—28 sts.

**Rnd 6:** *Sc in the next 6 sts, 2 sc in the next st; repeat from * 3 more times—32 sts.

**Rnd 7:** *Sc in the next 7 sts, 2 sc in the next st; repeat from * 3 more times—36 sts.

**Rnd 8:** *Sc in the next 5 sts, 2 sc in the next st; repeat from * 5 more times—42 sts.

**Rnd 9:** *Sc in the next 6 sts, 2 sc in the next st; repeat from * 5 more times—48 sts.

**Rnd 10:** Sc in each st.

**Rnd 11:** *Sc in the next 7 sts, 2 sc in the next st; repeat from * 5 more times—54 sts.

**Rnd 12:** Sc in each st.

**Rnd 13:** *Sc in the next 8 sts, 2 sc in the next st; repeat from * 5 more times—60 sts.

**Rnds 14–25:** Sc in each st.

**Rnd 26:** *Sc in the next 8 sts, sc2tog; repeat from * 5 more times—54 sts remain.

**Rnd 27:** Sc in each st.

**Rnd 28:** *Sc in the next 7 sts, sc2tog; repeat from * 5 more times—48 sts remain.

**Rnd 29:** Sc in each st.

**Rnd 30:** *Sc in the next 6 sts, sc2tog; repeat from * 5 more times—42 sts remain.

**Rnd 31:** *Sc in the next 5 sts, sc2tog; repeat from * 5 more times—36 sts remain.

**Rnd 32:** *Sc in the next 7 sts, sc2tog; repeat from * 3 more times—32 sts remain.

**Rnd 33:** *Sc in the next 6 sts, sc2tog; repeat from * 3 more times—28 sts remain.

**Rnd 34:** *Sc in the next 5 sts, sc2tog; repeat from * 3 more times—24 sts remain.

**Rnd 35:** *Sc in the next 2 sts, sc2tog; repeat from * 5 more times—18 sts remain.

Stuff the head.

**Rnd 36:** *Sc in the next st, sc2tog; repeat from * 5 more times—12 sts remain.

**Rnd 37:** *Sc2tog; repeat from * 5 more times—6 sts remain.

Fasten off and leave a yarn tail. Thread the yarn tail into the tapestry needle, then weave the yarn through the front loop of each remaining stitch and pull it tight to close. Weave in the yarn end.

## Body

**Rnd 1:** With Jade Gravel, work 6 sc in a magic ring—6 sts.

**Rnd 2:** 2 sc in each st—12 sts.

**Rnd 3:** *Sc in the next st, 2 sc in the next st; repeat from * 5 more times—18 sts.

**Rnd 4:** *Sc in the next 2 sts, 2 sc in the next st; repeat from * 5 more times—24 sts.

**Rnd 5:** *Sc in the next 3 sts, 2 sc in the next st; repeat from * 5 more times—30 sts.

**Rnd 6:** *Sc in the next 4 sts, 2 sc in the next st; repeat from * 5 more times—36 sts.

**Rnd 7:** *Sc in the next 5 sts, 2 sc in the next st; repeat from * 5 more times—42 sts.

**Rnd 8:** *Sc in the next 6 sts, 2 sc in the next st; repeat from * 5 more times—48 sts.

**Rnd 9:** *Sc in the next 7 sts, 2 sc in the next st; repeat from * 5 more times—54 sts.

**Rnds 10–13:** Sc in each st.

**Rnd 14:** *Sc in the next 7 sts, sc2tog; repeat from * 5 more times—48 sts remain.

**Rnd 15:** Sc in each st.

**Rnd 16:** *Sc in the next 6 sts, sc2tog; repeat from * 5 more times—42 sts remain.

**Rnds 17–23:** Sc in each st.

**Rnd 24:** *Sc in the next 5 sts, sc2tog; repeat from * 5 more times—36 sts remain.

Fasten off, leaving a long tail for sewing. Stuff the body.

## Tail

**Rnd 1:** With Jade Gravel, work 4 sc in a magic ring—4 sts.

**Rnd 2:** 2 sc in each st—8 sts.

**Rnd 3:** Hdc in the next st, sc in the next 4 sts, hdc in the next st, 2 hdc in the next 2 sts—10 sts.

**Rnd 4:** Sc in the next st, sl st in the next 4 sts, sc in the next st, (hdc in the next st, 2 hdc in the next st) 2 times—12 sts.

**Rnd 5:** Sc in the next 6 sts, (hdc in the next 2 sts, 2 hdc in the next st) 2 times—14 sts.

**Rnd 6:** Hdc in the next st, sc in the next 5 sts, (hdc in the next 3 sts, 2 hdc in the next st) 2 times—16 sts.

**Rnd 7:** Sc in the next st, sl st in the next 4 sts, sc in the next st, (hdc in the next 4 sts, 2 hdc in the next st) 2 times—18 sts.

**Rnd 8:** Hdc in the next st, sc in the next 5 sts, (hdc in the next 5 sts, 2 hdc in the next st) 2 times—20 sts.

**Rnd 9:** Sc in the next st, sl st in the next 5 sts, sc in the next st, hdc in the next 13 sts.

**Rnd 10:** Hdc in the next st, sc in the next 6 sts, hdc in the next 4 sts, 2 hdc in the next st, (hdc in the next 3 sts, 2 hdc in the next st) 2 times—23 sts.

**Rnd 11:** Sc in the next 8 sts, hdc in the next 14 sts, 2 hdc in the next st—24 sts.

In the next rounds, alternate between Jade Gravel and Glass. The color change is indicated in italics.

**Rnd 12:** *(Jade Gravel)* sc in next 11 sts, *(Glass)* 2 sc in the next st, *(Jade Gravel)* sc in next 12 sts—25 sts.

**Rnd 13:** *(Jade Gravel)* sc in next 11 sts, *(Glass)* sc in the next st, 2 sc in the next st, *(Jade Gravel)* sc in next 12 sts—26 sts.

**Rnd 14:** *(Jade Gravel)* sc in next 11 sts, *(Glass)* sc in the next 2 sts, 2 sc in the next st, *(Jade Gravel)* sc in next 12 sts—27 sts.

**Rnd 15:** *(Jade Gravel)* sc in next 11 sts, *(Glass)* sc in the next 3 sts, 2 sc in the next st, *(Jade Gravel)* sc in next 12 sts—28 sts.

**Rnd 16:** *(Jade Gravel)* sc in next 11 sts, *(Glass)* sc in the next 4 sts, 2 sc in the next st, *(Jade Gravel)* sc in next 12 sts—29 sts.

**Rnds 17–20:** *(Jade Gravel)* sc in next 11 sts, *(Glass)* sc in the next 6 sts, *(Jade Gravel)* sc in next 12 sts.

**Rnds 21–22:** *(Jade Gravel)* hdc in next 11 sts, *(Glass)* sc in the next 6 sts, *(Jade Gravel)* sc in next 12 sts.

**Rnd 23:** *(Jade Gravel)* hdc in next 11 sts, *(Glass)* sc in the next 6 sts, *(Jade Gravel)* sc in next 3 sts, sl st in the next 6 sts, sc in the next 3 sts.

**Rnd 24:** *(Jade Gravel)* hdc in next 11 sts, *(Glass)* sc in the next 6 sts, *(Jade Gravel)* sc in next 12 sts.

**Rnd 25:** *(Jade Gravel)* hdc in next 11 sts, *(Glass)* sc in the next 6 sts, *(Jade Gravel)* sc in next 3 sts, sl st in the next 6 sts, sc in the next 3 sts.

**Rnd 26:** *(Jade Gravel)* hdc in next 11 sts, *(Glass)* sc in the next 6 sts, *(Jade Gravel)* sc in next 12 sts.

**Rnd 27:** *(Jade Gravel)* sc in next 9 sts, sc2tog, *(Glass)* sc in the next 6 sts *(Jade Gravel)* sc in next 12 sts—28 sts remain.

**Rnd 28:** *(Jade Gravel)* sc in next 5 sts, sc2tog, sc in the next 3 sts, *(Glass)* sc in next 2 sts, sc2tog, sc in the next 2 sts, *(Jade Gravel)* sc in next 3 sts, sc2tog, sc in the next 5 sts, sc2tog—24 sts remain.

**Rnd 29:** *(Jade Gravel)* sc in next 9 sts, *(Glass)* sc in next 5 sts, *(Jade Gravel)* sc in next 4 sts, sc2tog, sc in the next 4 sts—23 sts remain.

**Rnd 30:** *(Jade Gravel)* sc in next 9 sts, *(Glass)* sc in next 5 sts, *(Jade Gravel)* sc in next 3 sts, sc2tog, sc in the next 4 sts—22 sts remain.

**Rnd 31:** *(Jade Gravel)* sc in next 9 sts, *(Glass)* sc in next 5 sts, *(Jade Gravel)* sc in next 4 sts, (sc2tog) 2 times—20 sts remain.

**Rnd 32:** *(Jade Gravel)* sc in next 9 sts, *(Glass)* sc in next 5 sts, *(Jade Gravel)* sc in next 2 sts, (sc2tog) 2 times—18 sts remain.

Stuff the tail. Flatten the opening of the tail.

**Next row:** Working through both layers to close the opening, sc in next 8 sts, sl st in the last st.

Fasten off, leaving a long tail for sewing.

## Arms (make 2)

**Rnd 1**: With Jade Gravel, work 8 sc in a magic ring—8 sts.

**Rnds 2–4:** Sc in each st.

The arms don't need to be stuffed. Flatten the opening of the arm.

**Next row:** Working through both layers to close the opening, sc in next 3 sts, sl st in the last st.

Fasten off, leaving a long tail for sewing.

## Horns (make 2)

**Rnd 1**: With Glass, work 4 sc in a magic ring—4 sts.

**Rnd 2:** 2 sc in each st—8 sts.

**Rnd 3:** Hdc in the next st, sc in the next 4 sts, hdc in the next st, (2 hdc in the next st) 2 times—10 sts.

Change to Cotton Candy.

**Rnd 4:** Sc in the next 6 sts, (hdc in the next st, 2 hdc in the next st) 2 times—12 sts.

**Rnd 5:** Sc in the next 6 sts, hdc in the next 6 sts.

Change to Glass.

**Rnds 6–7:** Sc in each st.

Fasten off, leaving a long tail for sewing.

## Gills (make 6)

**Rnd 1**: With Jade Gravel, work 6 sc in a magic ring—6 sts.

**Rnd 2:** 2 sc in each st—12 sts.

**Rnds 3–6:** Sc in each st.

The gills don't need to be stuffed.

**Rnd 7:** *Sc2tog; repeat from * 5 more times.

Fasten off, leaving a long tail for sewing. Embroider the center of each gill with Glass.

## Legs (make 2)

**Rnd 1**: With Jade Gravel, work 6 sc in a magic ring—6 sts.

**Rnd 2:** 2 sc in each st—12 sts.

**Rnds 3–6:** Sc in each st.

The legs don't need to be stuffed.

**Rnd 7:** *Sc2tog; repeat from * 5 more times.

Fasten off, leaving a long tail for sewing. Embroider the fingers with Black yarn.

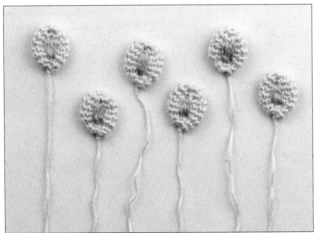

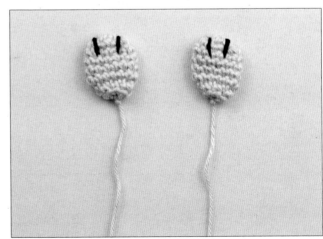

Cut the shapes for the eyes and mouth out of the felt fabric, using the graphics below as a guide.

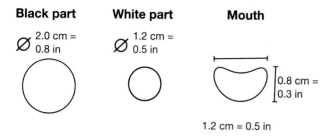

**Black part**

∅ 2.0 cm = 0.8 in

**White part**

∅ 1.2 cm = 0.5 in

**Mouth**

0.8 cm = 0.3 in

1.2 cm = 0.5 in

## Time to Put It All Together!

Glue the black parts of the eyes between Rnds 12 and 16 and between Rnds 26 and 30 of the head, then glue the white parts of the eyes on the black parts. Glue the mouth, centered between the eyes, between Rnds 20 and 22. Then glue the white part of the mouth.

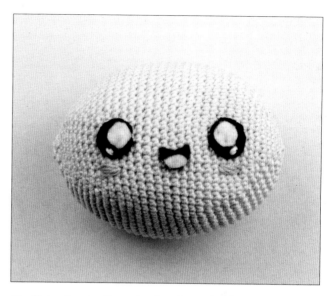

Stuff the body. Sew the body to the head between Rnds 14 and 25.

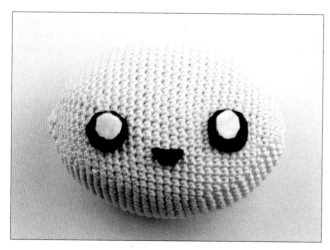

Using the sewing thread, finish securing the eyes and the mouth to the head. With White yarn, embroider the shine of the eyes. With Cotton Candy, embroider the cheeks under the eyes.

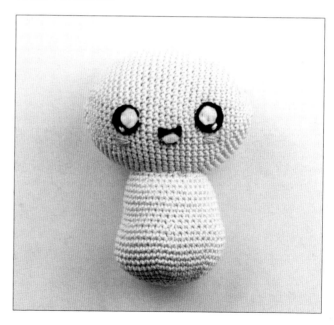

Sew the arms to the front of the body between Rnds 18 and 20, and aligned with the eyes.

Sew the legs to the front of the body between Rnds 9 and 15, with 6 sts between them, and aligned with the arms.

Stuff the horns. Sew the horns to the head between Rnds 10 and 13 and between Rnds 28 and 31.

Sew the gills to the sides of the head.

Sew the tail to the center of the back on Rnd 9. With Black yarn, embroider the eyebrows above the eyes.

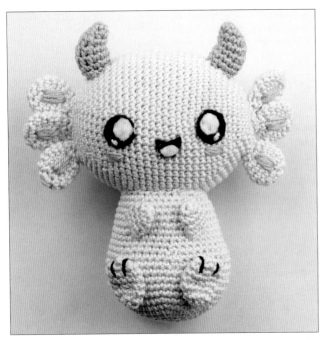

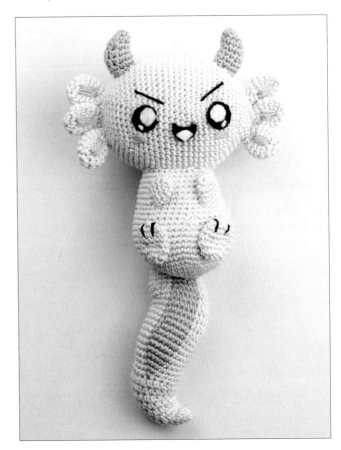

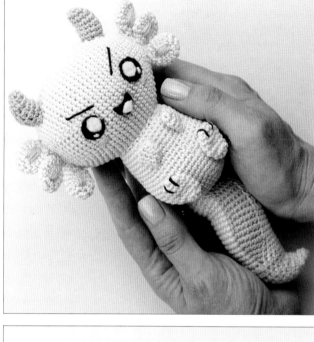
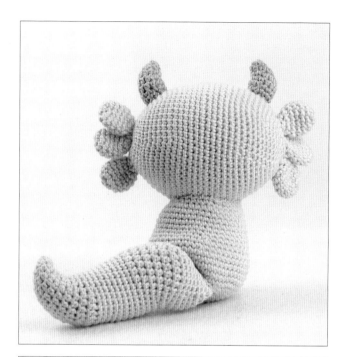
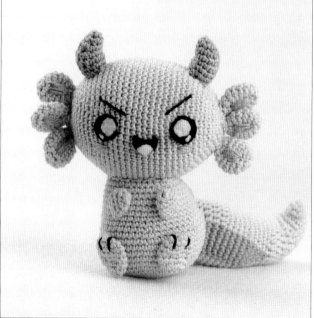
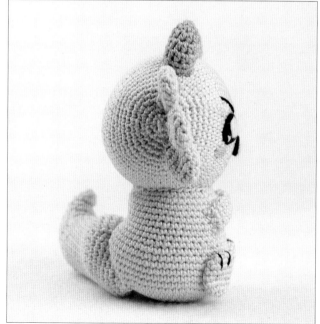

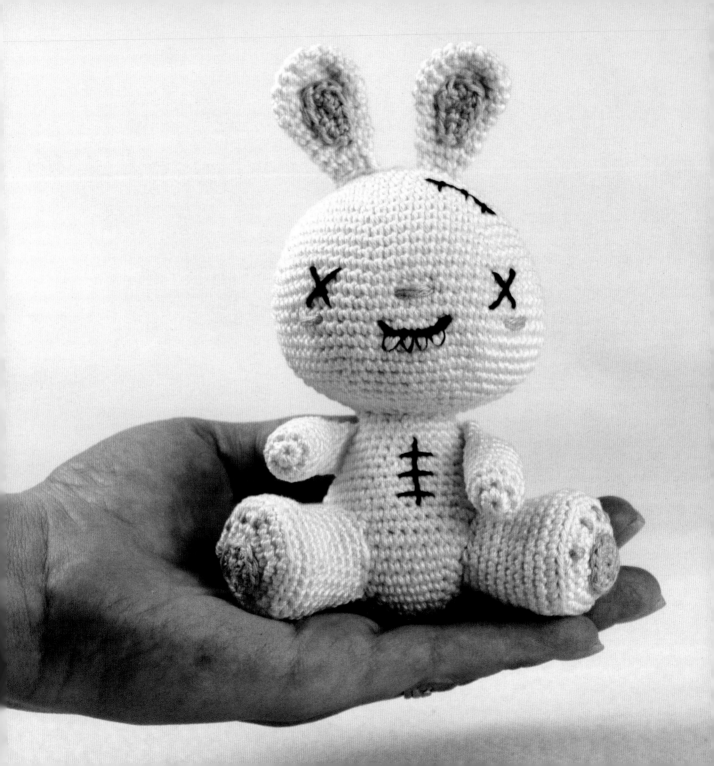

# CREEPY RABBIT

## MATERIALS

Yarn and Colors® 100% mercerized cotton (sport weight yarn)

1.75oz (50g); 137yds (125m)

### Colors:

Vanilla (010) 137yds (125m)

Cotton Candy (037) (leftover)

White (001) (leftover)

Black (100) (leftover)

- Size 2mm crochet hook
- Black sewing thread
- Fiberfill
- Tapestry needle
- Stitch marker
- Scissors
- Pins

### Gauge:

7 sts and 7 rnds = 1in/2.54cm in sc

## Let's Begin!

### Head

**Rnd 1:** With Vanilla, work 6 sc in a magic ring—6 sts.

**Rnd 2:** 2 sc in each st—12 sts.

**Rnd 3:** *Sc in the next st, 2 sc in the next st; repeat from * 5 more times—18 sts.

**Rnd 4:** *Sc in the next 2 sts, 2 sc in the next st; repeat from * 5 more times—24 sts.

**Rnd 5:** *Sc in the next 3 sts, 2 sc in the next st; repeat from * 5 more times—30 sts.

**Rnd 6:** *Sc in the next 4 sts, 2 sc in the next st; repeat from * 5 more times—36 sts.

**Rnd 7:** *Sc in the next 5 sts, 2 sc in the next st; repeat from * 5 more times—42 sts.

**Rnd 8:** *Sc in the next 6 sts, 2 sc in the next st; repeat from * 5 more times—48 sts.

**Rnd 9:** Sc in each st.

**Rnd 10:** *Sc in the next 7 sts, 2 sc in the next st; repeat from * 5 more times—54 sts.

**Rnd 11:** Sc in each st.

**Rnd 12:** *Sc in the next 8 sts, 2 sc in the next st; repeat from * 5 more times—60 sts.

**Rnd 13:** Sc in each st.

**Rnd 14:** *Sc in the next 9 sts, 2 sc in the next st; repeat from * 5 more times—66 sts.

**Rnd 15–21:** Sc in each st.

**Rnd 22:** *Sc in the next 9 sts, sc2tog; repeat from * 5 more times—60 sts remain.

**Rnd 23:** *Sc in the next 8 sts, sc2tog; repeat from * 5 more times—54 sts remain.

**Rnd 24:** *Sc in the next 7 sts, sc2tog; repeat from * 5 more times—48 sts remain.

**Rnd 25:** *Sc in the next 6 sts, sc2tog; repeat from * 5 more times—42 sts remain.

**Rnd 26:** *Sc in the next 5 sts, sc2tog; repeat from * 5 more times—36 sts remain.

**Rnd 27:** *Sc in the next 4 sts, sc2tog; repeat from * 5 more times—30 sts remain.

**Rnd 28:** *Sc in the next 3 sts, sc2tog; repeat from * 5 more times—24 sts remain.

Stuff the head.

Fasten off, leaving a long tail for sewing.

## Body

**Rnd 1:** With Vanilla, work 6 sc in a magic ring—6 sts.

**Rnd 2:** 2 sc in each st—12 sts.

**Rnd 3:** *Sc in the next st, 2 sc in the next st; repeat from * 5 more times—18 sts.

**Rnd 4:** *Sc in the next 2 sts, 2 sc in the next st; repeat from * 5 more times—24 sts.

**Rnd 5:** *Sc in the next 3 sts, 2 sc in the next st; repeat from * 5 more times—30 sts.

**Rnd 6:** *Sc in the next 4 sts, 2 sc in the next st; repeat from * 5 more times—36 sts.

**Rnd 7:** *Sc in the next 5 sts, 2 sc in the next st; repeat from * 5 more times—42 sts.

**Rnd 8:** *Sc in the next 6 sts, 2 sc in the next st; repeat from * 5 more times—48 sts.

**Rnds 9–12:** Sc in each st.

**Rnd 13:** *Sc in the next 6 sts, sc2tog; repeat from * 5 more times—42 sts remain.

**Rnd 14:** Sc in each st.

**Rnd 15:** *Sc in the next 5 sts, sc2tog; repeat from * 5 more times—36 sts remain.

**Rnd 16:** Sc in each st.

**Rnd 17:** *Sc in the next 4 sts, sc2tog; repeat from * 5 more times—30 sts remain.

**Rnds 18–20:** Sc in each st.

**Rnd 21:** *Sc in the next 3 sts, sc2tog; repeat from * 5 more times—24 sts remain.

Stuff the body.

**Rnd 22:** *Sc in the next 2 sts, sc2tog; repeat from * 5 more times—18 sts remain.

**Rnds 23–25:** Sc in each st.

**Rnd 26:** *Sc in the next st, sc2tog; repeat from * 5 more times—12 sts remain.

**Rnd 27:** *Sc2tog; rep from * 5 more times—6 sts remain.

Fasten off and leave a yarn tail. Thread the yarn tail into the tapestry needle, then weave the yarn through the front loop of each remaining stitch and pull it tight to close. Weave in the yarn end.

## Arms (make 2)

**Rnd 1:** With Vanilla, work 6 sc in a magic ring—6 sts.

**Rnd 2:** 2 sc in each st—12 sts.

**Rnds 3–9:** Sc in each st.

Lightly stuff the arm.

**Rnd 10:** *Sc in the next 2 sts, sc2tog; repeat from * 2 more times—9 sts remain.

Flatten the opening of the arm.

**Next row:** Working through both layers to close the opening, sc in next 3 sts, sl st in the last st.

Fasten off, leaving a long tail for sewing.

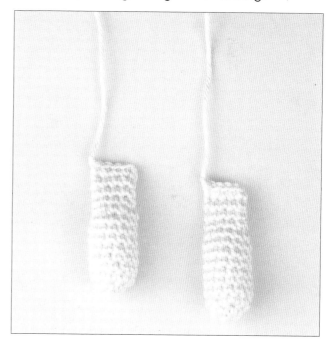

## Tail

**Rnd 1:** With Vanilla, work 6 sc in a magic ring—6 sts.

**Rnd 2:** 2 sc in each st—12 sts.

**Rnd 3:** *Sc in the next st, 2 sc in the next st; repeat from * 5 more times—18 sts.

**Rnds 4–5:** Sc in each st.

**Rnd 6:** *Sc in the next st, sc2tog; repeat from * 5 more times—12 sts remain.

Fasten off, leaving a long tail for sewing.

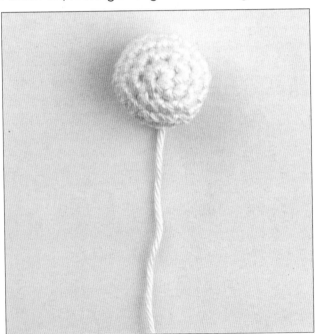

## Paws (make 2)

**Rnd 1:** With Vanilla, work 6 sc in a magic ring—6 sts.

**Rnd 2:** 2 sc in each st—12 sts.

**Rnd 3:** *Sc in the next st, 2 sc in the next st; repeat from * 5 more times—18 sts.

**Rnd 4:** *Sc in the next 2 sts, 2 sc in the next st; repeat from * 5 more times—24 sts.

**Rnd 5:** *Sc in the next 3 sts, 2 sc in the next st; repeat from * 5 more times—30 sts.

**Rnd 6:** BL sc in each st.

**Rnds 7–8:** Sc in each st.

**Rnd 9:** *Sc in the next 3 sts, sc2tog; repeat from * 5 more times—24 sts remain.

**Rnds 10–14:** Sc in each st.

Fasten off, leaving a long tail for sewing.

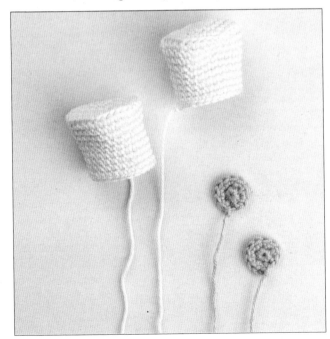

## Paw Pads (make 2)

**Rnd 1:** With Cotton Candy, work 6 sc in a magic ring—6 sts.

**Rnd 2:** 2 sc in each st—12 sts.

Fasten off, leaving a long tail for sewing. Sew the paw pad to the paw between Rnds 2 and 4, and embroider the four toe pads on Rnd 4 of the paw.

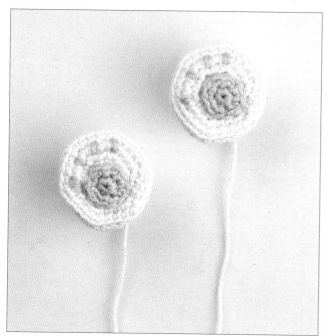

## Ears (make 2)

**Rnd 1:** With Vanilla, work 6 sc in a magic ring—6 sts.

**Rnd 2:** 2 sc in each st—12 sts.

**Rnd 3:** *Sc in the next st, 2 sc in the next st; repeat from * 5 more times—18 sts.

**Rnds 4–6:** Sc in each st.

**Rnd 7:** *Sc in the next st, sc2tog; repeat from * 5 more times—12 sts remain.

**Rnds 8–10:** Sc in each st.

**Rnd 11:** *Sc in the next st, sc2tog; repeat from * 3 more times—8 sts remain.

Flatten the opening of the ear.

**Next row:** Working through both layers to close the opening, sc in next 3 sts, sl st in the last st.

Fasten off, leaving a long tail for sewing.

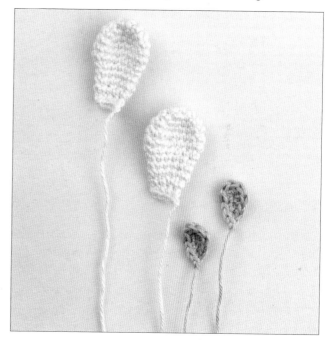

## Centers of the Ears (make 2)

Foundation ch: With Cotton Candy, ch 4. Stitches are worked around both sides of the foundation ch.

**Rnd 1:** Start in the 2nd ch from hook, sc in the next 2 sts, 5 dc in the next st, working along the bottom of the foundation ch, sc in the next 2 sts.

Fasten off, leaving a long tail for sewing. Sew each center of the ear to its ear, making sure to center it.

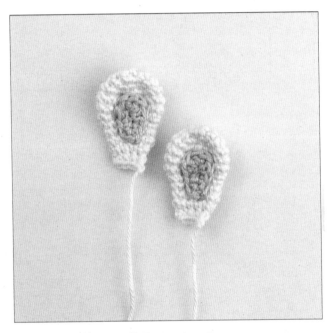

## Time to Put It All Together!

With Black yarn, embroider the eyes between Rnds 15 and 17 of the head, 13 sts apart. With Cotton Candy, embroider the cheeks under the eyes, and embroider the nose centered between the eyes at Rnd 16.

With Black yarn, embroider the mouth, centered under the nose at Rnd 19 and 7 sts wide. Embroider the fangs with White yarn and Black sewing thread.

Insert the smallest part of the body into the hole in the head and sew the head at Rnd 21 of the body.

Sew the arms to the sides of the body, between Rnds 15 and 20, with 15 sts between them at the back.

Sew the paws to the body between Rnds 7 and 14, with 7 sts between them at the front.

Sew the ears to the head between Rnds 2 and 5.

Stuff the tail and sew it centered on the back of the body between Rnds 7 and 10.

With Black yarn, embroider the decorative "seams" on the head and body.

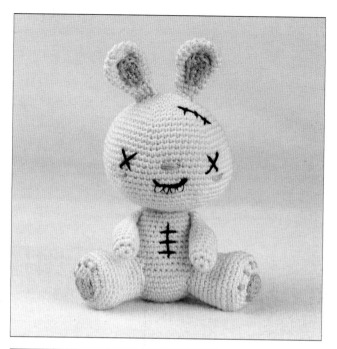
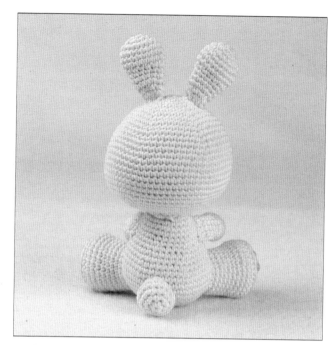
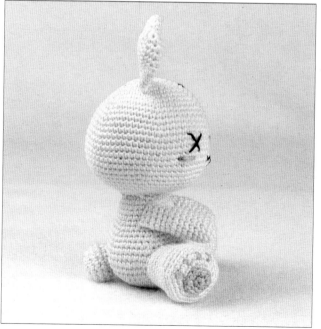
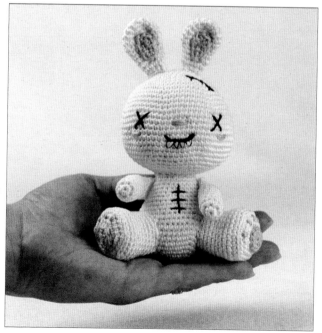

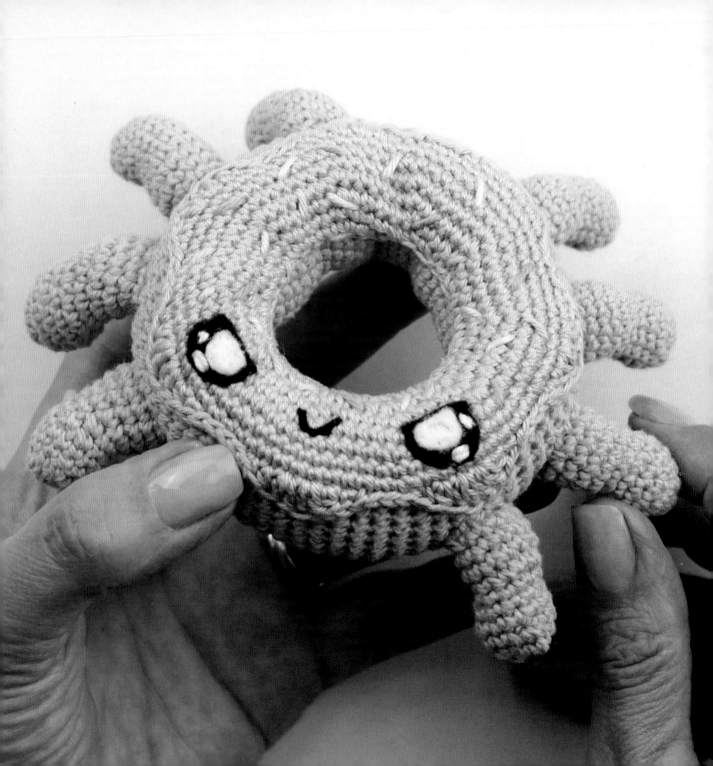

# SPiDER DONUT

## MATERIALS

Yarn and Colors® 100% mercerized cotton (sport weight yarn)

1.75oz (50g); 137yds (125m)

### Colors:

Limestone (009) 137yds (125m)

Cotton Candy (037) 10g

Black (100) (leftover)

Lollipop (036) (leftover)

Violet (053) (leftover)

Blue Lake (066) (leftover)

- Size 2mm crochet hook
- Felt fabric (black and white)
- Fiberfill
- Tapestry needle
- Stitch marker
- Scissors
- Glue
- Black and white thread and sewing needle
- Pins

### Gauge:

7 sts and 7 rnds = 1in/2.54cm in sc

## Let's Begin!

### Donut

Stuff the donut with fiberfill as you go.

**Rnd 1:** With Limestone, work 6 sc in a magic ring—6 sts.

**Rnd 2:** 2 sc in each st—12 sts.

**Rnd 3:** *Sc in the next st, 2 sc in the next st; repeat from * 5 more times—18 sts.

**Rnd 4:** *Sc in the next 2 sts, 2 sc in the next st; repeat from * 5 more times—24 sts.

**Rnds 5–70:** Sc in each st.

Fasten off, leaving a long tail for sewing. Sew the ends of the donut together. Fasten off and weave in the yarn ends.

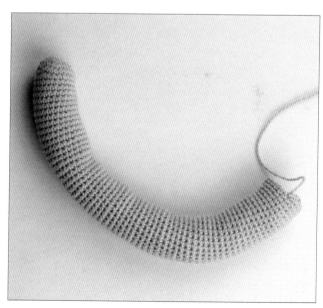

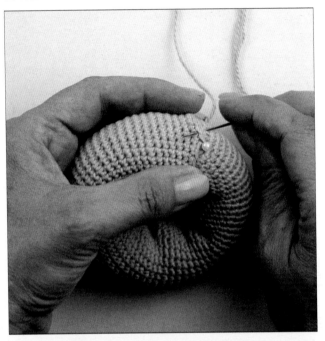

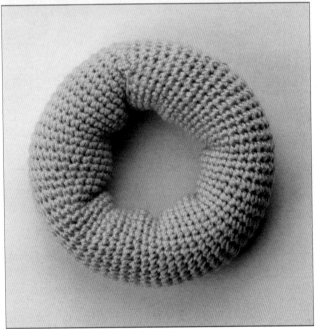

## Legs (make 8)

**Rnd 1:** With Limestone, work 6 sc in a magic ring—6 sts.

**Rnd 2:** 2 sc in each st—12 sts.

**Rnds 3–5:** Sc in each st.

**Rnds 6–7:** (Sc2tog) 2 times, sc in the next 3 sts, 2 sc in the next 2 sts, sc in the next 3 sts.

**Rnds 8–10:** Sc in each st.

Fasten off, leaving a long tail for sewing.

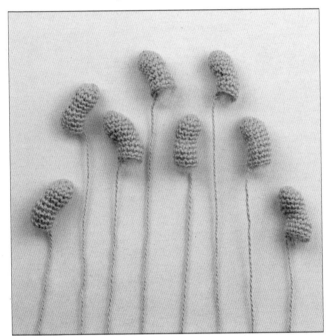

## Glaze

**Rnd 1:** With Cotton Candy, ch 30, join with sl st to make a ring, then ch 1—30 sts.

**Rnd 2:** *Sc in the next 2 sts, 2 sc in the next st; repeat from * 9 more times, sl st to join, ch 1—40 sts.

**Rnd 3:** *Sc in the next 3 sts, 2 sc in the next st; repeat from * 9 more times, sl st to join, ch 1—50 sts.

**Rnd 4:** *Sc in the next 4 sts, 2 sc in the next st; repeat from * 9 more times, sl st to join, ch 1—60 sts.

**Rnd 5:** *Sc in the next 5 sts, 2 sc in the next st; repeat from * 9 more times, sl st to join, ch 1—70 sts.

**Rnds 6–8:** Sc in each st.

**Rnd 9:** *Sl st in the next 2 sts, sc in the next st, hdc in the next st, 2 dc in the next 2 sts, hdc in the next st, sc in the next st, sl st in the next 2 sts; repeat from * 6 more times—84 sts.

Fasten off, leaving a long tail for sewing.

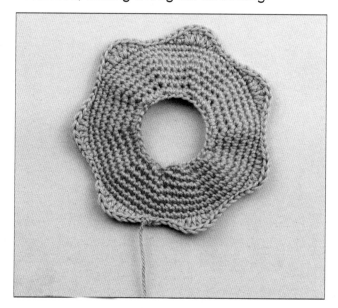

Cut the shapes for the eyes out of the felt fabric, using the graphics below as a guide.

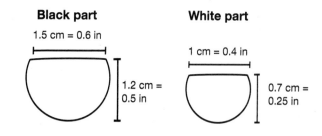

**Black part**

1.5 cm = 0.6 in

1.2 cm = 0.5 in

**White part**

1 cm = 0.4 in

0.7 cm = 0.25 in

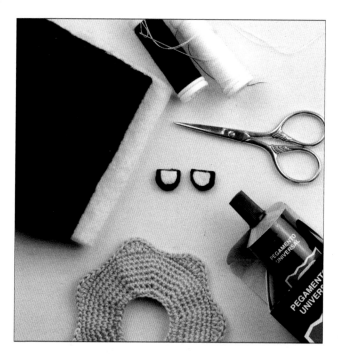

## Time to Put It All Together!

Glue the black parts of the eyes to the glaze between Rnds 4 and 7, with 10 sts in between. Glue the white parts of the eyes on top of the black parts.

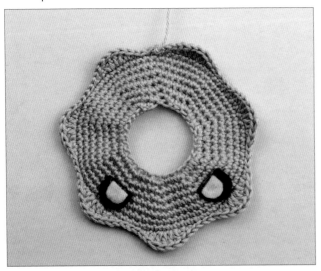

With Black yarn, embroider the mouth centered between the eyes, between Rnds 5 and 6.

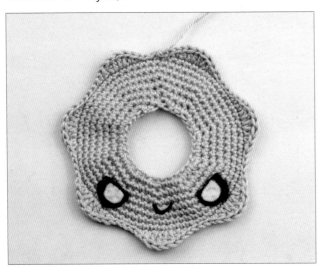

Using the sewing thread, finish securing the eyes to the glaze. With White yarn, embroider the shine of the eyes.

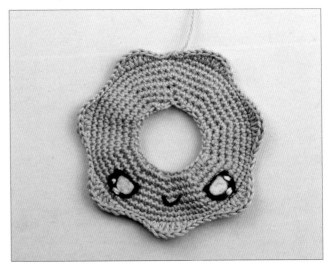

With Lollipop, Violet, and Blue Lake yarn embroider the candy sprinkles around the glaze.

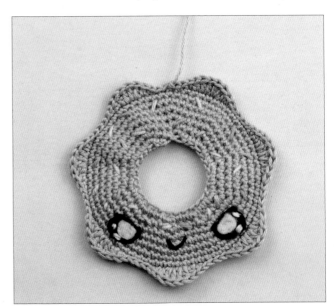

Sew the glaze to the donut.

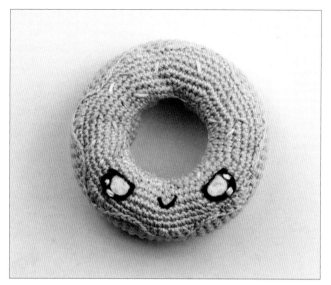

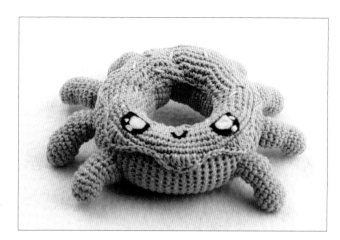

Stuff the legs. Sew the legs to the sides of the donut.

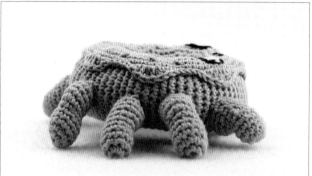

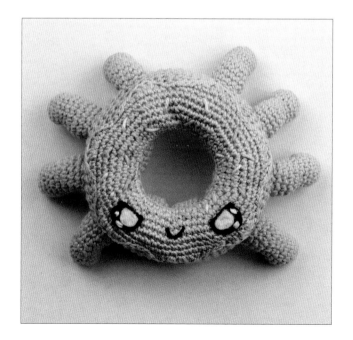

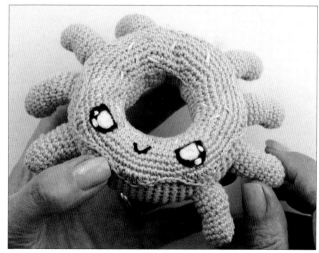

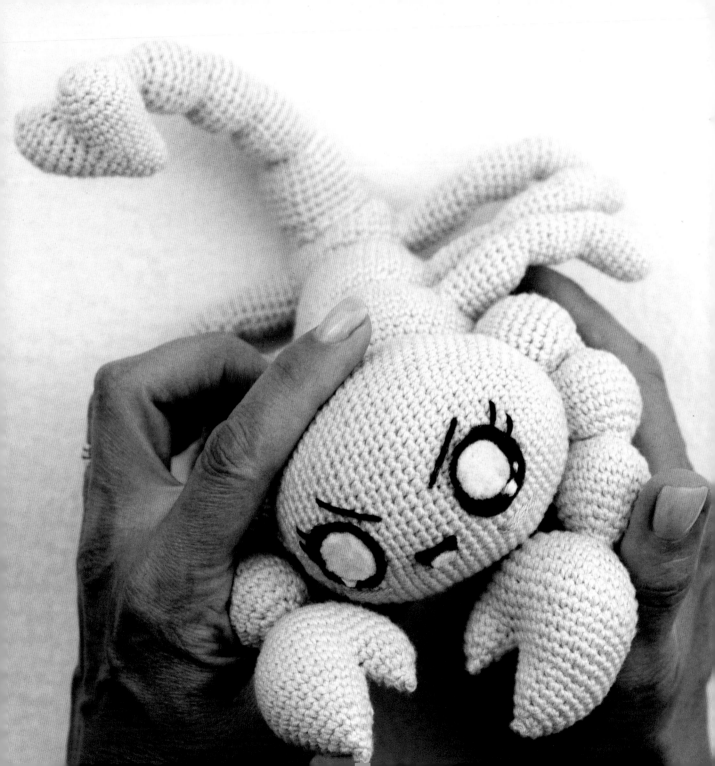

# SINISTER SCORPION

## MATERIALS

Yarn and Colors® 100% mercerized cotton (sport weight yarn)

1.75oz (50g); 137yds (125m)

### Colors:

Orchid (052) 137yds (125m)

Cotton Candy (037) (leftover)

White (001) (leftover)

Black (100) (leftover)

- Size 2mm crochet hook
- Felt fabric (black and white)
- Fiberfill
- Tapestry needle
- Stitch marker
- Scissors
- Glue
- Black and white thread and sewing needle
- Pins

### Gauge:

7 sts and 7 rnds = 1in/2.54cm in sc

## Let's Begin!

### Head

**Rnd 1:** With Orchid, work 6 sc in a magic ring—6 sts.

**Rnd 2:** 2 sc in each st—12 sts.

**Rnd 3:** *Sc in the next st, 2 sc in the next st; repeat from * 5 more times—18 sts.

**Rnd 4:** *Sc in the next 2 sts, 2 sc in the next st; repeat from * 5 more times—24 sts.

**Rnd 5:** *Sc in the next 3 sts, 2 sc in the next st; repeat from * 5 more times—30 sts.

**Rnd 6:** *Sc in the next 4 sts, 2 sc in the next st; repeat from * 5 more times—36 sts.

**Rnd 7:** Sc in each st.

**Rnd 8:** *Sc in the next 5 sts, 2 sc in the next st; repeat from * 5 more times—42 sts.

**Rnd 9:** Sc in each st.

**Rnd 10:** *Sc in the next 6 sts, 2 sc in the next st; repeat from * 5 more times—48 sts.

**Rnd 11:** Sc in each st.

**Rnd 12:** *Sc in the next 7 sts, 2 sc in the next st; repeat from * 5 more times—54 sts.

**Rnd 13:** Sc in each st.

**Rnd 14:** *Sc in the next 8 sts, 2 sc in the next st; repeat from * 5 more times—60 sts.

**Rnds 15–26:** Sc in each st.

**Rnd 27:** *Sc in the next 8 sts, sc2tog; repeat from * 5 more times—54 sts remain.

**Rnd 28:** Sc in each st.

**Rnd 29:** *Sc in the next 7 sts, sc2tog; repeat from * 5 more times—48 sts remain.

**Rnd 30:** Sc in each st.

**Rnd 31:** *Sc in the next 6 sts, sc2tog; repeat from * 5 more times—42 sts remain.

**Rnd 32:** Sc in each st.

**Rnd 33:** *Sc in the next 5 sts, sc2tog; repeat from * 5 more times—36 sts remain.

**Rnd 34:** Sc in each st.

**Rnd 35:** *Sc in the next 4 sts, sc2tog; repeat from * 5 more times—30 sts remain.

**Rnd 36:** *Sc in the next 3 sts, sc2tog; repeat from * 5 more times—24 sts remain.

**Rnd 37:** *Sc in the next 2 sts, sc2tog; repeat from * 5 more times—18 sts remain.

Stuff the head.

**Rnd 38:** *Sc in the next st, sc2tog; repeat from * 5 more times—12 sts remain.

**Rnd 39:** *Sc2tog; repeat from * 5 more times—6 sts remain.

Fasten off and leave a yarn tail. Thread the yarn tail into the tapestry needle, then weave the yarn tail through the front loop of each remaining stitch and pull it tight to close. Weave in the yarn end.

## Body

### First Part

**Rnd 1:** With Orchid, work 6 sc in a magic ring—6 sts.

**Rnd 2:** 2 sc in each st—12 sts.

**Rnd 3:** *Sc in the next st, 2 sc in the next st; repeat from * 5 more times—18 sts.

**Rnd 4:** *Sc in the next 2 sts, 2 sc in the next st; repeat from * 5 more times—24 sts.

**Rnd 5:** *Sc in the next 3 sts, 2 sc in the next st; repeat from * 5 more times—30 sts.

**Rnd 6:** *Sc in the next 4 sts, 2 sc in the next st; repeat from * 5 more times—36 sts.

**Rnd 7:** *Sc in the next 5 sts, 2 sc in the next st; repeat from * 5 more times—42 sts.

**Rnd 8:** *Sc in the next 6 sts, 2 sc in the next st; repeat from * 5 more times—48 sts.

**Rnd 9:** *Sc in the next 7 sts, 2 sc in the next st; repeat from * 5 more times—54 sts.

**Rnds 10–13:** Sc in each st.

**Rnd 14:** *Sc in the next 7 sts, sc2tog; repeat from * 5 more times—48 sts remain.

**Rnd 15:** Sc in each st.

**Rnd 16:** *Sc in the next 6 sts, sc2tog; repeat from * 5 more times—42 sts remain.

**Rnds 17–18:** Sc in each st.

**Rnd 19:** *Sc in the next 5 sts, sc2tog; repeat from * 5 more times—36 sts remain.

Fasten off, leaving a long tail for sewing. Stuff the first body part.

### Second Part

**Rnd 1:** With Orchid, work 6 sc in a magic ring—6 sts.

**Rnd 2:** 2 sc in each st—12 sts.

**Rnd 3:** *Sc in the next st, 2 sc in the next st; repeat from * 5 more times—18 sts.

**Rnd 4:** *Sc in the next 2 sts, 2 sc in the next st; repeat from * 5 more times—24 sts.

**Rnd 5:** *Sc in the next 3 sts, 2 sc in the next st; repeat from * 5 more times—30 sts.

**Rnd 6:** *Sc in the next 4 sts, 2 sc in the next st; repeat from * 5 more times—36 sts.

**Rnd 7:** *Sc in the next 5 sts, 2 sc in the next st; repeat from * 5 more times—42 sts.

**Rnds 8–14:** Sc in each st.

**Rnd 15:** *Sc in the next 5 sts, sc2tog; repeat from * 5 more times—36 sts remain.

Fasten off, leaving a long tail for sewing. Stuff the second body part.

**Third Part**

**Rnd 1:** With Orchid, work 6 sc in a magic ring—6 sts.

**Rnd 2:** 2 sc in each st—12 sts.

**Rnd 3:** *Sc in the next st, 2 sc in the next st; repeat from * 5 more times—18 sts.

**Rnd 4:** *Sc in the next 2 sts, 2 sc in the next st; repeat from * 5 more times—24 sts.

**Rnd 5:** *Sc in the next 3 sts, 2 sc in the next st; repeat from * 5 more times—30 sts.

**Rnds 6–12:** Sc in each st.

**Rnd 13:** *Sc in the next 3 sts, sc2tog; repeat from * 5 more times—24 sts remain.

Fasten off, leaving a long tail for sewing. Stuff the third body part.

**Tail**

**Rnd 1:** With Orchid, work 6 sc in a magic ring—6 sts.

**Rnd 2:** 2 sc in each st—12 sts.

**Rnds 3–6:** Sc in each st.

**Rnd 7:** *Sc in the next st, sc2tog; repeat from * 3 more times—8 sts remain.

Stuff this first segment, then continue stuffing as you go.

**Rnd 8:** *Sc in the next st, 2 sc in the next st; repeat from * 3 more times—12 sts.

**Rnd 9:** *Sc in the next st, 2 sc in the next st; repeat from * 5 more times—18 sts.

**Rnds 10–14:** Sc in each st.

**Rnd 15:** *Sc in the next st, sc2tog; repeat from * 5 more times—12 sts remain.

Stuff this second segment.

**Rnd 16:** *Sc in the next st, 2 sc in the next st; repeat from * 5 more times—18 sts.

**Rnds 17–21:** Sc in each st.

**Rnd 22:** *Sc in the next st, sc2tog; repeat from * 5 more times—12 sts remain.

Stuff this third segment.

**Rnd 23:** *Sc in the next st, 2 sc in the next st; repeat from * 5 more times—18 sts.

**Rnds 24–28:** Sc in each st.

**Rnd 29:** *Sc in the next st, sc2tog; repeat from * 5 more times—12 sts remain.

Stuff this fourth segment.

**Rnd 30:** *Sc in the next st, 2 sc in the next st; repeat from * 5 more times—18 sts.

**Rnd 31:** *Sc in the next 2 sts, 2 sc in the next st; repeat from * 5 more times—24 sts.

**Rnds 32–38:** Sc in each st.

Fasten off, leaving a long tail for sewing. Stuff this fifth segment.

## Tail Heart

**Rnd 1:** With Orchid, work 4 sc in a magic ring—4 sts.

**Rnd 2:** 2 sc in each st—8 sts.

**Rnd 3:** *Sc in the next st, 2 sc in the next st; repeat from * 3 more times—12 sts.

**Rnd 4:** Sc in each st.

**Rnd 5:** *Sc in the next 2 sts, 2 sc in the next st; repeat from * 3 more times—16 sts.

**Rnd 6:** Sc in each st.

**Rnd 7:** *Sc in the next 3 sts, 2 sc in the next st; repeat from * 3 more times—20 sts.

**Rnd 8:** *Sc in the next 4 sts, 2 sc in the next st; repeat from * 3 more times—24 sts.

**Rnd 9:** *Sc in the next 5 sts, 2 sc in the next st; repeat from * 3 more times—28 sts.

**Rnd 10:** *Sc in the next 6 sts, 2 sc in the next st; repeat from * 3 more times—32 sts.

**Rnd 11:** *Sc in the next 7 sts, 2 sc in the next st; repeat from * 3 more times—36 sts.

Divide the work in 2 sections of 18 sts each. Continue working the first part to create the rounded top half of the heart.

**Rnds 12–13:** Sc in each st—18 sts.

**Rnd 14:** *Sc in the next st, sc2tog; repeat from * 5 more times—12 sts remain.

**Rnd 15:** Sc in each st.

**Rnd 16:** *Sc2tog; repeat from * 5 more times—6 sts remain.

Fasten off and leave a yarn tail. Thread the yarn tail into the tapestry needle, then weave the yarn tail through the front loop of each remaining stitch and pull it tight to close. Weave in the yarn end.

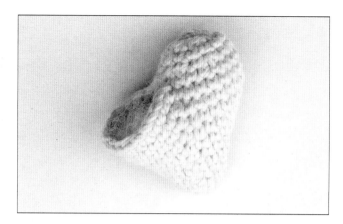

With Orchid, pull up a loop yarn in the next unworked stitch of Rnd 11.

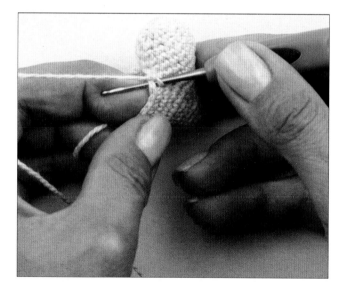

Fasten off and leave a yarn tail. Thread the yarn tail into the tapestry needle, then weave the yarn tail through the front loop of each remaining stitch and pull it tight to close. Pass the yarn through the heart to exit through the upper part of it and close the hole between the two parts with a few Sts. Fasten off, leaving a long tail for sewing.

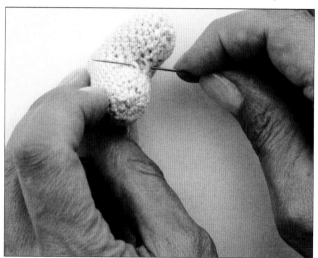

**Rnds 12–13:** Sc in each st—18 sts.

**Rnd 14:** *Sc in the next st, sc2tog; repeat from * 5 more times—12 sts remain.

**Rnd 15:** Sc in each st.

**Rnd 16:** *Sc2tog; repeat from * 5 more times—6 sts remain.

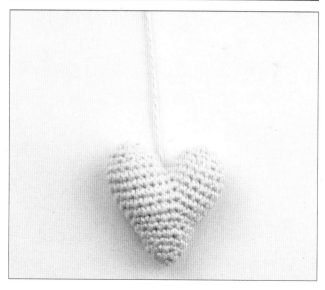

## Legs (make 6)

**Rnd 1:** With Orchid, work 6 sc in a magic ring—6 sts.

**Rnd 2:** *Sc in the next st, 2 sc in the next st; repeat from * 2 more times—9 sts.

**Rnd 3:** *Sc in the next 2 sts, 2 sc in the next st; repeat from * 2 more times—12 sts.

**Rnds 4–9:** Sc in each st.

**Rnds 10–11:** (Sc2tog) 2 times, sc in the next 3 sts, (2 sc in the next) 2 times, sc in the next 3 sts.

**Rnds 12–16:** Sc in each st.

**Rnds 17–18:** Sc in the next st, (sc2tog) 2 times, sc in the next 3 sts, (2 sc in the next st) 2 times, sc in the next 2 sts.

**Rnds 19–25:** Sc in each st.

Fasten off, leaving a long tail for sewing. Lightly stuff the legs.

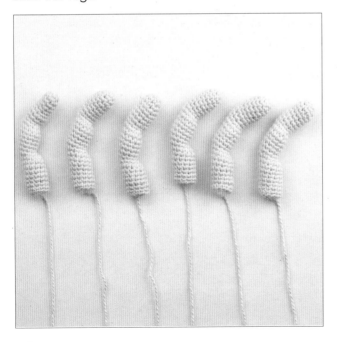

## Arms (make 2)

**Rnd 1:** With Orchid, work 6 sc in a magic ring—6 sts.

**Rnd 2:** 2 sc in each st—12 sts.

**Rnd 3:** *Sc in the next st, 2 sc in the next st; repeat from * 5 more times—18 sts.

**Rnd 4:** *Sc in the next 2 sts, 2 sc in the next st; repeat from * 5 more times—24 sts.

**Rnds 5–9:** Sc in each st.

**Rnd 10:** *Sc in the next 2 sts, sc2tog; repeat from * 5 more times—18 sts remain.

**Rnd 11:** *Sc in the next st, sc2tog; repeat from * 5 more times—12 sts remain.

Stuff this first segment.

**Rnd 12:** *Sc2tog; repeat from * 5 more times—6 sts remain.

**Rnd 13:** 2 sc in each st—12 sts.

**Rnd 14:** *Sc in the next st, 2 sc in the next st; repeat from * 5 more times—18 sts.

**Rnd 15:** *Sc in the next 2 sts, 2 sc in the next st; repeat from * 5 more times—24 sts.

**Rnds 16–20:** Sc in each st.

**Rnd 21:** *Sc in the next 2 sts, sc2tog; repeat from * 5 more times—18 sts remain.

**Rnd 22:** *Sc in the next st, sc2tog; repeat from * 5 more times—12 sts remain.

Stuff this second segment.

**Rnd 23:** *Sc2tog; repeat from * 5 more times—6 sts remain.

**Rnd 24:** 2 sc in each st—12 sts.

**Rnd 25:** *Sc in the next st, 2 sc in the next st; repeat from * 5 more times—18 sts remain.

**Rnd 26:** *Sc in the next 2 sts, 2 sc in the next st; repeat from * 5 more times—24 sts remain.

**Rnds 27–31:** Sc in each st.

**Rnd 32:** *Sc in the next 2 sts, sc2tog; repeat from * 5 more times—18 sts remain.

**Rnd 33:** *Sc in the next st, sc2tog; repeat from * 5 more times—12 sts remain.

Stuff this third segment.

**Rnd 34:** *Sc2tog; repeat from * 5 more times—6 sts remain.

**Rnd 35:** 2 sc in each st—12 sts.

**Rnd 36:** *Sc in the next st, 2 sc in the next st; repeat from * 5 more times—18 sts.

**Rnd 37:** *Sc in the next 2 sts, 2 sc in the next st; repeat from * 5 more times—24 sts.

**Rnd 38:** *Sc in the next 3 sts, 2 sc in the next st; repeat from * 5 more times—30 sts.

**Rnd 39:** *Sc in the next 4 sts, 2 sc in the next st; repeat from * 5 more times—36 sts.

**Rnds 40–44:** Sc in each st.

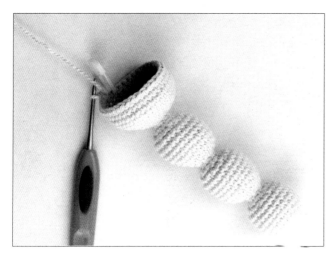

Divide the work in 2 parts: 12 Sts in the first section and 24 Sts in the second section. Continue working the first section to create a smaller round.

**Rnds 45–46:** Sc in each st—12 sts.

**Rnd 47:** *Sc2tog; repeat from * 5 more times—6 sts remain.

**Rnd 48:** *Sc2tog; repeat from * 2 more times—3 sts remain.

Fasten off and leave a yarn tail. Thread the yarn tail into the tapestry needle, then weave the yarn tail through the front loop of each remaining stitch and pull it tight to close. Weave in the yarn end.

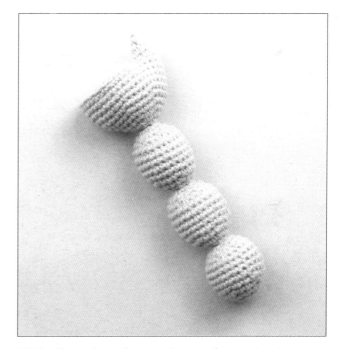

With Orchid, pull up a loop of yarn in the next unworked stitch of Rnd 44.

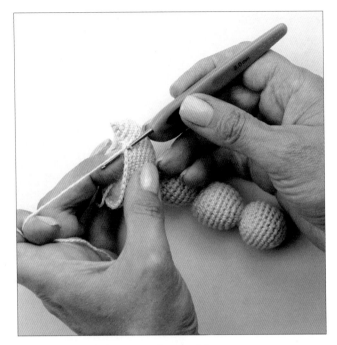

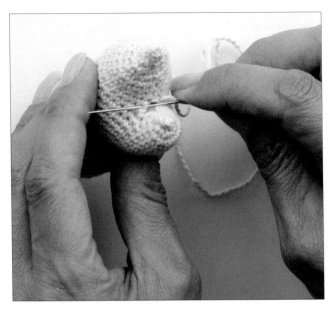

the arm to exit through the upper part of it and close the hole between the two parts with a few Sts. Fasten off.

**Rnds 45–46:** Sc in each st—24 sts.

**Rnd 47:** *Sc in the next 2 sts, sc2tog; repeat from * 5 more times—18 sts remain.

**Rnds 48–49:** Sc in each st.

**Rnd 50:** *Sc in the next st, sc2tog; repeat from * 5 more times—12 sts remain.

**Rnd 51:** Sc in each st.

Finish stuffing the arm.

**Rnd 52:** *Sc2tog; repeat from * 5 more times— 6 sts remain.

**Rnd 53:** *Sc2tog; repeat from * 2 more times— 3 sts remain.

Fasten off and leave a yarn tail. Thread the yarn tail into the tapestry needle, then weave the yarn tail through the front loop of each remaining stitch and pull it tight to close. Pass the yarn through

## Time to Put It All Together!

Sew the first part of the body to the head, centered between Rnds 12 and 28.

Sew the second part of the body to the first part at Rnd 9 of the first part of the body.

Sew the third part of the body to the second part at Rnd 5 of the second part of the body.

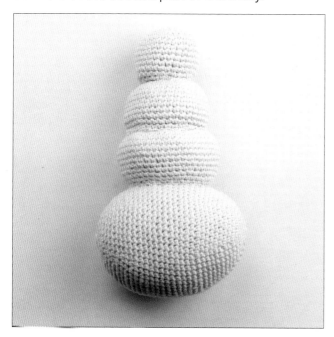

Sew the tail to the third part of the body between Rnds 2 and 10, aligned with the head.

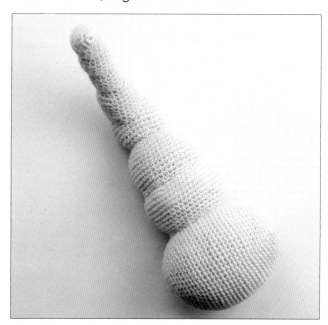

Sew the heart to the tip of the tail, with the pointed tip facing away from the tail.

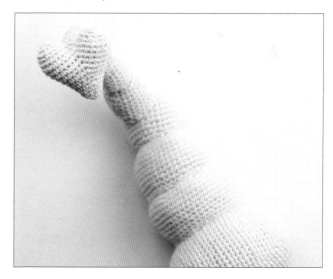

Sew the arms to the sides of the first part of the body at Rnd 16, with 18 Sts between them.

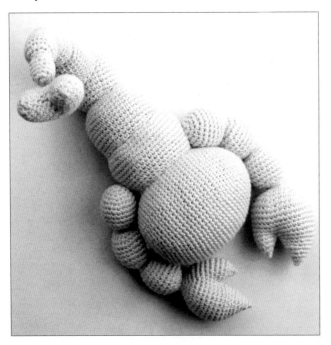

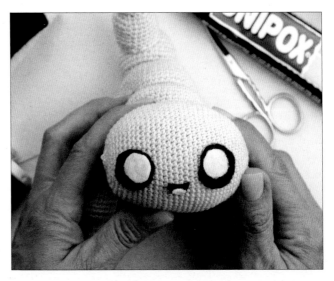

Cut out the shapes of the eyes and mouth from the felt fabric, using the graphics below as a guide.

Glue the black parts of the eyes between Rnds 9 and 15 and Rnds 25 and 31 of the head. Glue the white parts of the eyes on top of the black parts. Glue the mouth, centered between the eyes and between Rnds 18 and 21.

Using the sewing thread, finish securing the eyes and the mouth to the head. With White yarn, embroider the teeth and the shine of the eyes. With Cotton Candy, embroider the cheeks below the eyes. With Black yarn embroider the eyebrows above the eyes, and the eyelashes at the upper outside edges of the eyes.

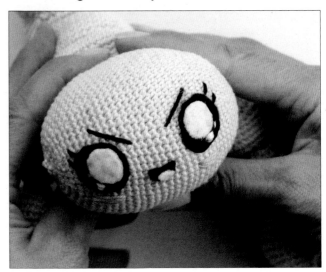

**Black part**

Ø 2.2 cm = 0.85 in

**White part**

Ø 1.5 cm = 0.6 in

**Mouth**

1.2 cm = 0.5 in

0.8 cm = 0.3 in

Sew two of the legs to the sides of the first body part between Rnds 10 and 13, with 22 Sts between them.

Sew two more legs to the sides of the second body part between Rnds 9 and 12, with 18 Sts between them.

Sew the last two legs to the sides of the third body part between Rnds 8 and 11, with 12 Sts between them.

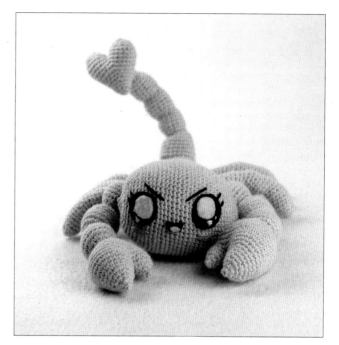

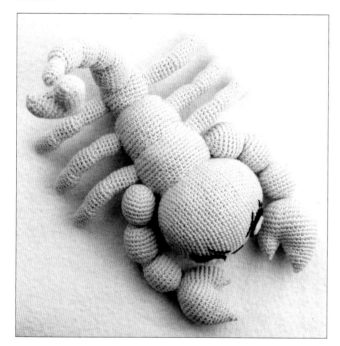

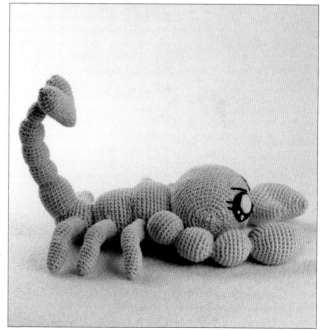

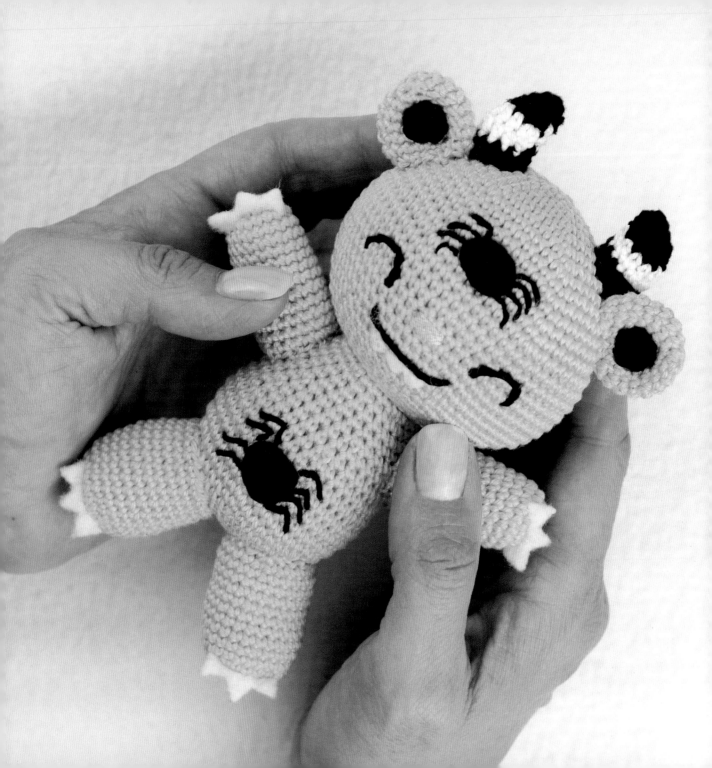

# GREEN DEVIL BEAR

## MATERIALS

Yarn and Colors® 100% mercerized cotton (sport weight yarn)

1.75oz (50g); 137yds (125m)

### Colors:

Pesto (085) 137yds (125m)

Cotton Candy (037) (leftover)

White (001) (leftover)

Black (100) (leftover)

- Size 2mm crochet hook
- Felt fabric (black and white)
- Fiberfill
- Tapestry needle
- Stitch marker
- Scissors
- Pins

### Gauge:

7 sts and 7 rnds = 1in/2.54cm in sc

## Let's Begin!

### Head

**Rnd 1:** With Pesto, work 6 sc in a magic ring—6 sts.

**Rnd 2:** 2 sc in each st—12 sts.

**Rnd 3:** *Sc in the next st, 2 sc in the next st; repeat from * 5 more times—18 sts.

**Rnd 4:** *Sc in the next 2 sts, 2 sc in the next st; repeat from * 5 more times—24 sts.

**Rnd 5:** *Sc in the next 3 sts, 2 sc in the next st; repeat from * 5 more times—30 sts.

**Rnd 6:** *Sc in the next 4 sts, 2 sc in the next st; repeat from * 5 more times—36 sts.

**Rnd 7:** *Sc in the next 5 sts, 2 sc in the next st; repeat from * 5 more times—42 sts.

**Rnd 8:** *Sc in the next 6 sts, 2 sc in the next st; repeat from * 5 more times—48 sts.

**Rnd 9:** Sc in each st.

**Rnd 10:** *Sc in the next 7 sts, 2 sc in the next st; repeat from * 5 more times—54 sts.

**Rnd 11:** Sc in each st.

**Rnd 12:** *Sc in the next 8 sts, 2 sc in the next st; repeat from * 5 more times—60 sts.

**Rnd 13:** Sc in each st.

**Rnd 14:** *Sc in the next 9 sts, 2 sc in the next st; repeat from * 5 more times—66 sts.

**Rnds 15–21:** Sc in each st.

**Rnd 22:** *Sc in the next 9 sts, sc2tog; repeat from * 5 more times—60 sts remain.

**Rnd 23:** *Sc in the next 8 sts, sc2tog; repeat from * 5 more times—54 sts remain.

**Rnd 24:** *Sc in the next 7 sts, sc2tog; repeat from * 5 more times—48 sts remain.

**Rnd 25:** *Sc in the next 6 sts, sc2tog; repeat from * 5 more times—42 sts remain.

**Rnd 26:** *Sc in the next 5 sts, sc2tog; repeat from * 5 more times—36 sts remain.

**Rnd 27:** *Sc in the next 4 sts, sc2tog; repeat from * 5 more times—30 sts remain.

**Rnd 28:** *Sc in the next 3 sts, sc2tog; repeat from * 5 more times—24 sts remain.

Fasten off, leaving a long tail for sewing.

Stuff the head.

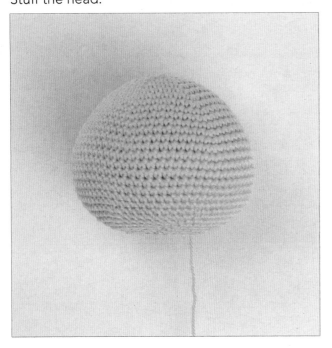

## Body

**Rnd 1:** With Pesto, work 6 sc in a magic ring—6 sts.

**Rnd 2:** 2 sc in each st—12 sts.

**Rnd 3:** *Sc in the next st, 2 sc in the next st; repeat from * 5 more times—18 sts.

**Rnd 4:** *Sc in the next 2 sts, 2 sc in the next st; repeat from * 5 more times—24 sts.

**Rnd 5:** *Sc in the next 3 sts, 2 sc in the next st; repeat from * 5 more times—30 sts.

**Rnd 6:** *Sc in the next 4 sts, 2 sc in the next st; repeat from * 5 more times—36 sts.

**Rnd 7:** *Sc in the next 5 sts, 2 sc in the next st; repeat from * 5 more times—42 sts.

**Rnd 8:** *Sc in the next 6 sts, 2 sc in the next st; repeat from * 5 more times—48 sts.

**Rnds 9–12:** Sc in each st.

**Rnd 13:** *Sc in the next 6 sts, sc2tog; repeat from * 5 more times—42 sts remain.

**Rnd 14:** Sc in each st.

**Rnd 15:** *Sc in the next 5 sts, sc2tog; repeat from * 5 more times—36 sts remain.

**Rnd 16:** Sc in each st.

**Rnd 17:** *Sc in the next 4 sts, sc2tog; repeat from * 5 more times—30 sts remain.

**Rnds 18–20:** Sc in each st.

**Rnd 21:** *Sc in the next 3 sts, sc2tog; repeat from * 5 more times—24 sts remain.

**Rnd 22:** *Sc in the next 2 sts, sc2tog; repeat from * 5 more times—18 sts remain.

**Rnds 23–25:** Sc in each st.

Stuff the body.

**Rnd 26:** *Sc in the next st, sc2tog; repeat from * 5 more times—12 sts remain.

**Rnd 27:** *Sc2tog; repeat from * 5 more times—6 sts remain.

Fasten off and leave a yarn tail. Thread the yarn tail into the tapestry needle, then weave the yarn tail through the front loop of each remaining stitch and pull it tight to close. Weave in the yarn end.

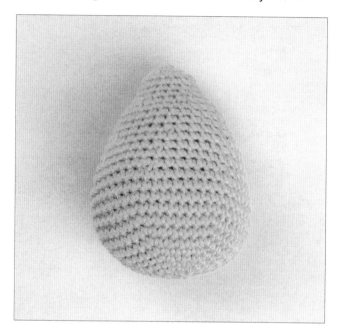

## Arms (make 2)

**Rnd 1:** With Pesto, work 6 sc in a magic ring—6 sts.

**Rnd 2:** 2 sc in each st—12 sts.

**Rnd 3:** *Sc in the next st, sc2tog; repeat from * 5 more times—18 sts.

**Rnds 4–14:** Sc in each st.

Fasten off, leaving a long tail for sewing. Stuff the arms.

## Legs (make 2)

**Rnd 1:** With Pesto, work 6 sc in a magic ring—6 sts.

**Rnd 2:** 2 sc in each st—12 sts.

**Rnd 3:** *Sc in the next st, 2 sc in the next st; repeat from * 5 more times—18 sts.

**Rnd 4:** *Sc in the next 2 sts, 2 sc in the next st; repeat from * 5 more times—24 sts.

**Rnds 5–14:** Sc in each st.

Fasten off, leaving a long tail for sewing. Stuff the legs.

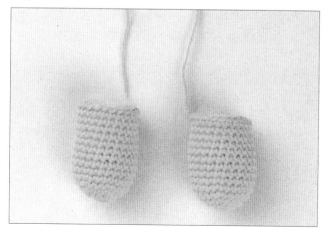

## Horns (make 2)

**Rnd 1:** With Black, work 4 sc in a magic ring—4 sts.

**Rnd 2:** 2 sc in each st—8 sts.

**Rnd 3:** Hdc in the next st, sc in the next 4 sts, hdc in the next st, 2 hdc in the next 2 sts—10 sts.

Change to White.

**Rnd 4:** Sc in the next 6 sts, *hdc in the next st, 2 hdc in the next st; repeat from * once more—12 sts.

**Rnd 5:** Sc in the next 6 sts, hdc in the next 6 sts.

Change to Black.

**Rnds 6–7:** Sc in each st.

Fasten off, leaving a long tail for sewing. Stuff the horns.

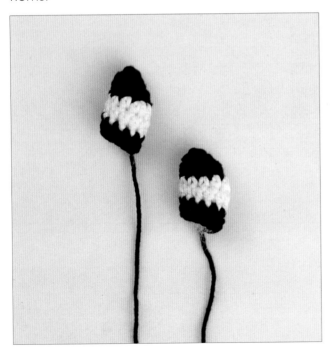

## Ears (make 2)

**Rnd 1:** With Pesto, work 6 sc in a magic ring—6 sts.

**Rnd 2:** 2 sc in each st—12 sts.

**Rnd 3:** *Sc in the next st, 2 sc in the next st; repeat from * 5 more times—18 sts.

**Rnds 4–7:** Sc in each st.

**Rnd 8:** *Sc in the next st, sc2tog; repeat from * 5 more times—12 sts remain.

Fasten off, leaving a long tail for sewing.

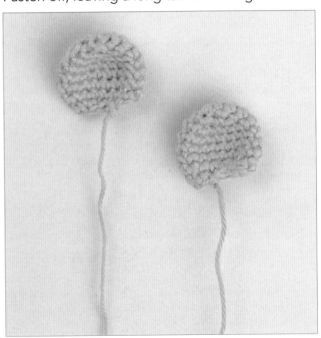

## Centers of the Ears (make 2)

**Rnd 1:** With Black, work 6 sc in a magic ring—6 sts.

Fasten off, leaving a long tail for sewing. Sew each center of the ear centered to the ears.

## Time to Put It All Together!

Insert the smallest part of the body into the hole in the head and sew the head to the body at Rnd 21.

Sew the arms to the sides of the body between Rnds 15 and 19, with 13 sts between them at the back.

Sew the legs to the body between Rnds 2 and 7.

With Black yarn, embroider the eyes on the front of the head between Rnds 17 and 18, and 8 sts apart. Embroider the mouth between Rnds 20 and 21. With Cotton Candy, embroider the nose at Rnd 18, centered between the eyes.

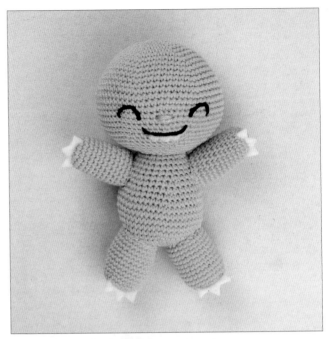

Cut out the shape of the claws and teeth from the white felt fabric, and glue them to the arms, legs, and head. Use the black felt fabric to cut out the shape of the spiders and glue them to the body and head. Use the graphics below as a guide.

**Claws and teeth (make 5)**

2 cm

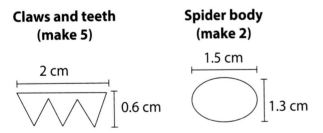

0.6 cm

**Spider body (make 2)**

1.5 cm

1.3 cm

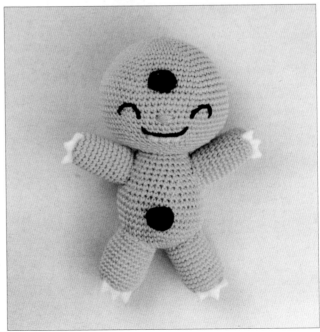

With Black yarn, embroider the legs of the spiders. Sew the ears to the head between Rnds 9 and 12. Sew the horns to the top of the head between Rnds 5 and 8.

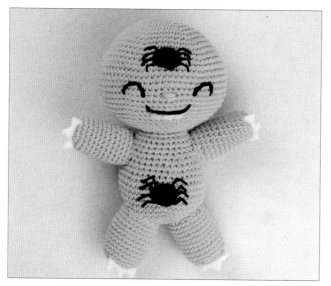

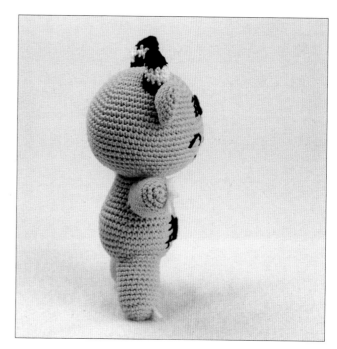

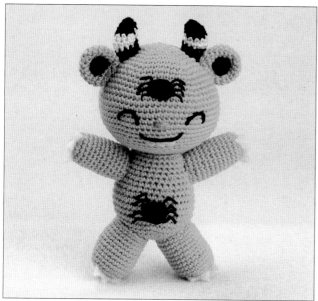

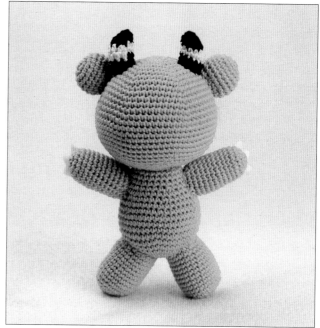

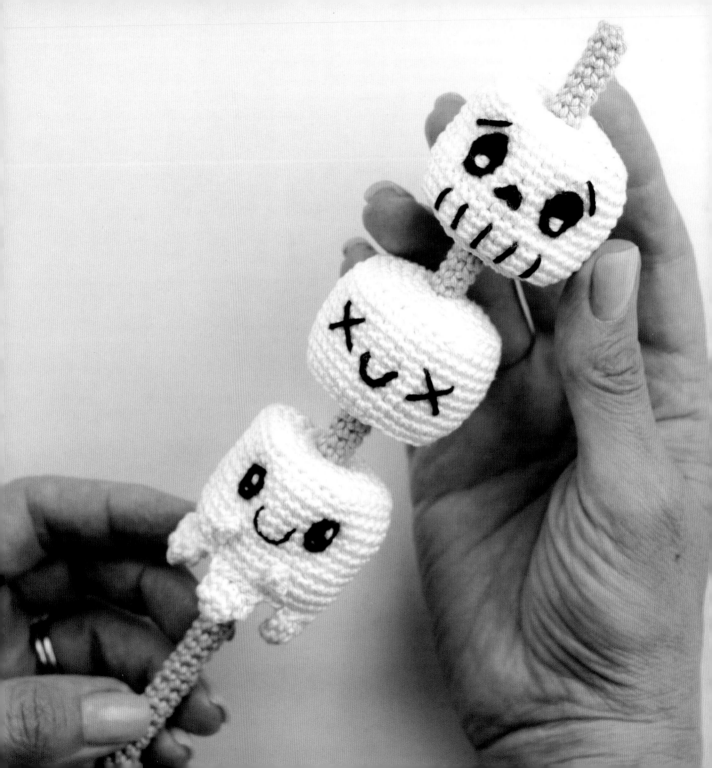

# MORBID MARSHMALLOWS

## MATERIALS

Yarn and Colors® 100% mercerized cotton (sport weight yarn)

1.75oz (50g); 137yds (125m)

### Colors:

Limestone (009) 28yds (25.5m)

White (001) (leftover)

Black (100) (leftover)

- Size 2mm crochet hook
- Felt fabric (black and white)
- Fiberfill
- Tapestry needle
- Scissors
- Pliers
- Skewer stick
- Glue
- Black and white thread and sewing needle

### Gauge:

7 sts and 7 rnds = 1in/2.54cm in sc

## Let's Begin!

### Stick

**Rnd 1:** With Limestone, work 6 sc in a magic ring—6 sts.

**Rnds 2–65:** Sc in each st.

Fasten off and leave a yarn tail.

Place a drop of glue on one of the ends of the skewer and insert it into the work. Cut the excess stick with pliers.

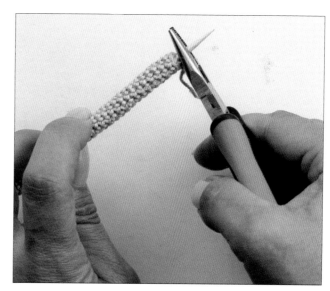

Place another drop of glue on the other end of the skewer. Using the yarn needle, weave the yarn tail through the front loop of each remaining stitch and pull it tight to close. Weave in the yarn end.

## Marshmallows (make 3)

With White, ch 12, join with sl st to make a ring, ch 1–12 sts.

**Rnds 1–10:** Sc in each st.

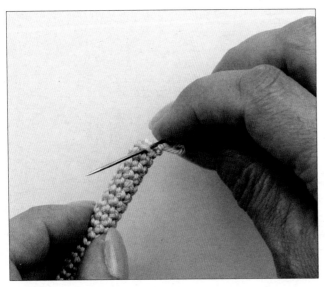

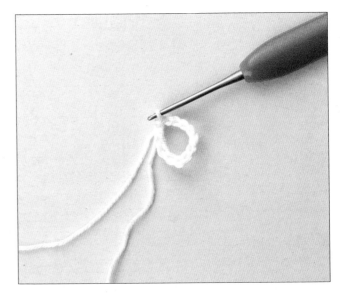

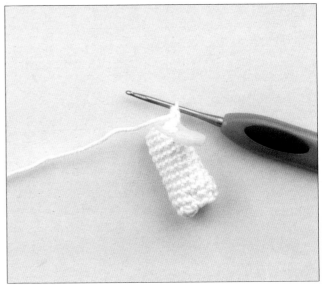

**Rnd 11:** Holding the work with the top edge facing, and working through back loop of the sts of Rnd 10, insert the hook from the inside to the outside of the work, *BL sc in the next st, 2 BL sc in the next st; repeat from * 5 more times—18 sts.

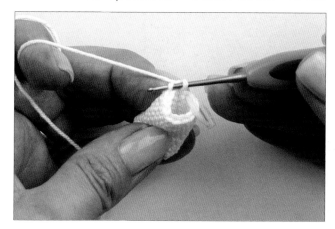

**Rnd 12:** *Sc in the next 2 sts, 2 sc in the next st; repeat from * 5 more times—24 sts.

**Rnd 13:** *Sc in the next 3 sts, 2 sc in the next st; repeat from * 5 more times—30 sts.

**Rnd 14:** *Sc in the next 4 sts, 2 sc in the next st; repeat from * 5 more times—36 sts.

**Rnd 15:** Working through the back loop of the sts of Rnd 14, BL sc in each st.

**Rnds 16–24:** Sc in each st.

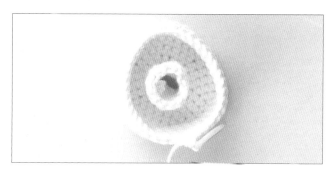

Stuff the marshmallow. Use a pencil to maintain the central part so that the marshmallow does not lose its shape while it is stuffed.

**Rnd 25:** Working through the back loops of the sts of Rnd 24, *sc in the next 4 sts, sc2tog; repeat from * 5 more times—30 sts remain.

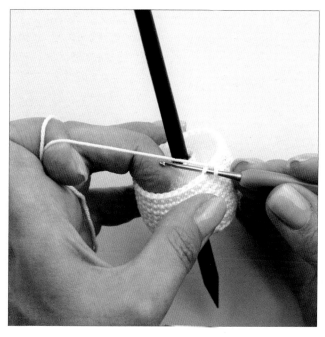

**Rnd 26:** *Sc in the next 3 sts, sc2tog; repeat from * 5 more times—24 sts remain.

**Rnd 27:** *Sc in the next 2 sts, sc2tog; repeat from * 5 more times—18 sts remain.

**Rnd 28:** *Sc in the next st, sc2tog; repeat from * 5 more times—12 sts remain.

Fasten off, leaving a long tail for sewing. Thread the yarn tail into the tapestry needle, then sew the remaining sts from Rnd 28 to the starting ch to close the marshmallow.

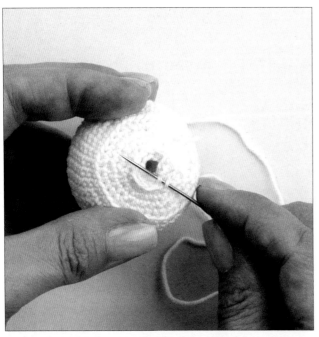

## Time to Put It All Together!

Embroider the faces of the marshmallows however you like. You can use the photos as a guide. (If you use felt eyes for a marshmallow, cut the shapes out of black and white felt fabric.)

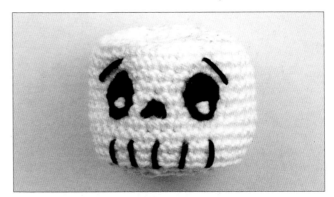

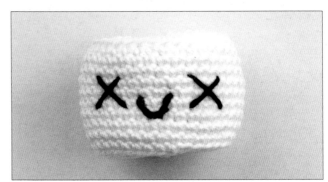

To make the melted marshmallow, use the following instructions for the little hands and drips.

### Drips (make 3)

**Rnd 1:** With White, work 6 sc in a magic ring—6 sts.

**Rnd 2:** *Sc in the next st, 2 sc in the next st; repeat from * 2 more times—9 sts.

The drips don't need to be stuffed. Flatten the opening of the drips.

**Next row:** Working through both layers to close the opening, hdc in next 2 sts, sc in the next st, sl st in the last st.

Fasten off, leaving a long tail for sewing.

### Little Hands (make 2)

**Rnd 1:** With White, work 3 sc in a magic ring—3 sts.

Fasten off, leaving a long tail for sewing.

Place the marshmallows on the stick.

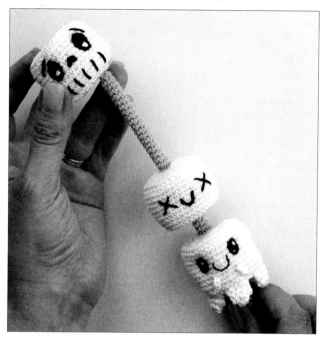

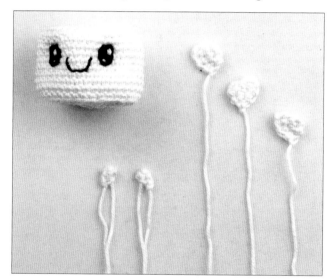

Sew the hands to the front of the marshmallow, below the eyes. Sew the drips to lower edge of the marshmallow.

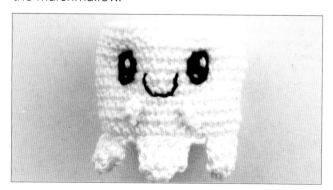

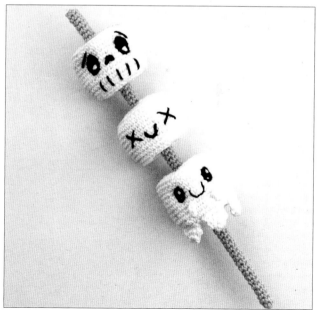

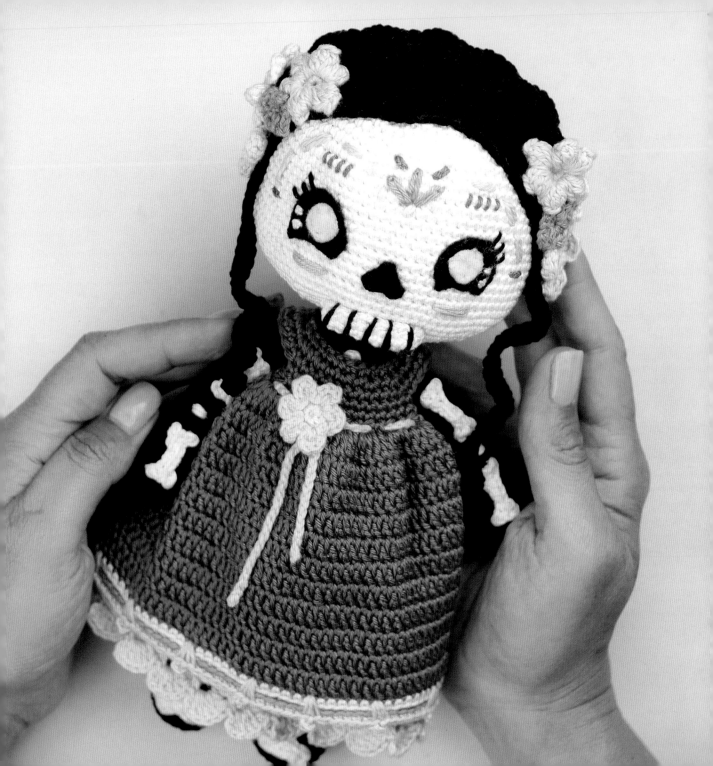

# LA CATRINA

## MATERIALS

Yarn and Colors® 100% mercerized cotton (sport weight yarn)

1.75oz (50g); 137yds (125m)

### Colors:

White (001) 82yds (75m)

Black (100) 137yds (125m)

Orchid (052) 55yds (50m)

Clematis (057) 55yds (50m)

Salmon (039) (leftover)

Vanilla (010) (leftover)

Opaline Glass (074) (leftover)

Cotton Candy (037) (leftover)

- Size 2mm crochet hook
- Felt fabric (black and white)
- Fiberfill
- Tapestry needle
- Stitch marker
- Scissors
- Glue
- Black and white thread and sewing needle
- Pins

### Gauge:

7 sts and 7 rnds = 1in/2.54cm in sc

## Let's Begin!

### Body

**Rnd 1:** With Black, work 8 sc in a magic ring—8 sts.

**Rnd 2:** 2 sc in each st—16 sts.

**Rnds 3–10:** Sc in each st.

**Rnd 11:** *Sc in the next 3 sts, 2 sc in the next st; repeat from * 3 more times—20 sts.

**Rnd 12:** Sc in each st.

**Rnd 13:** *Sc in the next 4 sts, 2 sc in the next st; repeat from * 3 more times—24 sts.

**Rnd 14:** Sc in each st.

**Rnd 15:** *Sc in the next 3 sts, 2 sc in the next st; repeat from * 5 more times—30 sts.

**Rnd 16:** Sc in each st.

**Rnd 17:** *Sc in the next 4 sts, 2 sc in the next st; repeat from * 5 more times—36 sts.

**Rnd 18:** Sc in each st.

**Rnd 19:** *Sc in the next 5 sts, 2 sc in the next st; repeat from * 5 more times—42 sts.

**Rnd 20:** Sc in each st.

**Rnd 21:** *Sc in the next 6 sts, 2 sc in the next st; repeat from * 5 more times—48 sts.

**Rnds 22–30:** Sc in each st.

**Rnd 31:** BL sc in each st.

**Rnds 32–37:** Sc in each st.

**Rnd 38:** *Sc in the next 6 sts, sc2tog; repeat from * 5 more times—42 sts remain.

**Rnd 39:** *Sc in the next 5 sts, sc2tog; repeat from * 5 more times—36 sts remain.

**Rnd 40:** *Sc in the next 4 sts, sc2tog; repeat from * 5 more times—30 sts remain.

**Rnd 41:** *Sc in the next 3 sts, sc2tog; repeat from * 5 more times—24 sts remain.

**Rnd 42:** *Sc in the next 2 sts, sc2tog; repeat from * 5 more times—18 sts remain.

Stuff the body.

**Rnd 43:** *Sc in the next st, sc2tog; repeat from * 5 more times—12 sts remain.

**Rnd 44:** *Sc2tog; repeat from * 5 more times—6 sts remain.

Fasten off and leave a yarn tail. Thread the yarn tail into the tapestry needle, then weave the yarn tail through the front loop of each remaining stitch and pull it tight to close. Weave in the yarn end.

## Petticoat

With Orchid, pull up a loop in the front loop of the center stitch at the back of the body on Rnd 30.

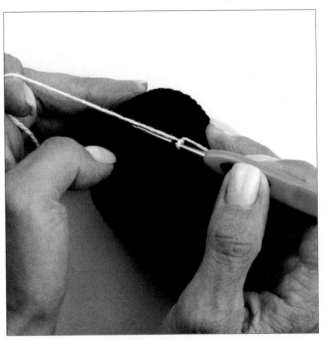

**Rnd 1:** Ch 2 (count as 1st st), dc in the next st, (2 dc in the next st) 47 times, sl st in the 2nd ch of the beginning-ch to join—96 sts.

**Rnds 2–8:** Ch 2 (count as 1st st), dc in each st, sl st in the 2nd ch of the beginning-ch to join.

**Rnd 9:** Ch 1 (don't count as 1st st), sc in each st, sl st in the 1st ch of the beginning-ch to join.

**Rnd 10:** (See also Scallop Edge Chart) Ch 1 (don't count as 1st st), *sc in the next st, skip 2 sts, dc in next st to form scallop base, ch 3, 6 dc around post of scallop base; repeat from * 23 more times, sl st in the 1st ch of the beginning-ch to join.

**Scallop Edge Chart**

Multiple of 4

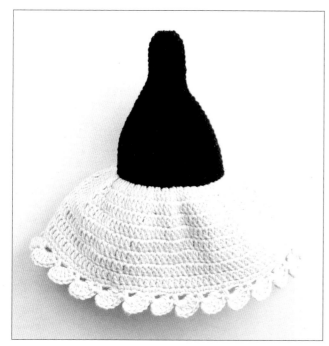

## Ribs and Spine

With White, ch 17.

**Rnd 1:** Start in the 2nd ch from hook, sl st in the next 16 sts, work along the other side of the ch, sl st in the next 16 sts—32 sts.

Fasten off, leaving a long tail for sewing.

## Short Ribs (make 2)

**Rnd 1:** With White, ch 5, start in the 2nd ch from hook, sc in the next 4 sts—4 sts.

Fasten off, leaving a long tail for sewing.

## Medium Ribs (make 2)

**Rnd 1:** With White, ch 7, start in the 2nd ch from hook, sc in the next 6 sts—6 sts.

Fasten off, leaving a long tail for sewing.

## Long Ribs (make 2)

**Rnd 1:** With White, ch 9, start in the 2nd ch from hook, sc in the next 8 sts—8 sts.

Fasten off, leaving a long tail for sewing.

Sew the spine to the body, centered on the front and between Rnds 11 and 26. Sew the short ribs on either side of the spine along Rnd 16 of the body. Sew the medium ribs below the short ribs, along Rnd 21 of the body. Sew the long ribs below the medium ribs, along Rnd 25 of the body.

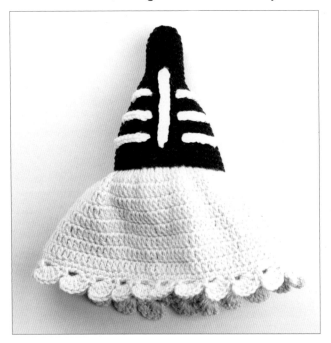

## Arms (make 2)

**Rnd 1:** With Black, work 6 sc in a magic ring—6 sts.

**Rnd 2:** 2 sc in each st—12 sts.

**Rnd 3:** *Sc in the next st, 2 sc in the next st; repeat from * 5 more times—18 sts.

**Rnds 4–6:** Sc in each st.

**Rnd 7:** Sc in the next 16 sts, sc2tog—17 sts remain.

**Rnd 8:** Sc in the next 7 sts, sc2tog, sc in the next 8 sts—16 sts remain.

**Rnd 9:** Sc in the next 14 sts, sc2tog—15 sts remain.

**Rnd 10:** Sc2tog, sc in the next 13 sts—14 sts remain.

**Rnd 11:** Sc in the next 6 sts, sc2tog, sc in the next 6 sts—13 sts remain.

**Rnd 12:** Sc in the next 11 sts, sc2tog—12 sts remain.

**Rnd 13:** Sc in the next 4 sts, sc2tog, sc in the next 6 sts—11 sts remain.

**Rnd 14:** Sc in the next 9 sts, sc2tog—10 sts remain.

**Rnds 15–25:** Sc in each st.

**Rnd 26:** *Sc2tog; repeat from * 4 more times—5 sts remain.

Fasten off, leaving a long tail for sewing.

## Arm Bones (make 4)

With White, ch 8.

**Rnd 1:** Start in the 2nd ch from hook, (sc, ch 2, sl st) in the same ch st, (sc, ch 2, sl st) in the next ch st, sl st in the next 3 ch sts, (sc, ch 2, sl st) in the next ch st, (sc, ch 2, sl st) in the next ch st, work along the other side of the ch, sl st in the next 3 sts, sl st in the 8th ch of the beginning-ch to join.

Fasten off, leaving a long tail for sewing.

Sew the bones centered on the arms. Embroider small sts between the bones.

## Legs (make 2)

**Rnd 1:** With Black, work 6 sc in a magic ring—6 sts.

**Rnd 2:** 2 sc in each st—12 sts.

**Rnd 3:** *Sc in the next st, 2 sc in the next st; repeat from * 5 more times—18 sts.

**Rnd 4:** *Sc in the next 2 sts, 2 sc in the next st; repeat from * 5 more times—24 sts.

**Rnds 5–6:** Sc in each st.

**Rnd 7:** *Sc in the next 4 sts, sc2tog; repeat from * 3 more times—20 sts remain.

**Rnds 8–16:** Sc in each st.

**Rnd 17:** *Sc in the next 3 sts, sc2tog; repeat from * 3 more times—16 sts remain.

**Rnds 18–29:** Sc in each st.

**Rnd 30:** *Sc2tog; repeat from * 7 more times—8 sts remain.

Fasten off and leave a yarn tail. Thread the yarn tail into the tapestry needle, then weave the yarn tail through the front loop of each remaining stitch and pull it tight to close. Weave in the yarn end.

## Leg Bones (make 2)

With White, ch 23.

**Rnd 1:** Start in the 2nd ch from hook, (sl st, 3 hdc, sl st) in the same ch st, sl st in the next 2 chs, (sl st, 3 hdc, sl st) in the next ch st, sl st in the next 14 ch sts, (sl st, 3 hdc, sl st) in the next ch st, sl st in the next 2 ch sts, (sl st, 3 hdc, sl st) in the next ch st, work along the other side of the ch, sl st in the next 14 sts, sl st in the 23rd ch of the beginning-ch to join.

Fasten off, leaving a long tail for sewing.

Sew the bones centered on the legs between Rnds 5 and 20.

Sew the arms to the sides of the body at Rnd 15, with 15 stitches between each other.

Sew the legs to the sides of the body between Rnds 34 and 35.

## Dress

Foundation ch: With Clematis, ch 28, sl st in 1st ch to form a ring (do not twist).

**Rnd 1:** Ch 1, sc in each ch around, sl st in the beginning-ch to join—28 sts.

**Rnd 2:** Ch 1, *sc in the next st, 2 sc in the next st; repeat from * 13 more times, sl st to in the beginning-ch join—42 sts.

**Rnd 3:** Ch 1, sc in each st, sl st in the beginning-ch to join.

**Rnd 4:** Ch 1, sc in the next 7 sts, skip the next 8 sts, ch 6, sc in the next 13 sts, skip the next 8 sts, ch 6, sc in the next 6 sts, sl st in the beginning-ch to join—38 sts, with 26 sc and 12 ch.

**Rnd 5:** Ch 1, sc in the next 7 sts, sc in each ch of ch-6 space, sc in the next 13 sts, sc in each in ch of ch-6 space, sc in the next 6 sts, sl st in the beginning-ch to join.

**Rnd 6:** *Ch 2, skip the next st, sc in the next st; repeat from * 17 more times, ch 2, skip the next st, sl st in the beginning-ch to join—56 sts, with 18 sc and 38 ch.

**Rnd 7:** Ch 2 (count as 1 st), 5 dc in the next ch-space, *dc in the next st, 4 dc in the next ch-space; repeat from * 17 more times, sl st in the 1st ch of the beginning-ch to join—96 sts.

**Rnds 8–17:** Ch 2 (count as 1 st), dc in each st around, sl st in 1st ch of the beginning-ch to join.

Change to Vanilla.

**Rnd 18:** Ch 1, BL sc in each st around, sl st in the beginning-ch to join.

Change to Salmon.

**Rnd 19:** Ch 1, BL sc in each st around, sl st in the beginning-ch to join.

Change to Opaline Glass.

**Rnd 20:** Ch 1, *BL sc in the next 5 sc, (spike-sc in the next st of Rnd 17, picot 1, spike-sc) in the same st; repeat from * 15 more times, sl st in the beginning-ch to join. (See p. 78 for a description of the spike-sc and picot stitch.)

Fasten off and weave in the yarn ends.

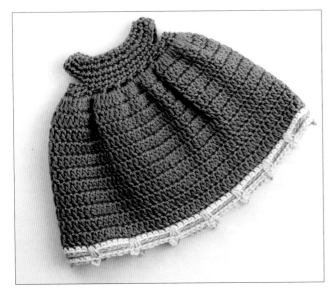

## Dress Flower

**Rnd 1:** With Vanilla, work 6 sc in a magic ring—6 sts.

Change to Orchid.

**Rnd 2:** (Ch 3, 2 dc, ch 2, sl st) in the same st, (sl st, ch 2, 2 dc, ch 2, sl st) in the next st 5 times—6 petals.

Fasten off, leaving a long tail for sewing.

## Dress Ribbon

With Orchid, ch 90.

Fasten off and weave in the yarn ends.

Weave the ribbon through the stitches of Rnd 6 of the dress. Sew the flower to the dress.

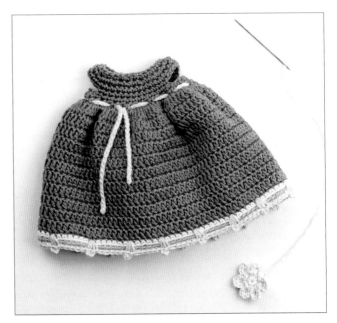

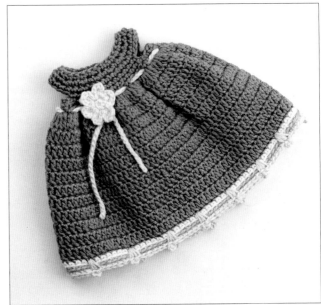

Place the dress on the body.

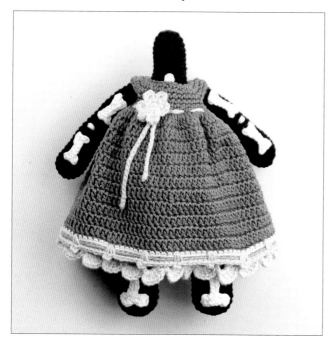

## Head

**Rnd 1:** With White, work 6 sc in a magic ring—6 sts.

**Rnd 2:** 2 sc in each st—12 sts.

**Rnd 3:** *2 sc in the next 3 sts, sc in the next 3 sts; repeat from * 1 more time—18 sts.

**Rnd 4:** (Sc in the next st, 2 sc in the next st) 3 times, sc in the next 3 sts, (sc in the next st, 2 sc in the next st) 3 times, sc in the next 3 sts—24 sts.

**Rnd 5:** (Sc in the next 2 sts, 2 sc in the next st) 3 times, sc in the next 3 sts, (sc in the next 2 sts, 2 sc in the next st) 3 times, sc in the next 3 sts—30 sts.

**Rnd 6:** (Sc in the next 3 sts, 2 sc in the next st) 3 times, sc in the next 3 sts, (sc in the next 3 sts, 2 sc in the next st) 3 times, sc in the next 3 sts—36 sts.

**Rnd 7:** (Sc in the next 4 sts, 2 sc in the next st) 3 times, sc in the next 3 sts, (sc in the next 4 sts, 2 sc in the next st) 3 times, sc in the next 3 sts—42 sts.

**Rnd 8:** (Sc in the next 5 sts, 2 sc in the next st) 3 times, sc in the next 3 sts, (sc in the next 5 sts, 2 sc in the next st) 3 times, sc in the next 3 sts—48 sts.

**Rnd 9:** Sc in the next 7 sts, 2 sc in the next st, (sc in the next 3 sts, 2 sc in the next st) 2 times, sc in the next 15 sts, 2 sc in the next st, (sc in the next 3 sts, 2 sc in the next st) 2 times, sc in the next 8 st sts—54 sts.

**Rnd 10:** Sc in the next 8 sts, 2 sc in the next st, (sc in the next 4 sts, 2 sc in the next st) 2 times, sc in the next 16 sts, 2 sc in the next st, (sc in the next 4 sts, 2 sc in the next st) 2 times, sc in the next 8 sts—60 sts.

**Rnd 11:** Sc in the next 8 sts, 2 sc in the next st, (sc in the next 5 sts, 2 sc in the next st) 2 times, sc in the next 17 sts, 2 sc in the next st, (sc in the next 5 sts, 2 sc in the next st) 2 times, sc in the next 9 sts—66 sts.

**Rnd 12:** Sc in the next 9 sts, 2 sc in the next st, (sc in the next 6 sts, 2 sc in the next st) 2 times, sc in the next 18 sts, 2 sc in the next st, (sc in the next 6 sts, 2 sc in the next st) 2 times, sc in the next 9 sts—72 sts.

**Rnd 13:** Sc in the next 9 sts, 2 sc in the next st, (sc in the next 7 sts, 2 sc in the next st) 2 times, sc in the next 19 sts, 2 sc in the next st, (sc in the next 7 sts, 2 sc in the next st) 2 times, sc in the next 10 sts—78 sts.

**Rnds 14–28:** Sc in each st.

**Rnd 29:** Sc in the next 9 sts, sc2tog, (sc in the next 7 sts, sc2tog) 2 times, sc in the next 19 sts, sc2tog, (sc in the next 7 sts, sc2tog) 2 times, sc in the next 10 sts—72 sts remain.

**Rnd 30:** Sc in the next 9 sts, sc2tog, (sc in the next 6 sts, sc2tog) 2 times, sc in the next 18 sts, sc2tog, (sc in the next 6 sts, sc2tog) 2 times, sc in the next 9 sts—66 sts remain.

**Rnd 31:** Sc in the next 8 sts, sc2tog, (sc in the next 5 sts, sc2tog) 2 times, sc in the next 17 sts, sc2tog, (sc in the next 5 sts, sc2tog) 2 times, sc in the next 9 sts—60 sts remain.

**Rnd 32:** Sc in the next 8 sts, sc2tog, (sc in the next 4 sts, sc2tog) 2 times, sc in the next 16 sts, sc2tog, (sc in the next 4 sts, sc2tog) 2 times, sc in the next 8 sts—54 sts remain.

**Rnd 33:** Sc in the next 7 sts, sc2tog, (sc in the next 3 sts, sc2tog) 2 times, sc in the next 15 sts, sc2tog, (sc in the next 3 sts, sc2tog) 2 times, sc in the next 8 sts—48 sts remain.

**Rnd 34:** *Sc in the next 4 sts, sc2tog; repeat from * 7 more times—40 sts remain.

**Rnd 35:** *Sc in the next 3 sts, sc2tog; repeat from * 7 more times—32 sts remain.

**Rnd 36:** *Sc in the next 2 sts, sc2tog; repeat from * 7 more times—24 sts remain.

**Rnd 37:** *Sc in the next st, sc2tog; repeat from * 7 more times—16 sts remain.

**Spike-sc:** Insert hook in indicated st, yarn over, draw up a loop to the height of the stitches of the current round, yarn over and pull through both loops on hook. Skip the stitch of current round, which is located behind the spike stitch.

**Picot stitch:** Picots are created by working the number of chains mentioned in the pattern and then working a slip stitch in the 1st chain stitch you made.

## Teeth

With White, ch 11.

**Rnd 1:** Start in the 2nd ch from hook, sc in the next 10 sts, work along the other side of the ch, sc in the next 10 sts—20 sts.

**Rnd 2:** Sc in each st around.

Fasten off, leaving a long tail for sewing.

## Braid

**Rnd 1:** With Black, work 6 sc in a magic ring—6 sts.

**Rnd 2:** 2 sc in each st—12 sts.

**Rnd 3:** (2 sc in the next 3 sts, sc in the next 3 sts) 2 times—18 sts.

**Rnd 4:** Sc in the next 6 sts.

**Rnds 5–40:** Working in the 6 sts worked in the last rnd, sc in each st. Fasten off and weave in the yarn ends.

Rejoin the yarn into the next st of Rnd 3, and repeat Rnds 4–40 twice more—3 "tufts."

Do not cut the yarn. Braid the tufts.

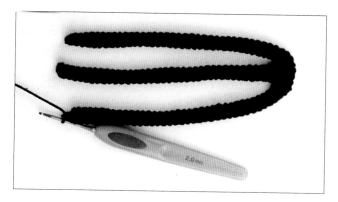

**Rnd 41:** Sc in each st, joining the strands—18 sts.

**Rnd 42:** (Sc in the next st, sc2tog) 6 times—12 sts remain.

**Rnd 43:** *Sc2tog; repeat from * 5 more times—6 sts remain.

Fasten off, leaving a long tail for sewing.

## Headdress Flowers

### Flower 1 (make 2)

**Rnd 1:** With Orchid, work 6 sc in a magic ring—6 sts.

**Rnd 2:** 2 sc in each st—12 sts.

**Rnd 3:** Sl st in the next st, (ch 3, skip 1 st, sl st in the next st) 5 times, ch 3, skip 1 st, sl st both in the 1st sl st and in 1st ch-space—6 ch-space.

**Rnd 4:** (Ch 1, dc, ch 1, sl st) in the same ch-space, (sl st, ch 1, dc, ch 1, sl st in the next ch-space) 5 times—6 petals.

Fasten off, leaving a long tail for sewing.

### Flower 2 (make 2)

**Rnd 1:** With Vanilla, work 6 sc in a magic ring—6 sts.

**Rnd 2:** (Ch 3, 2 dc, ch 2, sl st) in the same st, (sl st, ch 2, 2 dc, ch 2, sl st in the next st) 5 times—6 petals.

Fasten off, leaving a long tail for sewing.

## Flower 3 (make 2)

**Rnd 1:** With Opaline Glass, work 6 sc in a magic ring—6 sts.

**Rnd 2:** (Ch 2, popcorn, ch 2, sl st in the same st) 6 times—6 petals. For a popcorn stitch, make 4 dc stitches in the same stitch. Remove hook from the last dc and insert it into both loops of the 1st dc. Grab the last dc with the hook, and pull it through the 1st dc. Fasten off, leaving a long tail for sewing.

## Flower 4 (make 2)

**Rnd 1:** With Salmon, work (ch 2, 2 hdc, ch 2, sl st) 4 times in a magic ring—4 petals.

Adjust the ring to form the flower.

Fasten off, leaving a long tail for sewing.

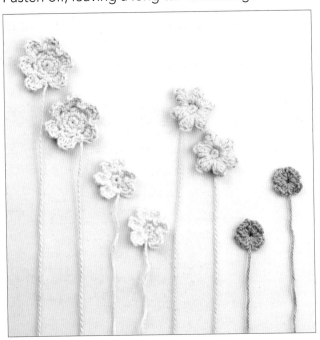

## Wig

**Rnd 1:** With Black, work 6 sc in a magic ring—6 sts.

**Rnd 2:** 2 sc in each st—12 sts.

**Rnd 3:** (2 sc in the next 3 sts, sc in the next 3 sts) 2 times—18 sts.

**Rnd 4:** (Sc in the next st, 2 sc in the next st) 3 times, sc in the next 3 sts, (sc in the next st, 2 sc in the next st) 3 times, sc in the next 3 sts—24 sts.

**Rnd 5:** (Sc in the next 2 sts, 2 sc in the next st) 3 times, sc in the next 3 sts, (sc in the next 2 sts, 2 sc in the next st) 3 times, sc in the next 3 sts—30 sts.

**Rnd 6:** (Sc in the next 3 sts, 2 sc in the next st) 3 times, sc in the next 3 sts, (sc in the next 3 sts, 2 sc in the next st) 3 times, sc in the next 3 sts—36 sts.

**Rnd 7:** (Sc in the next 4 sts, 2 sc in the next st) 3 times, sc in the next 3 sts, (sc in the next 4 sts, 2 sc in the next st) 3 times, sc in the next 3 sts—42 sts.

**Rnd 8:** (Sc in the next 5 sts, 2 sc in the next st) 3 times, sc in the next 3 sts, (sc in the next 5 sts, 2 sc in the next st) 3 times, sc in the next 3 sts—48 sts.

**Rnd 9:** Sc in the next 7 sts, 2 sc in the next st, (sc in the next 3 sts, 2 sc in the next st) 2 times, sc in the next 15 sts, 2 sc in the next st, (sc in the next 3 sts, 2 sc in the next st) 2 times, sc in the next 8 sts—54 sts.

**Rnd 10:** Sc in the next 8 sts, 2 sc in the next st, (sc in the next 4 sts, 2 sc in the next st) 2 times, sc in the next 16 sts, 2 sc in the next st, (sc in the next 4 sts, 2 sc in the next st) 2 times, sc in the next 8 sts—60 sts.

**Rnd 11:** Sc in the next 8 sts, 2 sc in the next st, (sc in the next 5 sts, 2 sc in the next st) 2 times, sc in the next 17 sts, 2 sc in the next st, (sc in the next 5 sts, 2 sc in the next st) 2 times, sc in the next 9 sts—66 sts.

**Rnd 12:** Sc in the next 9 sts, 2 sc in the next st, (sc in the next 6 sts, 2 sc in the next st) 2 times, sc in the next 18 sts, 2 sc in the next st, (sc in the next 6 sts, 2 sc in the next st) 2 times, sc in the next 9 sts—72 sts.

**Rnd 13:** Sc in the next 9 sts, 2 sc in the next st, (sc in the next 7 sts, 2 sc in the next st) 2 times, sc in the next 19 sts, 2 sc in the next st, (sc in the next 7 sts, 2 sc in the next st) 2 times, sc in the next 10 sts—78 sts.

**Rnds 14–23:** Sc in each st.

**Rnd 24:** Turn the work, ch 1, sc in the next 20 sts, ch 40, start in the 2nd ch from hook, sc in the next 39 ch, sc in the next 40 sts of the rnd, ch 40, start in the 2nd ch from hook, sc in the next 39 ch, sc to the end of the rnd, sl st in the beginning-ch to join.

Fasten off, leaving a long tail for sewing. Place the wig on the head at Rnd 10 in the front of the head, and Rnd 33 at the back of the head. Sew the wig to the head.

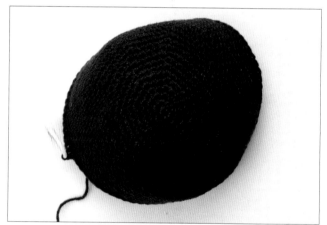

Place the braid on top of the wig and sew it place as shown in the photo.

## Time to Put It All Together!

Sew one of each flower to each side of the wig at the ends of the braid.

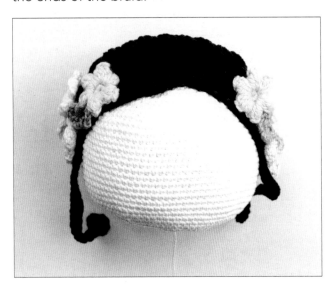

Sew the teeth to the front of the head, centered between Rnds 30 and 29.

Cut out the shapes of the eyes from the felt fabric, using the graphics below as a guide.

Glue the black parts of the eyes to the head between Rnds 23 and 18, and 9 sts apart. Glue the white parts of the eyes on top of the black parts. Cut a small heart shape out of black felt and glue it upside down centered between the eyes on Rnds 25 and 22. Using the sewing thread, finish securing the eyes to the head.

Using different colors of yarn, work embroidery on the face with a variety of stitches. Using Black yarn, embroider the teeth and eyelashes.

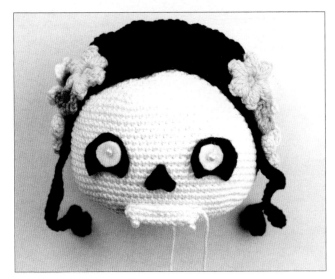

Attach the head onto the body. Use your finger to poke a hole into the fiberfill in the head so you can pull the neck through the opening of the head and 3 to 4 rounds of the neck are still visible. Sew the head onto the neck of the body.

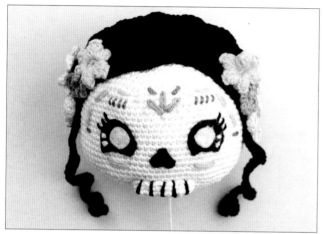

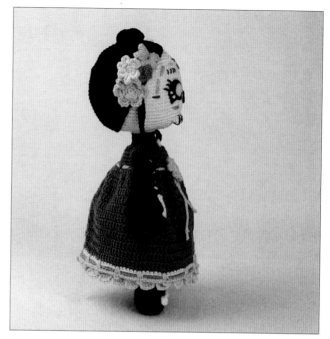

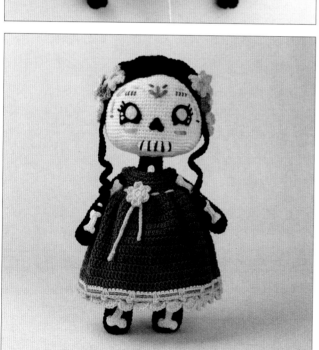

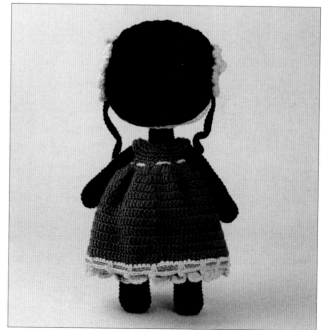

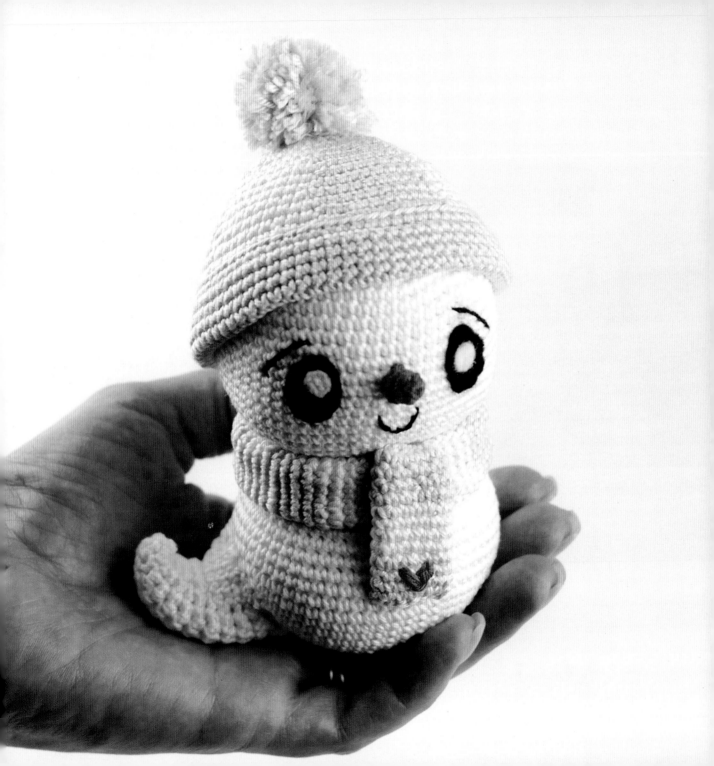

# SNOW-GHOST

## MATERIALS

Yarn and Colors® 100% mercerized cotton (sport weight yarn)

1.75oz (50g); 137yds (125m)

### Colors:

White (001) 83yds (76m)

Cotton Candy (037) 83yds (76m)

Vanilla (010) 55yds (50m)

Lollipop (036) (leftover)

Black (100) (leftover)

- Size 2mm crochet hook
- Felt fabric (black and white)
- Fiberfill
- Tapestry needle
- Stitch marker
- Scissors
- Glue
- Black and white thread and sewing needle
- Pins

### Gauge:

7 sts and 7 rnds = 1in/2.54cm in sc

## Let's Begin!

### Tail

**Rnd 1:** With White, work 4 sc in a magic ring—4 sts.

**Rnd 2:** 2 sc in each st—8 sts.

**Rnd 3:** Hdc in the next st, sc in the next 4 sts, hdc in the next st, 2 hdc in the next 2 sts—10 sts.

**Rnd 4:** Sc in the next st, sl st in the next 4 sts, sc in the next st, (hdc in the next st, 2 hdc in the next st) 2 times—12 sts.

**Rnd 5:** Sc in the next 6 sts, (hdc in the next 2 sts, 2 hdc in the next st) 2 times—14 sts.

**Rnd 6:** Hdc in the next st, sc in the next 5 sts, (hdc in the next 3 sts, 2 hdc in the next st) 2 times—16 sts.

**Rnd 7:** Sc in the next st, sl st in the next 4 sts, sc in the next st, (hdc in the next 4 sts, 2 hdc in the next st) 2 times—18 sts.

**Rnd 8:** Hdc in the next st, sc in the next 5 sts, (hdc in the next 5 sts, 2 hdc in the next st) 2 times—20 sts.

**Rnd 9:** Sc in the next st, sl st in the next 5 sts, sc in the next st, hdc in the next 13 sts.

**Rnd 10:** Hdc in the next st, sc in the next 6 sts, hdc in the next 4 sts, 2 hdc in the next st, (hdc in the next 3 sts, 2 hdc in the next st) 2 times—23 sts.

**Rnd 11:** Sc in the next 8 sts, hdc in the next 14 sts, 2 hdc in the next st—24 sts.

**Rnd 12:** Sc in the next 9 sts, 2 sc in the next st, sc in the next 11 sts, sl st in the next st, then leave the last 2 sts unworked—23 sts.

Fasten off, leaving a long tail for sewing.

## Body

**Rnd 1:** With White, work 8 sc in a magic ring—8 sts.

**Rnd 2:** 2 sc in each st—16 sts.

**Rnd 3:** *Sc in the next st, 2 sc in the next st; repeat from * 7 more times—24 sts.

**Rnd 4:** *Sc in the next 2 sts, 2 sc in the next st; repeat from * 7 more times—32 sts.

**Rnd 5:** *Sc in the next 7 sts, 2 sc in the next st; repeat from * 3 more times—36 sts.

**Rnd 6:** *Sc in the next 8 sts, 2 sc in the next st; repeat from * 3 more times—40 sts.

**Rnd 7:** *Sc in the next 9 sts, 2 sc in the next st; repeat from * 3 more times—44 sts.

**Rnd 8:** *Sc in the next 10 sts, 2 sc in the next st; repeat from * 3 more times—48 sts.

**Rnd 9:** *Sc in the next 11 sts, 2 sc in the next st; repeat from * 3 more times—52 sts.

**Rnd 10:** *Sc in the next 12 sts, 2 sc in the next st; repeat from * 3 more times—56 sts.

**Rnd 11:** *Sc in the next 13 sts, 2 sc in the next st; repeat from * 3 more times—60 sts.

**Rnds 12–17:** Sc in each st.

**Rnd 18:** *Sc in the next 8 sts, sc2tog; repeat from * 5 more times—54 sts remain.

**Rnd 19:** *Sc in the next 7 sts, sc2tog; repeat from * 5 more times—48 sts remain.

**Rnd 20:** *Sc in the next 6 sts, sc2tog; repeat from * 5 more times—42 sts remain.

**Rnd 21:** *Sc in the next 5 sts, sc2tog; repeat from * 5 more times—36 sts remain.

**Rnd 22:** *Sc in the next 4 sts, sc2tog; repeat from * 5 more times—30 sts remain.

**Rnd 23:** *Sc in the next 3 sts, sc2tog; repeat from * 5 more times—24 sts remain.

**Rnds 24–26:** Sc in each st.

**Rnd 27:** *Sc in the next 2 sts, sc2tog; repeat from * 5 more times—18 sts remain.

**Rnds 28–29:** Sc in each st.

Stuff the body.

**Rnd 30:** *Sc in the next st, sc2tog; repeat from * 5 more times—12 sts remain.

**Rnd 31:** *Sc2tog; repeat from * 5 more times—6 sts remain.

Fasten off and leave a yarn tail. Thread the yarn tail into the tapestry needle, then weave the yarn tail through the front loop of each remaining stitch and pull it tight to close. Weave in the yarn end.

## Head

**Rnd 1:** With White, work 6 sc in a magic ring—6 sts.

**Rnd 2:** 2 sc in each st—12 sts.

**Rnd 3:** *Sc in the next st, 2 sc in the next st; repeat from * 5 more times—18 sts.

**Rnd 4:** *Sc in the next 2 sts, 2 sc in the next st; repeat from * 5 more times—24 sts.

**Rnd 5:** *Sc in the next 3 sts, 2 sc in the next st; repeat from * 5 more times—30 sts.

**Rnd 6:** *Sc in the next 4 sts, 2 sc in the next st; repeat from * 5 more times—36 sts.

**Rnd 7:** *Sc in the next 5 sts, 2 sc in the next st; repeat from * 5 more times—42 sts.

**Rnd 8:** *Sc in the next 6 sts, 2 sc in the next st; repeat from * 5 more times—48 sts.

**Rnd 9:** *Sc in the next 7 sts, 2 sc in the next st; repeat from * 5 more times—54 sts.

**Rnd 10:** *Sc in the next 8 sts, 2 sc in the next st; repeat from * 5 more times—60 sts.

**Rnds 11–19:** Sc in each st.

**Rnd 20:** *Sc in the next 9 sts, 2 sc in the next st; repeat from * 5 more times—66 sts.

**Rnds 21–23:** Sc in each st.

**Rnd 24:** *Sc in the next 9 sts, sc2tog; repeat from * 5 more times—60 sts remain.

**Rnd 25:** *Sc in the next 8 sts, sc2tog; repeat from * 5 more times—54 sts remain.

**Rnd 26:** *Sc in the next 7 sts, sc2tog; repeat from * 5 more times—48 sts remain.

**Rnd 27:** *Sc in the next 4 sts, sc2tog; repeat from * 7 more times—40 sts remain.

**Rnd 28:** *Sc in the next 3 sts, sc2tog; repeat from * 7 more times—32 sts remain.

**Rnd 29:** *Sc in the next 2 sts, sc2tog; repeat from * 7 more times—24 sts remain.

Fasten off, leaving a long tail for sewing.

## Nose

**Rnd 1:** With Lollipop, work 4 sc in a magic ring—4 sts.

**Rnd 2:** *Sc in the next st, 2 in the next st; repeat from * once more—6 sts.

**Rnd 3:** Sc in each st.

Fasten off, leaving a long tail for sewing. The nose doesn't need to be stuffed.

## Scarf (long part)

Foundation ch: With Cotton Candy, ch 7. Stitches are worked around both sides of the foundation ch.

**Rnd 1:** Start in the 2nd ch from hook, sc in the next 5 sts, 2 sc in the next st, working along the bottom of the foundation ch, sc in the next 5 sts—12 sts.

**Rnds 2–4:** Sc in each st.

Change to Vanilla.

**Rnds 5–8:** Sc in each st.

Change to Cotton Candy.

**Rnds 9–12:** Sc in each st.

Change to Vanilla.

**Rnds 13–52:** Repeat Rnds 5-12 another 5 times.

Change to Vanilla.

**Rnds 53–55:** Sc in each st.

Flatten the opening of the scarf.

**Next row:** Working through both layers to close the opening, sc in next 5 sts, sl st in the last st.

Fasten off, leaving a long tail for sewing.

## Scarf (short part)

Foundation ch: with Cotton Candy, ch 7. Stitches are worked around both sides of the foundation ch.

**Rnd 1:** Start in the 2nd ch from hook, sc in the next 5 sts, 2 sc in the next st, working along the bottom of the foundation ch, sc in the next 5 sts—12 sts.

**Rnds 2–4:** Sc in each st.

Change to Vanilla.

**Rnds 5–8:** Sc in each st.

Change to Cotton Candy.

**Rnds 9–11:** Sc in each st.

Flatten the opening of the scarf.

**Next row:** Working through both layers to close the opening, sc in next 5 sts, sl st in the last st.

Fasten off, leaving a long tail for sewing.

## Hat

**Rnd 1:** With Cotton Candy, ch 66, join with sl st to make a ring, then ch 1—66 sts.

**Rnds 2–8:** Sc in each st, sl st to join, then ch 1.

Fold in half with the top edge and foundation ch together.

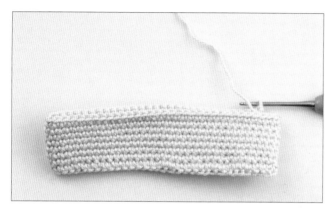

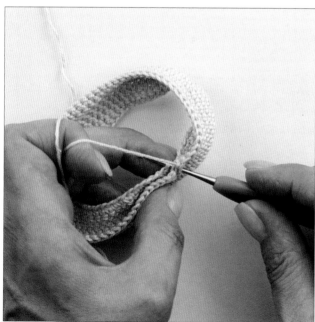

**Rnd 9:** Working through both layers to close the brim, sc in each st.

In the next rounds, we alternate between Cotton Candy and Vanilla yarn. The color change is indicated in italics; hold the unused color along the top of the row when changing colors and crochet around it.

**Rnd 10:** *(Cotton Candy) BL sc in next 11 sts, (Vanilla) BL sc in the next 11 st; repeat from * 2 more times.

**Rnd 11:** *(Cotton Candy) sc in next 9 sts, sc2tog, (Vanilla) sc in next 9 sts, sc2tog; repeat from * 2 more times—60 sts remain.

**Rnd 12:** *(Cotton Candy) sc in next 10 sts, (Vanilla) sc in the next 10 sts; repeat from * 2 more times.

**Rnd 13:** *(Cotton Candy) sc2tog, sc in next 8 sts, (Vanilla) sc2tog, sc in next 8 sts; repeat from * 2 more times—54 sts remain.

**Rnd 14:** *(Cotton Candy) sc in next 9 sts, (Vanilla) sc in the next 9 sts; repeat from * 2 more times.

**Rnd 15:** *(Cotton Candy) sc in next 7 sts, sc2tog, (Vanilla) sc in next 7 sts, sc2tog; repeat from * 2 more times—48 sts remain.

**Rnd 16:** *(Cotton Candy) sc in next 8 sts, (Vanilla) sc in the next 8 sts; repeat from * 2 more times.

**Rnd 17:** *(Cotton Candy) sc2tog, sc in next 6 sts, (Vanilla) sc2tog, sc in next 6 sts; repeat from * 2 more times—42 sts remain.

**Rnd 18:** *(Cotton Candy) sc in next 5 sts, sc2tog, (Vanilla) sc in next 5 sts, sc2tog; repeat from * 2 more times—36 sts remain.

**Rnd 19:** *(Cotton Candy) sc2tog, sc in next 4 sts, (Vanilla) sc2tog, sc in next 4 sts; repeat from * 2 more times—30 sts remain.

**Rnd 20:** *(Cotton Candy) sc in next 3 sts, sc2tog, (Vanilla) sc in next 3 sts, sc2tog; repeat from * 2 more times—24 sts remain.

**Rnd 21:** *(Cotton Candy) sc2tog, sc in next 2 sts, (Vanilla) sc2tog, sc in next 2 sts; repeat from * 2 more times—18 sts remain.

**Rnd 22:** *(Cotton Candy) sc in next st, sc2tog, (Vanilla) sc in next st, sc2tog; repeat from * 2 more times—12 sts remain. Cut Vanilla and leave a long tail.

**Rnd 23:** *(Cotton Candy) sc2tog; repeat from * 5 more times—6 sts remain.

Fasten off and leave a yarn tail. Thread the yarn tail into the tapestry needle, then weave the yarn tail through the front loop of each remaining stitch and pull it tight to close. Weave in the yarn end.

Make a 1.5in/4cm pom-pom with Cotton Candy and sew it to the top of the hat.

Stuff the tail and sew it on one side of the body between Rnds 7 and 13.

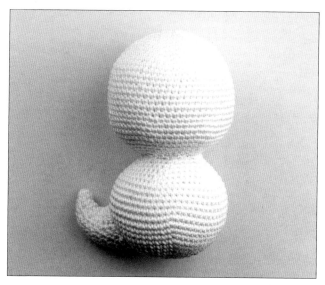

## Time to Put It All Together!

Stuff the head. Insert the smallest part of the body into the hole in the head and sew the head at Rnd 26 of the body.

Cut the shapes for the eyes out of the felt fabric, using the graphics below as a guide.

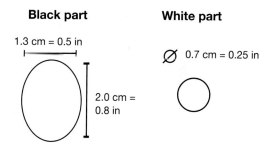

**Black part**

1.3 cm = 0.5 in

2.0 cm = 0.8 in

**White part**

⌀ 0.7 cm = 0.25 in

Making a pom-pom is quite easy. There are devices that you can buy and use, or you can simply use yarn, scissors, and your hands.

Glue the black parts of the eyes between Rnds 15 and 20 of the head, with 8 sts in between. Glue the white parts of the eyes on top of the black parts.

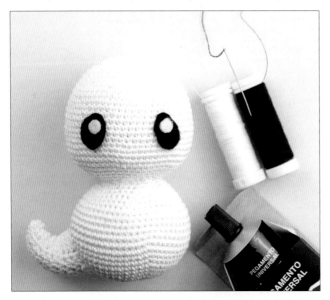

Sew the nose to the head, centered between the eyes, and between Rnds 17 and 18.

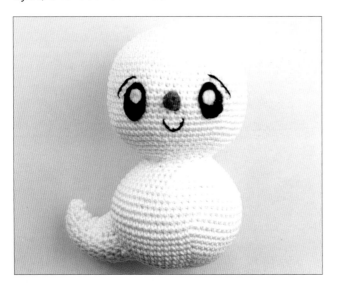

With Black yarn, embroider the mouth below the nose, between Rnds 21 and 22 of the head.

With Black yarn, embroider the eyebrows above the eyes.

Using the sewing thread, finish securing the eyes to the head.

With Lollipop, embroider a heart on the short part of the scarf.

Wrap the long part of the scarf around the neck at the join of the head and body, then sew the ends together.

Sew the short part of the scarf over the seam, also attaching it to the body with a few stitches.

Place the hat on the head.

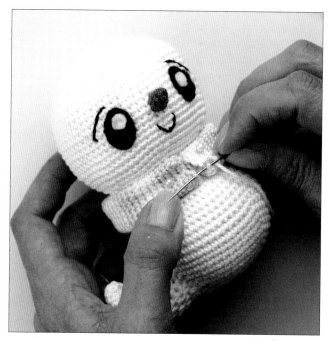
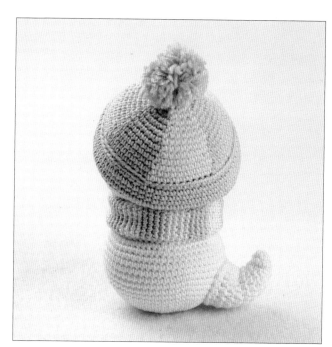
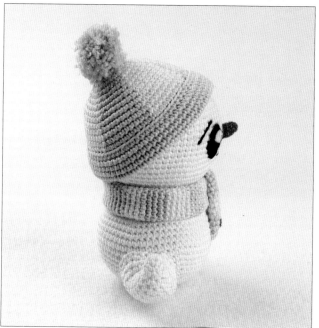
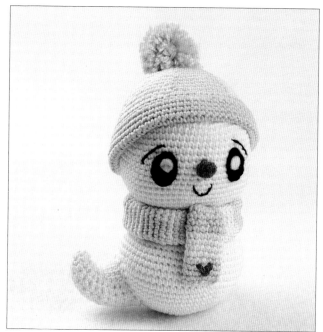

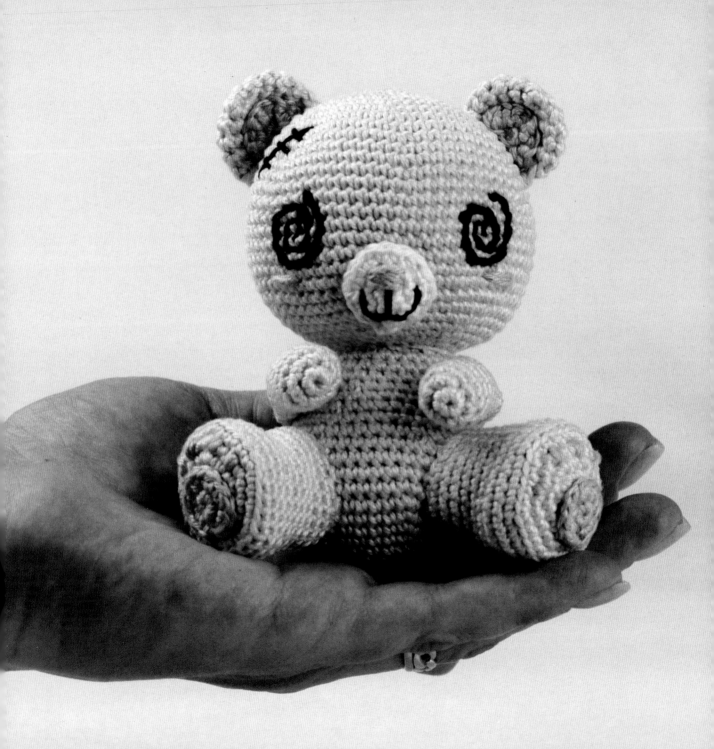

# CREEPY BEAR

## MATERIALS

Yarn and Colors® 100% mercerized cotton (sport weight yarn)

1.75oz (50g); 137yds (125m)

### Colors:

Ice Blue (063) 137yds (125m)

Cotton Candy (037) (leftover)

White (001) (leftover)

Black (100) (leftover)

- Size 2mm crochet hook
- Fiberfill
- Tapestry needle
- Stitch marker
- Scissors
- Black and white thread and sewing needle
- Pins

### Gauge:

7 sts and 7 rnds = 1in/2.54cm in sc

## Let's Begin!

### Head

**Rnd 1:** With Ice Blue, work 6 sc in a magic ring—6 sts.

**Rnd 2:** 2 sc in each st—12 sts.

**Rnd 3:** *Sc in the next st, 2 sc in the next st; repeat from * 5 more times—18 sts.

**Rnd 4:** *Sc in the next 2 sts, 2 sc in the next st; repeat from * 5 more times—24 sts.

**Rnd 5:** *Sc in the next 3 sts, 2 sc in the next st; repeat from * 5 more times—30 sts.

**Rnd 6:** *Sc in the next 4 sts, 2 sc in the next st; repeat from * 5 more times—36 sts.

**Rnd 7:** *Sc in the next 5 sts, 2 sc in the next st; repeat from * 5 more times—42 sts.

**Rnd 8:** *Sc in the next 6 sts, 2 sc in the next st; repeat from * 5 more times—48 sts.

**Rnd 9:** Sc in each st.

**Rnd 10:** *Sc in the next 7 sts, 2 sc in the next st; repeat from * 5 more times—54 sts.

**Rnd 11:** Sc in each st.

**Rnd 12:** *Sc in the next 8 sts, 2 sc in the next st; repeat from * 5 more times—60 sts.

**Rnd 13:** Sc in each st.

**Rnd 14:** *Sc in the next 9 sts, 2 sc in the next st; repeat from * 5 more times—66 sts.

**Rnds 15–21:** Sc in each st.

**Rnd 22:** *Sc in the next 9 sts, sc2tog; repeat from * 5 more times—60 sts remain.

**Rnd 23:** *Sc in the next 8 sts, sc2tog; repeat from * 5 more times—54 sts remain.

**Rnd 24:** *Sc in the next 7 sts, sc2tog; repeat from * 5 more times—48 sts remain.

**Rnd 25:** *Sc in the next 6 sts, sc2tog; repeat from * 5 more times—42 sts remain.

**Rnd 26:** *Sc in the next 5 sts, sc2tog; repeat from * 5 more times—36 sts remain.

**Rnd 27:** *Sc in the next 4 sts, sc2tog; repeat from * 5 more times—30 sts remain.

**Rnd 28:** *Sc in the next 3 sts, sc2tog; repeat from * 5 more times—24 sts remain.

Stuff the head.

Fasten off, leaving a long tail for sewing.

## Body

**Rnd 1:** With Ice Blue, work 6 sc in a magic ring—6 sts.

**Rnd 2:** 2 sc in each st—12 sts.

**Rnd 3:** *Sc in the next st, 2 sc in the next st; repeat from * 5 more times—18 sts.

**Rnd 4:** *Sc in the next 2 sts, 2 sc in the next st; repeat from * 5 more times—24 sts.

**Rnd 5:** *Sc in the next 3 sts, 2 sc in the next st; repeat from * 5 more times—30 sts.

**Rnd 6:** *Sc in the next 4 sts, 2 sc in the next st; repeat from * 5 more times—36 sts.

**Rnd 7:** *Sc in the next 5 sts, 2 sc in the next st; repeat from * 5 more times—42 sts.

**Rnd 8:** *Sc in the next 6 sts, 2 sc in the next st; repeat from * 5 more times—48 sts.

**Rnds 9–12:** Sc in each st.

**Rnd 13:** *Sc in the next 6 sts, sc2tog; repeat from * 5 more times—42 sts remain.

**Rnd 14:** Sc in each st.

**Rnd 15:** *Sc in the next 5 sts, sc2tog; repeat from * 5 more times—36 sts remain.

**Rnd 16:** Sc in each st.

**Rnd 17:** *Sc in the next 4 sts, sc2tog; repeat from * 5 more times—30 sts remain.

**Rnds 18–20:** Sc in each st.

**Rnd 21:** *Sc in the next 3 sts, sc2tog; repeat from * 5 more times—24 sts remain.

Stuff the body.

**Rnd 22:** *Sc in the next 2 sts, sc2tog; repeat from * 5 more times—18 sts remain.

**Rnds 23–25:** Sc in each st.

**Rnd 26:** *Sc in the next st, sc2tog; repeat from * 5 more times—12 sts remain.

**Rnd 27:** *Sc2tog; repeat from * 5 more times— 6 sts remain.

Fasten off and leave a yarn tail. Thread the yarn tail into the tapestry needle, then weave the yarn through the front loop of each remaining stitch and pull it tight to close. Weave in the yarn end.

## Arms (make 2)

**Rnd 1:** With Ice Blue, work 6 sc in a magic ring—6 sts.

**Rnd 2:** 2 sc in each st—12 sts.

**Rnds 3–9:** Sc in each st.

Lightly stuff the arm.

**Rnd 10:** *Sc in the next 2 sts, sc2tog; repeat from * 2 more times—9 sts remain.

Flatten the opening of the arm.

**Next row:** Working through both layers to close the opening, sc in next 3 sts, sl st in the last st.

Fasten off, leaving a long tail for sewing.

## Tail

**Rnd 1:** With Ice Blue, work 6 sc in a magic ring—6 sts.

**Rnd 2:** 2 sc in each st—12 sts.

**Rnd 3:** *Sc in the next st, 2 sc in the next st; repeat from * 5 more times—18 sts.

**Rnds 4–5:** Sc in each st.

**Rnd 6:** *Sc in the next st, sc2tog; repeat from * 5 more times—12 sts remain.

Fasten off, leaving a long tail for sewing.

## Paws (make 2)

**Rnd 1:** With Ice Blue, work 6 sc in a magic ring— 6 sts.

**Rnd 2:** 2 sc in each st—12 sts.

**Rnd 3:** *Sc in the next st, 2 sc in the next st; repeat from * 5 more times—18 sts.

**Rnd 4:** *Sc in the next 2 sts, 2 sc in the next st; repeat from * 5 more times—24 sts.

**Rnd 5:** *Sc in the next 3 sts, 2 sc in the next st; repeat from * 5 more times—30 sts.

**Rnd 6:** BL sc in each st.

**Rnds 7–8:** Sc in each st.

**Rnd 9:** *Sc in the next 3 sts, sc2tog; repeat from * 5 more times—24 sts remain.

**Rnds 10–14:** Sc in each st.

Fasten off, leaving a long tail for sewing.

## Paw Pads (make 2)

**Rnd 1:** With Cotton Candy, work 6 sc in a magic ring—6 sts.

**Rnd 2:** 2 sc in each st—12 sts.

Fasten off, leaving a long tail for sewing. Sew each paw pad to its paw between Rnds 2 and 4, and embroider the four toe pads on Rnd 4 of the paw.

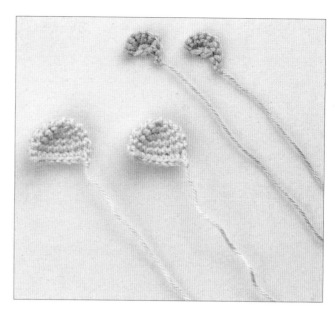

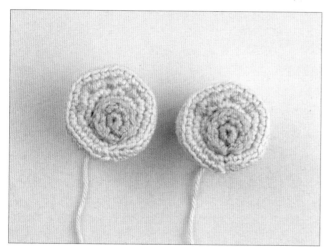

## Ears (make 2)

**Rnd 1:** With Ice Blue, work 6 sc in a magic ring—6 sts.

**Rnd 2:** 2 sc in each st—12 sts.

**Rnd 3:** *Sc in the next st, 2 sc in the next st; repeat from * 5 more times—18 sts.

**Rnds 4–5:** Sc in each st.

Flatten the opening of the ear.

**Next row:** Working through both layers to close the opening, sc in next 8 sts, sl st in the last st.

Fasten off, leaving a long tail for sewing.

## Centers of the Ears (make 2)

**Row 1:** With Cotton Candy, work 4 sc in a magic ring, ch 1, turn—4 sts.

**Row 2:** 2 sc in each st—8 sts.

Fasten off, leaving a long tail for sewing. Sew each center of the ear to its ear, making sure to center it.

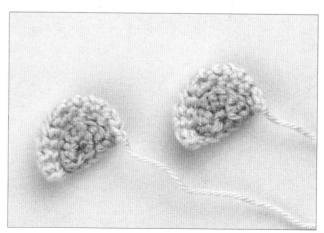

## Snout

**Rnd 1:** With White, work 6 sc in a magic ring—6 sts.

**Rnd 2:** 2 sc in each st—12 sts.

**Rnd 3:** *2 sc in each of next 3 sts, sc in the next 3 sts; repeat from * once more—18 sts.

Fasten off, leaving a long tail for sewing. Embroider the nose with Cotton Candy and the mouth with Black.

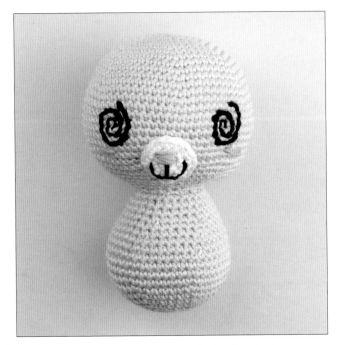

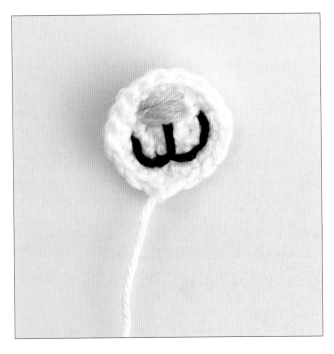

## Time to Put It All Together!

Sew the snout between Rnds 18 and 24 of the head. With Black, embroider the eyes between Rnds 15 and 19 of the head, and 11 sts apart. With Cotton Candy, embroider the cheeks below the eyes. Insert the smallest part of the body into the hole in the head and sew the head at Rnd 21 of the body.

Sew the arms to the sides of the body, between Rnds 15 and 20, with 15 sts between them at the back.

Sew the paws to the body between Rnds 7 and 14 of the body, with 7 sts between them at the front.

Sew the ears to the head between Rnds 7 and 13.

Stuff the tail and sew it centered on the back of the body between Rnds 7 and 10.

With Black, embroider the decorative "seams" on the head and body.

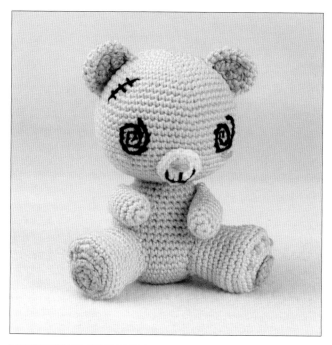
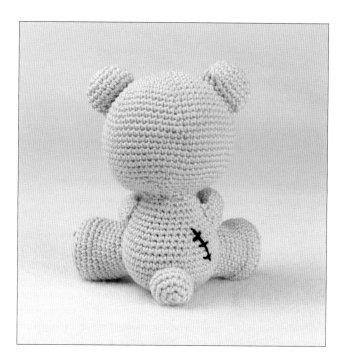
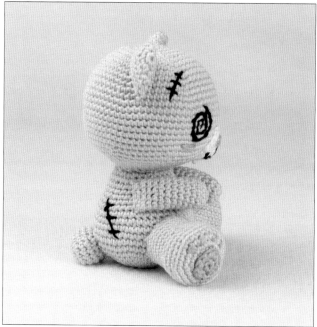
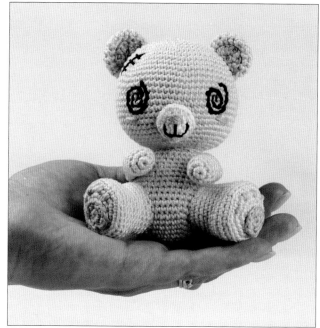

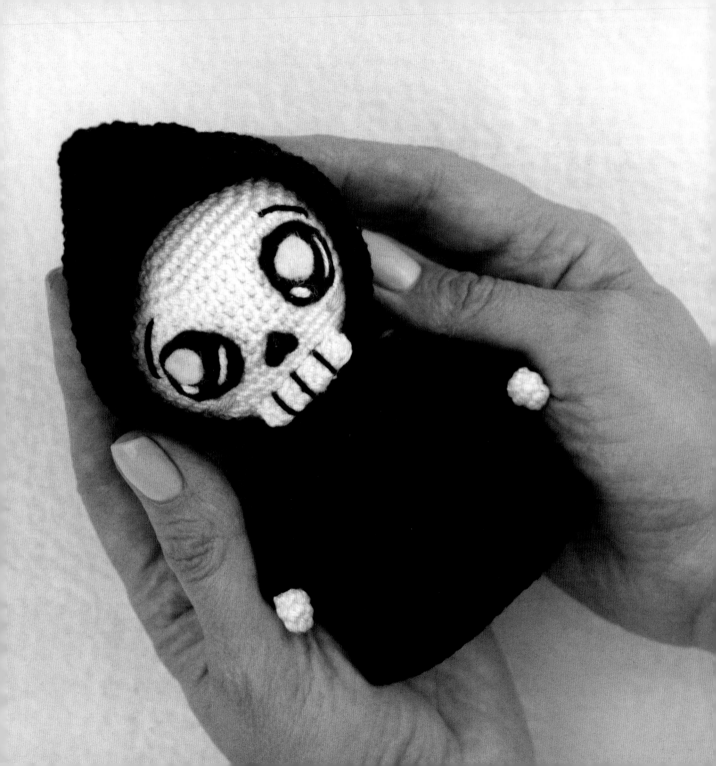

# GRIM REAPER

## MATERIALS

Yarn and Colors® 100% mercerized cotton (sport weight yarn)

1.75oz (50g); 137yds (125m)

### Colors:

Black (100) 137yds (125m)

White (001) 55yds (50m)

Cotton Candy (037) (leftover)

- Size 2mm crochet hook
- Felt fabric (black and white)
- Fiberfill
- Tapestry needle
- Stitch marker
- Scissors
- Glue
- Black and white thread and sewing needle
- Pins

### Gauge:

7 sts and 7 rnds = 1in/2.54cm in sc

## Let's Begin!

### Head and Body

**Rnd 1:** With White, work 6 sc in a magic ring—6 sts.

**Rnd 2:** 2 sc in each st—12 sts.

**Rnd 3:** *Sc in the next st, 2 sc in the next st; repeat from * 5 more times—18 sts.

**Rnd 4:** *Sc in the next 2 sts, 2 sc in the next st; repeat from * 5 more times—24 sts.

**Rnd 5:** *Sc in the next 3 sts, 2 sc in the next st; repeat from * 5 more times—30 sts.

**Rnd 6:** *Sc in the next 4 sts, 2 sc in the next st; repeat from * 5 more times—36 sts.

**Rnd 7:** *Sc in the next 5 sts, 2 sc in the next st; repeat from * 5 more times—42 sts.

**Rnd 8:** *Sc in the next 6 sts, 2 sc in the next st; repeat from * 5 more times—48 sts.

**Rnd 9:** *Sc in the next 7 sts, 2 sc in the next st; repeat from * 5 more times—54 sts.

**Rnds 10–18:** Sc in each st.

**Rnd 19:** *Sc in the next 7 sts, sc2tog; repeat from * 5 more times—48 sts remain.

**Rnd 20:** *Sc in the next 6 sts, sc2tog; repeat from * 5 more times—42 sts remain.

**Rnd 21:** *Sc in the next 5 sts, sc2tog; repeat from * 5 more times—36 sts remain.

**Rnd 22:** *Sc in the next 4 sts, sc2tog; repeat from * 5 more times—30 sts remain.

**Rnd 23:** *Sc in the next 3 sts, sc2tog; repeat from * 5 more times—24 sts remain.

Fasten off. Stuff the head.

Pull up a loop of Black in the back loop of any st of Rnd 23.

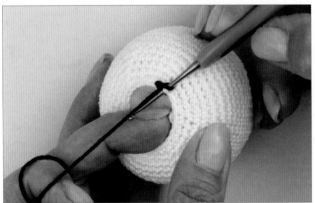

**Rnd 24:** BL sc in each st.

**Rnd 25:** *Sc in the next 3 sts, 2 sc in the next st; repeat from * 5 more times—30 sts.

**Rnd 26:** Sc in each st.

**Rnd 27:** *Sc in the next 4 sts, 2 sc in the next st; repeat from * 5 more times—36 sts.

**Rnd 28:** Sc in each st.

**Rnd 29:** *Sc in the next 5 sts, 2 sc in the next st; repeat from * 5 more times—42 sts.

**Rnd 30:** Sc in each st.

**Rnd 31:** *Sc in the next 6 sts, 2 sc in the next st; repeat from * 5 more times—48 sts.

**Rnd 32:** Sc in each st.

**Rnd 33:** *Sc in the next 7 sts, 2 sc in the next st; repeat from * 5 more times—54 sts.

**Rnd 34:** Sc in each st.

**Rnd 35:** *Sc in the next 8 sts, 2 sc in the next st; repeat from * 5 more times—60 sts.

**Rnds 36–39:** Sc in each st.

**Rnd 40:** *FL sc in the next 9 sts, 2 FL sc in the next st; repeat from * 5 more times—66 sts.

**Rnd 41:** Sc in each st.

**Rnd 42:** *Sc in the next 10 sts, 2 sc in the next st; repeat from * 5 more times—72 sts.

**Rnd 43:** Sc in each st.

Fasten off and weave in the yarn ends.

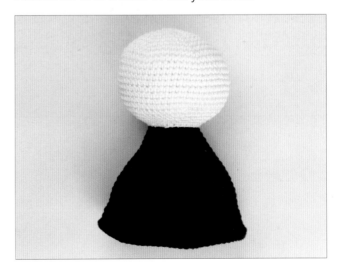

## Bottom

Pull up a loop of Black through the back loop of any st of Rnd 39.

**Rnd 40:** *BL sc in the next 10 sts, BL sc2tog; repeat from * 5 more times—66 sts remain.

**Rnd 41:** *Sc in the next 9 sts, sc2tog; repeat from * 5 more times—60 sts remain.

**Rnd 42:** *Sc in the next 8 sts, sc2tog; repeat from * 5 more times—54 sts remain.

**Rnd 43:** *Sc in the next 7 sts, sc2tog; repeat from * 5 more times—48 sts remain.

**Rnd 44:** *Sc in the next 4 sts, sc2tog; repeat from * 7 more times—40 sts remain.

**Rnd 45:** *Sc in the next 3 sts, sc2tog; repeat from * 7 more times—32 sts remain.

**Rnd 46:** *Sc in the next 2 sts, sc2tog; repeat from * 7 more times—24 sts remain.

Stuff the body.

**Rnd 47:** *Sc in the next st, sc2tog; repeat from * 7 more times—16 sts remain.

**Rnd 48:** *Sc2tog; repeat from * 7 more times— 8 sts remain.

Fasten off and leave a yarn tail. Thread the yarn tail into the tapestry needle, then weave the yarn tail through the front loop of each remaining stitch and pull it tight to close. Weave in the yarn end.

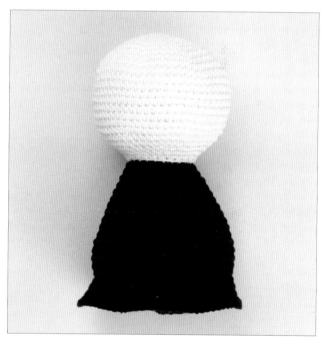

## Hood

Foundation ch: With Black, ch 53.

**Row 1:** Start in the 2nd ch from hook, sc in next 52 ch, ch 1, turn—52 sts.

**Row 2:** Sc in next 2 sts, hdc in next 2 sts, dc in next 44 sts, hdc in next 2 sts, sc in next 2 sts, ch 1, turn.

**Row 3:** FL sc in each st, ch 1, turn.

**Row 4:** Sc in next 2 sts, hdc in next 2 sts, dc in next 44 sts, hdc in next 2 sts, sc in next 2 sts, ch 1, turn.

**Row 5:** FL sc in each st, ch 1, turn.

**Row 6:** Sc in next 2 sts, hdc in next 2 sts, dc in next 44 sts, hdc in next 2 sts, sc in next 2 sts, ch 1, turn.

**Row 7:** FL sc in next 16 sts, 2 FL sc in next st, FL sc in next 18 sts, 2 FL sc in next st, sc in next 16 sts, ch 1, turn—54 sts.

**Row 8:** Sc in next 2 sts, hdc in next 2 sts, dc in next 46 sts, hdc in next 2 sts, sc in next 2 sts, ch 1, turn.

**Row 9:** FL sc in next 17 sts, 2 FL sc in next st, FL sc in next 18 sts, 2 FL sc in next st, FL sc in next 17 sts, ch 1, turn—56 sts.

**Row 10:** Sc in next 2 sts, hdc in next 2 sts, dc in next 48 sts, hdc in next 2 sts, sc in next 2 sts, ch 1, turn.

**Row 11:** FL sc in each st, ch 1, turn.

**Row 12:** Sc in next 2 sts, hdc in next 2 sts, dc in next 48 sts, hdc in next 2 sts, sc in next 2 sts, ch 1, turn.

**Row 13:** FL sc in next 17 sts, FL sc2tog, FL sc in next 18 sts, FL sc2tog, sc in next 17 sts, ch 1, turn—54 sts remain.

**Row 14:** Sc in next 2 sts, hdc in next 2 sts, dc in next 46 sts, hdc in next 2 sts, sc in next 2 sts, ch 1, turn.

**Row 15:** FL sc in next 16 sts, FL sc2tog, FL sc in next 18 sts, FL sc2tog, FL sc in next 16 sts, ch 1, turn—52 sts remain.

**Row 16:** Sc in next 2 sts, hdc in next 2 sts, dc in next 44 sts, hdc in next 2 sts, sc in next 2 sts, ch 1, turn.

Fasten off, leaving a long tail for sewing.

Fold the hood in half so that the side edges touch. Sew one long edge together to form the back of the hood.

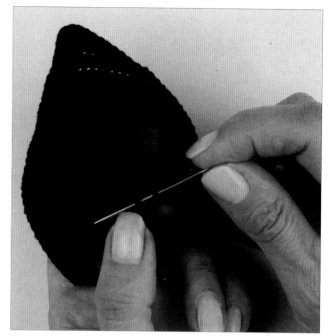

## Arms (make 2)

**Rnd 1:** With White, work 6 sc in a magic ring—6 sts.

**Rnd 2:** *Sc in the next st, 2 sc in the next st; repeat from * 2 more times—9 sts.

**Rnds 3–4:** Sc in each st.

Change to Black.

**Rnd 5:** Sc in each st.

**Rnd 6:** FL sc in each st.

**Rnds 7–12:** Sc in each st.

Stuff the arm. Flatten the opening of the arm.

**Next row:** Working through both layers to close the opening, sc in next 3 sts, sl st in the last st.

Fasten off, leaving a long tail for sewing.

To work the cuff, pull up a loop of Black in the front loop of any st of Rnd 6.

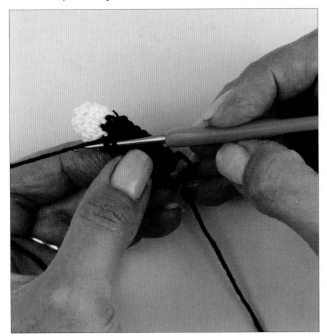

**Rnd 7:** *Sc in the next 2 sts, 2 sc in the next st; repeat from * 2 more times—12 sts.

**Rnd 8:** Sc in each st.

Fasten off and weave in the yarn ends.

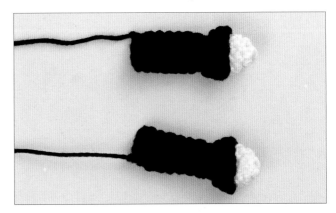

## Teeth

Foundation ch: With White, ch 9. Stitches are worked around both sides of the foundation ch.

**Rnd 1:** Start in the 2nd ch from hook, sc in the next 8 sts, working along the bottom of the foundation ch, sc in the next 8 st—16 sts.

**Rnd 2:** Sc in each st.

Fasten off, leaving a long tail for sewing.

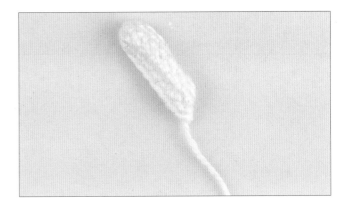

## Time to Put It All Together!

Cut out the shapes of the eyes from the felt fabric, using the graphics below as a guide.

**Black part**

Ø 2.0 cm =
0.8 in

**White part**

Ø 1 cm =
0.4 in

Glue the black parts of the eyes between Rnds 12 and 16 of the head, with 5 stitches between them. Glue the white parts of the eyes on top of the black parts. Cut a small heart shape out of black felt and glue it upside down between Rnds 15 and 17, and centered between the eyes.

With the sewing thread, finish securing the eyes to the head.

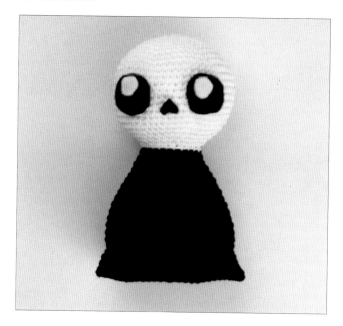

With Cotton Candy, embroider the cheeks below the eyes. With White yarn, embroider the shine of the eyes.

Sew the teeth between Rnds 20 and 21, centered under the eyes.

With Black yarn, embroider the teeth and the eyebrows.

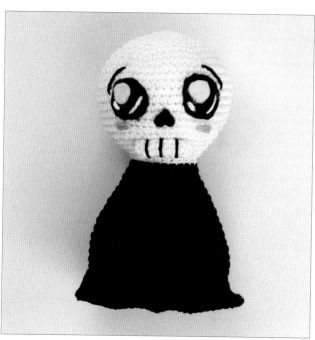

Sew the hood to the FL of Rund 24 of the body.

Sew the arms to the sides of the body at Rnd 26, with 15 stitches between them.

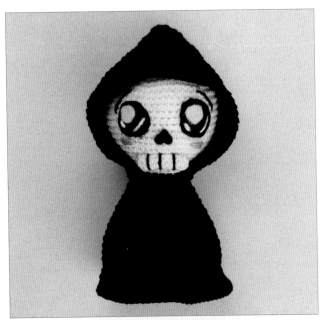

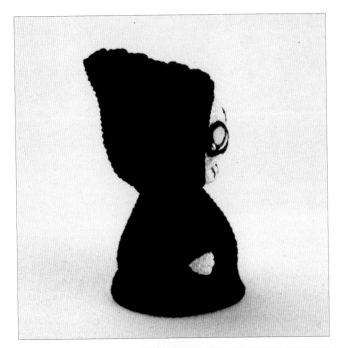

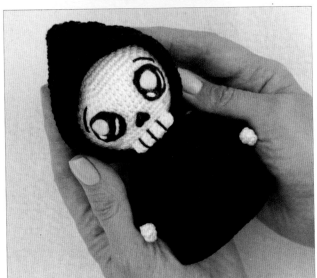

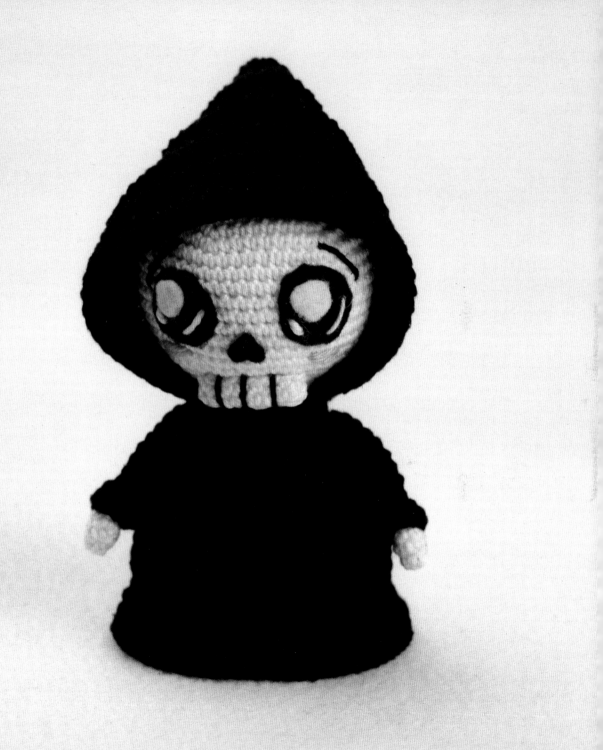

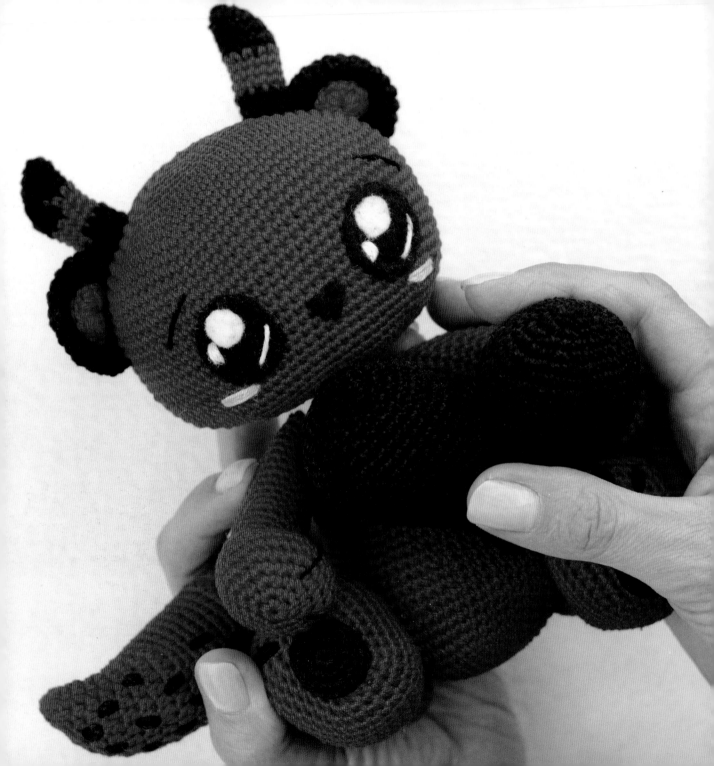

# RED DEVIL BEAR

## MATERIALS

Yarn and Colors® 100% mercerized cotton
(sport weight yarn)
1.75oz (50g); 137yds (125m)

### Colors:

Cardinal (031) 137yds (125m)

Black (100) 55yds (50 m)

White (001) (leftover)

Cotton Candy (037) (leftover)

- Size 2mm crochet hook
- Felt fabric (black and white)
- Fiberfill
- Tapestry needle
- Stitch marker
- Scissors
- Glue
- Black and white thread and sewing needle
- Pins

### Gauge:

7 sts and 7 rnds = 1in/2.54cm in sc

## Let's Begin!

### Body

**Rnd 1:** With Cardinal, work 6 sc in a magic ring—6 sts.

**Rnd 2:** 2 sc in each st—12 sts.

**Rnd 3:** *Sc in the next st, 2 sc in the next st; repeat from * 5 more times—18 sts.

**Rnd 4:** *Sc in the next 2 sts, 2 sc in the next st; repeat from * 5 more times—24 sts.

**Rnd 5:** *Sc in the next 3 sts, 2 sc in the next st; repeat from * 5 more times—30 sts.

**Rnd 6:** *Sc in the next 4 sts, 2 sc in the next st; repeat from * 5 more times—36 sts.

**Rnd 7:** *Sc in the next 5 sts, 2 sc in the next st; repeat from * 5 more times—42 sts.

**Rnd 8:** *Sc in the next 6 sts, 2 sc in the next st; repeat from * 5 more times—48 sts.

**Rnd 9:** *Sc in the next 7 sts, 2 sc in the next st; repeat from * 5 more times—54 sts.

**Rnd 10:** *Sc in the next 8 sts, 2 sc in the next st; repeat from * 5 more times—60 sts.

**Rnds 11–16:** Sc in each st.

**Rnd 17:** *Sc in the next 8 sts, sc2tog; repeat from * 5 more times—54 sts remain.

**Rnd 18:** Sc in each st.

**Rnd 19:** *Sc in the next 7 sts, sc2tog; repeat from * 5 more times—48 sts remain.

**Rnds 20–29:** Sc in each st.

**Rnd 30:** *Sc in the next 6 sts, sc2tog; repeat from * 5 more times—42 sts remain.

**Rnd 31:** *Sc in the next 5 sts, sc2tog; repeat from * 5 more times—36 sts remain.

**Rnd 32:** *Sc in the next 4 sts, sc2tog; repeat from * 5 more times—30 sts remain.

**Rnd 33:** *Sc in the next 3 sts, sc2tog; repeat from * 5 more times—24 sts remain.

Stuff the body.

**Rnd 34:** *Sc in the next st, sc2tog; repeat from * 7 more times—16 sts remain.

**Rnds 35–42:** Sc in each st.

Finish stuffing the body.

**Rnd 43:** *Sc2tog; repeat from * 7 more times—8 sts remain.

Fasten off and leave a yarn tail. Thread the yarn tail into the tapestry needle, then weave the yarn tail through the front loop of each remaining stitch and pull it tight to close. Weave in the yarn end.

## Paws (make 2)

With Cardinal, ch 7. Stitches are worked around both sides of the foundation ch.

**Rnd 1:** Start in the 2nd ch from hook, sc in the next 5 sts, 3 sc in the next st, working along the bottom of the foundation ch, sc in the next 4 sts, 2 sc in the next st—14 sts.

**Rnd 2:** 2 sc in the next st, sc in the next 4 sts, 2 sc in the each of next 4 sts, sc in the next 4 sts, 2 sc in the next st—20 sts.

**Rnd 3:** Sc in the next st, 2 sc in the next st, sc in the next 4 sts, (sc in the next st, 2 sc in the next st) 3 times, 2 sc in the next st, sc in the next 5 sts, 2 sc in the next st, sc in the next st—26 sts.

**Rnd 4:** Sc in the next st, 2 sc in the next st, sc in the next 4 sts, (2 sc in the next st, sc in the next st) 5 times, 2 sc in the next st, sc in the next 6 sts, 2 sc in the next st, sc in the next 2 sts—34 sts.

**Rnd 5:** Sc in the next 2 sts, 2 sc in the next st, sc in the next 9 sts, (2 sc in the next st, sc in the next 3 sts) 2 times, 2 sc in the next st, sc in the next 9 sts, 2 sc in the next st, sc in the next 2 sts, 2 sc in the next st—40 sts.

**Rnds 6–10:** Sc in each st.

**Rnd 11:** Sc in the next 11 sts, (sc2tog) 4 times, sc in the next 2 sts, (sc2tog) 4 times, sc in the next 11 sts—32 sts remain.

**Rnd 12:** Sc in the next 9 sts, (sc2tog) 8 times, sc in the next 7 sts—24 sts remain.

**Rnd 13:** Sc in each st.

**Rnd 14:** *Sc in the next 4 sts, sc2tog; repeat from * 3 more times—20 sts remain.

**Rnd 15:** Sc in the next 4 sts, (sc2tog) 6 times, sc in the next 4 sts—14 sts remain.

Stuff the leg with fiberfill and continue stuffing as you go.

**Rnds 16–18:** Sc in each st.

**Rnd 19:** Sc in the next 6 sts, (2 sc in the next st, sc in the next st) 2 times, sc in the next 4 sts—16 sts.

**Rnd 20:** Sc in the next 8 sts, 2 sc in each of the next 2 sts, sc in the next 6 sts—18 sts.

**Rnd 21:** Sc in the next 9 sts, 2 sc in each of the next 2 sts, sc in the next 7 sts—20 sts.

**Rnd 22:** Sc in the next 8 sts, (2 sc in the next st, sc in the next st) 4 times, sc in the next 4 sts—24 sts.

**Rnds 23–25:** Sc in each st.

**Rnd 26:** *Sc in the next 2 sts, sc2tog; repeat from * 5 more times—18 sts remain.

**Rnd 27:** *Sc in the next st, sc2tog; repeat from * 5 more times—12 sts remain.

**Rnd 28:** *Sc2tog; repeat from * 5 more times—6 sts remain.

Fasten off and leave a yarn tail. Thread the yarn tail into the tapestry needle, then weave the yarn tail through the front loop of each remaining stitch and pull it tight to close. Weave in the yarn end.

## Paw Pads (make 2)

**Rnd 1:** With Black, work 6 sc in a magic ring—6 sts.

**Rnd 2:** 2 sc in each st—12 sts.

**Rnd 3:** *Sc in the next 3 sts, 2 sc in each of the next 3 sts; repeat from * once more—18 sts.

Fasten off, leaving a long tail for sewing.

Sew each paw pad to its leg at Rnd 3, and embroider the toes with Black yarn.

## Arms (make 2)

**Rnd 1:** With Cardinal, work 6 sc in a magic ring—6 sts.

**Rnd 2:** 2 sc in each st—12 sts.

**Rnd 3:** *Sc in the next st, 2 sc in the next st; repeat from * 5 more times—18 sts.

**Rnd 4:** *Sc in the next 2 sts, 2 sc in the next st; repeat from * 5 more times—24 sts.

**Rnd 5:** *Sc in the next 3 sts, 2 sc in the next st; repeat from * 5 more times—30 sts.

**Rnds 6–8:** Sc in each st.

**Rnd 9:** (Sc2tog) 6 times, sc in the next 18 sts—24 sts remain.

**Rnd 10:** (Sc2tog) 6 times, sc in the next 12 sts—18 sts remain.

**Rnds 11–27:** Sc in each st.

Stuff the arm. Flatten the opening of the arm.

**Next row:** Working through both layers to close the opening, sc in next 8 sts, sl st in the last st.

Fasten off, leaving a long tail for sewing.

With Black yarn, embroider the separation between the fingers.

## Tail

**Rnd 1:** With Cardinal, work 4 sc in a magic ring—4 sts.

**Rnd 2:** 2 sc in each st—8 sts.

**Rnd 3:** Hdc in the next st, sc in the next 4 sts, hdc in the next st, 2 hdc in each of the next 2 sts—10 sts.

**Rnd 4:** Sc in the next st, sl st in the next 4 sts, sc in the next st, (hdc in the next st, 2 hdc in the next st) 2 times—12 sts.

**Rnd 5:** Sc in the next 6 sts, (hdc in the next 2 sts, 2 hdc in the next st) 2 times—14 sts.

**Rnd 6:** Hdc in the next st, sc in the next 5 sts, (hdc in the next 3 sts, 2 hdc in the next st) 2 times—16 sts.

**Rnd 7:** Sc in the next st, sl st in the next 4 sts, sc in the next st, (hdc in the next 4 sts, 2 hdc in the next st) 2 times—18 sts.

**Rnd 8:** Hdc in the next st, sc in the next 5 sts, (hdc in the next 5 sts, 2 hdc in the next st) 2 times—20 sts.

**Rnd 9:** Sc in the next st, sl st in the next 5 sts, sc in the next st, hdc in the next 13 sts.

**Rnd 10:** Hdc in the next st, sc in the next 6 sts, hdc in the next 4 sts, 2 hdc in the next st, (hdc in the next 3 sts, 2 hdc in the next st) 2 times—23 sts.

**Rnd 11:** Sc in the next 8 sts, hdc in the next 14 sts, 2 hdc in the next st—24 sts.

**Rnd 12:** Sc in next 11 sts, 2 sc in the next st, sc in next 12 sts—25 sts.

**Rnd 13:** Sc in next 12 sts, 2 sc in the next st, sc in next 12 sts—26 sts.

**Rnd 14:** Sc in next 13 sts, 2 sc in the next st, sc in next 12 sts—27 sts.

**Rnd 15:** Sc in next 14 sts, 2 sc in the next st, sc in next 12 sts—28 sts.

**Rnd 16:** Sc in next 15 sts, 2 sc in the next st, sc in next 12 sts—29 sts.

**Rnds 17–20:** Sc in each st.

**Rnds 21–22:** Hdc in next 11 sts, sc in the next 18 sts.

**Rnd 23:** Hdc in next 11 sts, sc in the next 9 sts, sl st in the next 6 sts, sc in the next 3 sts.

**Rnd 24:** Hdc in next 11 sts, sc in the next 18 sts.

**Rnd 25:** Hdc in next 11 sts, sc in the next 9 sts, sl st in the next 6 sts, sc in the next 3 sts.

**Rnd 26:** Hdc in next 11 sts, sc in the next 18 sts.

**Rnd 27:** Sc in next 9 sts, sc2tog, sc in the next 18 sts—28 sts remain.

**Rnd 28:** Sc in next 5 sts, sc2tog, sc in the next 5 sts, sc2tog, sc in the next 5 sts, sc2tog, sc in the next 5 sts, sc2tog—24 sts remain.

**Rnds 29–38:** Sc in each st.

**Rnd 39:** Sc in the next 18 sts, sc2tog, sc in the next 4 sts—23 sts remain.

**Rnd 40:** Sc in the next 17 sts, sc2tog, sc in the next 4 sts—22 sts remain.

**Rnd 41:** Sc in the next 18 sts, sc2tog—20 sts remain.

**Rnd 42:** Sc in the next 16 sts, (sc2tog) 2 times—18 sts remain.

Stuff the tail. Flatten the opening of the tail.

**Next row:** Working through both layers to close opening, sc in next 8 sts, sl st in the last st.

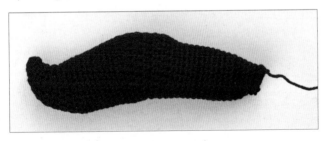

Fasten off, leaving a long tail for sewing.

With Black yarn, embroider the spots on the tail.

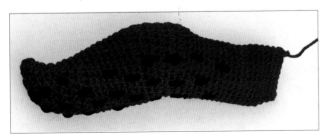

## Heart

**Rnd 1:** With Black, work 4 sc in a magic ring—4 sts.

**Rnd 2:** 2 sc in each st—8 sts.

**Rnd 3:** *Sc in the next st, 2 sc in the next st; repeat from * 3 more times—12 sts.

**Rnd 4:** Sc in each st.

**Rnd 5:** *Sc in the next 2 sts, 2 sc in the next st; repeat from * 3 more times—16 sts.

**Rnd 6:** Sc in each st.

**Rnd 7:** *Sc in the next 3 sts, 2 sc in the next st; repeat from * 3 more times—20 sts.

**Rnd 8:** *Sc in the next 4 sts, 2 sc in the next st; repeat from * 3 more times—24 sts.

**Rnd 9:** *Sc in the next 5 sts, 2 sc in the next st; repeat from * 3 more times—28 sts.

**Rnd 10:** *Sc in the next 6 sts, 2 sc in the next st; repeat from * 3 more times—32 sts.

**Rnd 11:** *Sc in the next 7 sts, 2 sc in the next st; repeat from * 3 more times—36 sts.

**Rnd 12:** *Sc in the next 5 sts, 2 sc in the next st; repeat from * 5 more times—42 sts.

**Rnd 13:** *Sc in the next 6 sts, 2 sc in the next st; repeat from * 5 more times—48 sts.

**Rnd 14:** *Sc in the next 7 sts, 2 sc in the next st; repeat from * 5 more times—54 sts.

**Rnd 15:** *Sc in the next 8 sts, 2 sc in the next st; repeat from * 5 more times—60 sts.

**Rnd 16:** *Sc in the next 9 sts, 2 sc in the next st; repeat from * 5 more times—66 sts.

**Rnd 17:** *Sc in the next 10 sts, 2 sc in the next st; repeat from * 5 more times—72 sts.

**Rnd 18:** *Sc in the next 11 sts, 2 sc in the next st; repeat from * 5 more times—78 sts.

Divide the work in 2 parts of 39 stitches each. Continue working the first part, creating a smaller round for the first lobe.

**Rnds 19–23:** Sc in each st—39 sts.

**Rnd 24:** *Sc in the next 10 sts, sc2tog; repeat from * 2 more times, sc in the next 3 sts—36 sts remain.

**Rnd 25:** *Sc in the next 4 sts, sc2tog; repeat from * 5 more times—30 sts remain.

**Rnd 26:** *Sc in the next 3 sts, sc2tog; repeat from * 5 more times—24 sts remain.

**Rnd 27:** *Sc in the next 2 sts, sc2tog; repeat from * 5 more times—18 sts remain.

**Rnd 28:** *Sc in the next st, sc2tog; repeat from * 5 more times—12 sts remain.

**Rnd 29:** *Sc2tog; repeat from * 5 more times—6 sts remain.

Fasten off and leave a yarn tail. Thread the yarn tail into the tapestry needle, then weave the yarn tail through the front loop of each remaining stitch and pull it tight to close. Weave in the yarn end. Stuff the heart.

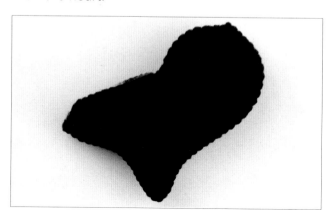

Pull up a loop of Black in the next unworked st of Rnd 18.

**Rnds 19–23:** Sc in each st—39 sts.

**Rnd 24:** *Sc in the next 10 sts, sc2tog; repeat from * 2 more times, sc in the next 3 sts—36 sts remain.

**Rnd 25:** *Sc in the next 4 sts, sc2tog; repeat from * 5 more times—30 sts remain.

**Rnd 26:** *Sc in the next 3 sts, sc2tog; repeat from * 5 more times—24 sts remain.

**Rnd 27:** *Sc in the next 2 sts, sc2tog; repeat from * 5 more times—18 sts remain.

**Rnd 28:** *Sc in the next st, sc2tog; repeat from * 5 more times—12 sts remain.

Finish stuffing the heart.

**Rnd 29:** *Sc2tog; repeat from * 5 more times—6 sts.

Fasten off and leave a yarn tail. Thread the yarn tail into the tapestry needle, then weave the yarn tail through the front loop of each remaining stitch

and pull it tight to close. Pass the yarn through the heart to exit through the upper part of it and close the gap between the two parts with a few stitches. Fasten off and weave the yarn ends.

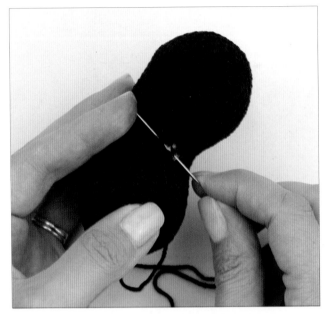

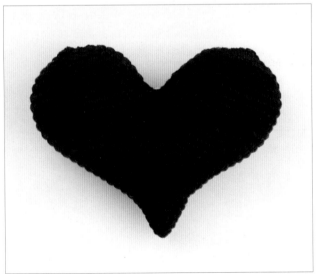

## Ears (make 2)

**Rnd 1:** With Black, work 6 sc in a magic ring—6 sts.

**Rnd 2:** 2 sc in each st—12 sts.

**Rnd 3:** *Sc in the next st, 2 sc in the next st; repeat from * 5 more times—18 sts.

**Rnd 4:** *Sc in the next 2 sts, 2 sc in the next st; repeat from * 5 more times—24 sts.

**Rnds 5–7:** Sc in each st.

The ears don't need to be stuffed. Flatten the opening of the ear.

**Next row:** Working through both layers to close opening, sc in next 8 sts, sl st in the last st.

Fasten off, leaving a long tail for sewing.

## Centers of the Ears (make 2)

Rnd 1: With Cardinal, work 8 hdc in a magic ring—8 sts.

Fasten off, leaving a long tail for sewing. Sew each center of the ear to its ear.

## Horns (make 2)

**Rnd 1:** With Black, work 4 sc in a magic ring—4 sts.

**Rnd 2:** 2 sc in each st—8 sts.

**Rnd 3:** Hdc in the next st, sc in the next 4 sts, hdc in the next st, 2 hdc in each of the next 2 sts—10 sts.

**Rnd 4:** Sc in the next 6 sts, (hdc in the next st, 2 hdc in the next st) 2 times—12 sts.

**Rnd 5:** Sc in the next 6 sts, hdc in the next 6 sts.

Change to Cardinal.

**Rnds 6–9:** Sc in each st.

Change to Black.

**Rnds 10–12:** Sc in each st.

Fasten off, leaving a long tail for sewing. The horns don't need to be stuffed.

## Head

**Rnd 1:** With Cardinal, work 6 sc in a magic ring—6 sts.

**Rnd 2:** 2 sc in each st—12 sts.

**Rnd 3:** (2 sc in each of the next 3 sts, sc in the next 3 sts) 2 times—18 sts.

**Rnd 4:** (Sc in the next st, 2 sc in the next st) 3 times, sc in the next 3 sts, (sc in the next st, 2 sc in the next st) 3 times, sc in the next 3 sts—24 sts.

**Rnd 5:** (Sc in the next 2 sts, 2 sc in the next st) 3 times, sc in the next 3 sts, (sc in the next 2 sts, 2 sc in the next st) 3 times, sc in the next 3 sts—30 sts.

**Rnd 6:** (Sc in the next 3 sts, 2 sc in the next st) 3 times, sc in the next 3 sts, (sc in the next 3 sts, 2 sc in the next st) 3 times, sc in the next 3 sts—36 sts.

**Rnd 7:** (Sc in the next 4 sts, 2 sc in the next st) 3 times, sc in the next 3 sts, (sc in the next 4 sts, 2 sc in the next st) 3 times, sc in the next 3 sts—42 sts.

**Rnd 8:** (Sc in the next 5 sts, 2 sc in the next st) 3 times, sc in the next 3 sts, (sc in the next 5 sts, 2 sc in the next st) 3 times, sc in the next 3 sts—48 sts.

**Rnd 9:** Sc in the next 7 sts, 2 sc in the next st, (sc in the next 3 sts, 2 sc in the next st) 2 times, sc in the next 15 sts, 2 sc in the next st, (sc in the next 3 sts, 2 sc in the next st) 2 times, sc in the next 8 sts—54 sts.

**Rnd 10:** Sc in the next 8 sts, 2 sc in the next st, (sc in the next 4 sts, 2 sc in the next st) 2 times, sc in the next 16 sts, 2 sc in the next st, (sc in the next 4 sts, 2 sc in the next st) 2 times, sc in the next 8 sts—60 sts.

**Rnd 11:** Sc in the next 8 sts, 2 sc in the next st, (sc in the next 5 sts, 2 sc in the next st) 2 times, sc in the next 17 sts, 2 sc in the next st, (sc in the next 5 sts, 2 sc in the next st) 2 times, sc in the next 9 sts—66 sts.

**Rnd 12:** Sc in the next 9 sts, 2 sc in the next st, (sc in the next 6 sts, 2 sc in the next st) 2 times, sc in the next 18 sts, 2 sc in the next st, (sc in the next 6 sts, 2 sc in the next st) 2 times, sc in the next 9 sts—72 sts.

**Rnd 13:** Sc in the next 9 sts, 2 sc in the next st, (sc in the next 7 sts, 2 sc in the next st) 2 times, sc in the next 19 sts, 2 sc in the next st, (sc in the next 7 sts, 2 sc in the next st) 2 times, sc in the next 10 sts—78 sts.

**Rnds 14–28:** Sc in each st.

**Rnd 29:** Sc in the next 9 sts, sc2tog, (sc in the next 7 sts, sc2tog) 2 times, sc in the next 19 sts, sc2tog, (sc in the next 7 sts, sc2tog) 2 times, sc in the next 10 sts—72 sts remain.

**Rnd 30:** Sc in the next 9 sts, sc2tog, (sc in the next 6 sts, sc2tog) 2 times, sc in the next 18 sts, sc2tog, (sc in the next 6 sts, sc2tog) 2 times, sc in the next 9 sts—66 sts remain.

**Rnd 31:** Sc in the next 8 sts, sc2tog, (sc in the next 5 sts, sc2tog) 2 times, sc in the next 17 sts, s2tog, (sc in the next 5 sts, sc2tog) 2 times, sc in the next 9 sts—60 sts remain.

**Rnd 32:** Sc in the next 8 sts, sc2tog, (sc in the next 4 sts, sc2tog) 2 times, sc in the next 16 sts, sc2tog, (sc in the next 4 sts, sc2tog) 2 times, sc in the next 8 sts—54 sts remain.

**Rnd 33:** Sc in the next 7 sts, sc2tog, (sc in the next 3 sts, sc2tog) 2 times, sc in the next 15 sts, sc2tog, (sc in the next 3 sts, sc2tog) 2 times, sc in the next 8 sts—48 sts remain.

**Rnd 34:** *Sc in the next 4 sts, sc2tog; repeat from * 7 more times—40 sts remain.

**Rnd 35:** *Sc in the next 3 sts, sc2tog; repeat from * 7 more times—32 sts remain.

**Rnd 36:** *Sc in the next 2 sts, sc2tog; repeat from * 7 more times—24 sts remain.

**Rnd 37:** *Sc in the next st, sc2tog; repeat from * 7 more times—16 sts remain.

Fasten off, leaving a long tail for sewing.

Stuff the head.

## Time to Put It All Together!

Cut out the shapes of the eyes from the felt fabric, using the graphics below as a guide.

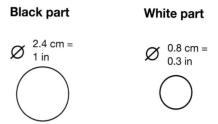

**Black part**

Ø 2.4 cm = 1 in

**White part**

Ø 0.8 cm = 0.3 in

Glue the black parts of the eyes to the head between Rnds 19 and 26, with 8 stitches in between. Glue the white parts of the eyes on top of the black parts. Cut a small heart shape out of black felt and glue it to the head between Rnds 24 and 26, centered between the eyes.

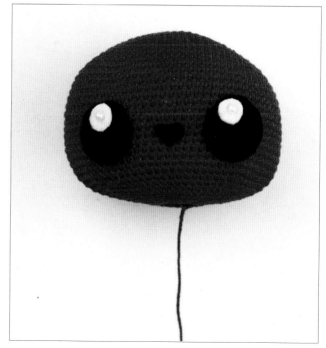

Using the sewing thread, finish securing the eyes to the head. With Cotton Candy, embroider the cheeks below the eyes. With White yarn, embroider the shine of the eyes.

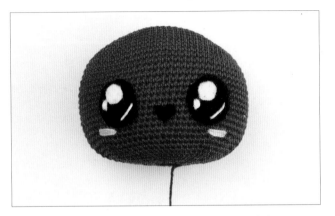

Sew the ears to the sides of the head between Rnds 11 and 20. Sew the horns behind the ears between Rnds 7 and 11.

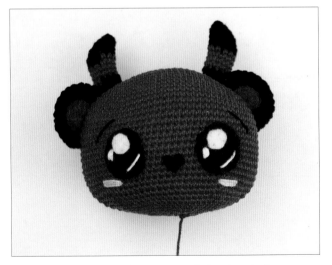

Sew the paws to the sides of the body between Rnds 7 and 14, with 15 stitches between them at the back.

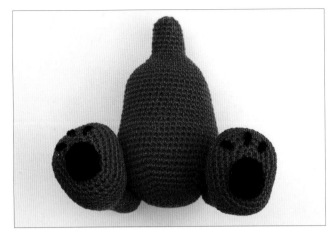

Sew the arms to the sides of the body between Rnds 28 and 34, with 15 stitches between them at the back.

Sew the tail to the center of the back, between Rnds 10 and 16.

Attach the head onto the body. Use your finger to poke a hole inside the filling and pull the neck through the opening of the head so that 1 to 2 rounds of the neck are visible. Sew the head onto the neck.

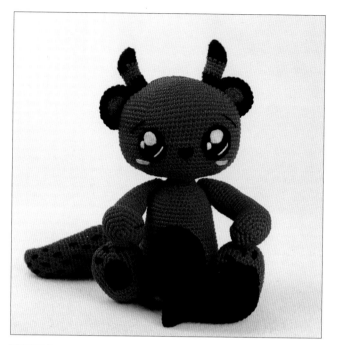
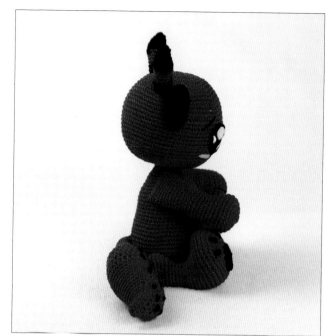
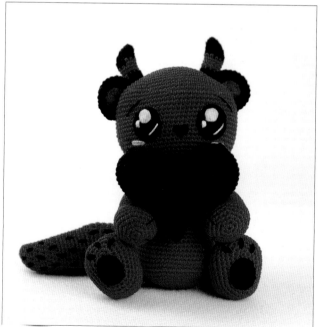
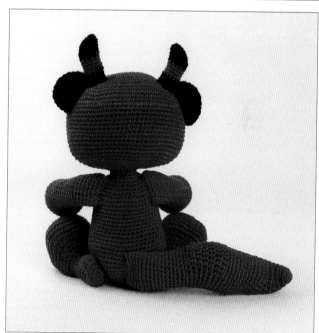

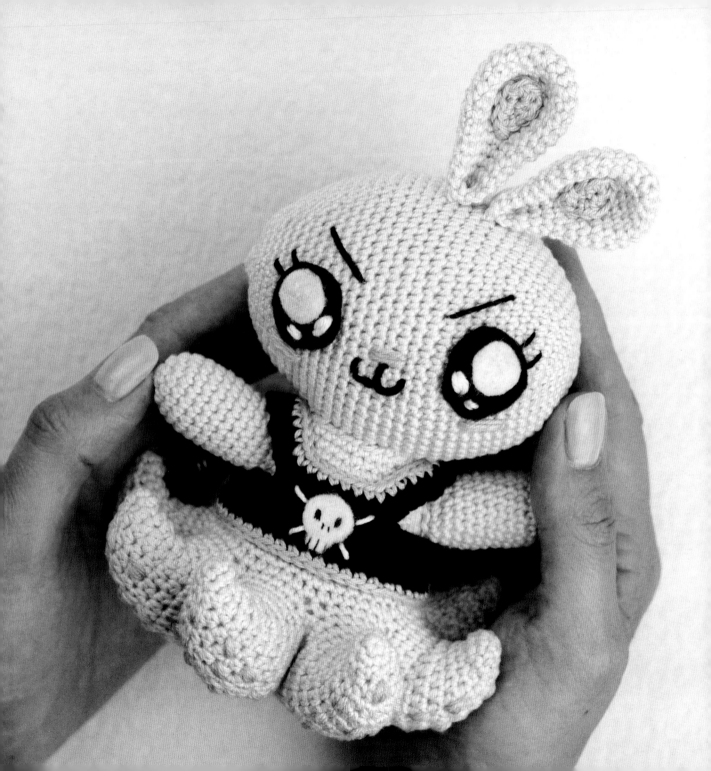

# OCTOBUNNY

## MATERIALS

Yarn and Colors® 100% mercerized cotton (sport weight yarn)

1.75oz (50g); 137yds (125m)

### Colors:

Blossom (045) 137yds (125m)

Black (100) 55yds (50m)

White (001) (leftover)

Cotton Candy (037) (leftover)

- Size 2mm crochet hook
- Felt fabric (black and white)
- Fiberfill
- Tapestry needle
- Stitch marker
- Scissors
- Glue
- Black and white thread and sewing needle
- Pins

### Gauge:

7 sts and 7 rnds = 1in/2.54cm in sc

## Let's Begin!

### Head

**Rnd 1:** With Blossom, work 6 sc in a magic ring—6 sts.

**Rnd 2:** 2 sc in each st—12 sts.

**Rnd 3:** *Sc in the next st, 2 sc in the next st; repeat from * 5 more times—18 sts.

**Rnd 4:** *Sc in the next 2 sts, 2 sc in the next st; repeat from * 5 more times—24 sts.

**Rnd 5:** *Sc in the next 5 sts, 2 sc in the next st; repeat from * 3 more times—28 sts.

**Rnd 6:** *Sc in the next 6 sts, 2 sc in the next st; repeat from * 3 more times—32 sts.

**Rnd 7:** *Sc in the next 7 sts, 2 sc in the next st; repeat from * 3 more times—36 sts.

**Rnd 8:** *Sc in the next 5 sts, 2 sc in the next st; repeat from * 5 more times—42 sts.

**Rnd 9:** *Sc in the next 6 sts, 2 sc in the next st; repeat from * 5 more times—48 sts.

**Rnd 10:** Sc in each st.

**Rnd 11:** *Sc in the next 7 sts, 2 sc in the next st; repeat from * 5 more times—54 sts.

**Rnd 12:** Sc in each st.

**Rnd 13:** *Sc in the next 8 sts, 2 sc in the next st; repeat from * 5 more times—60 sts.

**Rnds 14–25:** Sc in each st.

**Rnd 26:** *Sc in the next 8 sts, sc2tog; repeat from * 5 more times—54 sts remain.

**Rnd 27:** Sc in each st.

**Rnd 28:** *Sc in the next 7 sts, sc2tog; repeat from * 5 more times—48 sts remain.

**Rnd 29:** Sc in each st.

**Rnd 30:** *Sc in the next 6 sts, sc2tog; repeat from * 5 more times—42 sts remain.

**Rnd 31:** *Sc in the next 5 sts, sc2tog; repeat from * 5 more times—36 sts remain.

**Rnd 32:** *Sc in the next 7 sts, sc2tog; repeat from * 3 more times—32 sts remain.

**Rnd 33:** *Sc in the next 6 sts, sc2tog; repeat from * 3 more times—28 sts remain.

**Rnd 34:** *Sc in the next 5 sts, sc2tog; repeat from * 3 more times—24 sts remain.

**Rnd 35:** *Sc in the next 2 sts, sc2tog; repeat from * 5 more times—18 sts remain.

Stuff the head.

**Rnd 36:** *Sc in the next st, sc2tog; repeat from * 5 more times—12 sts remain.

**Rnd 37:** *Sc2tog; repeat from * 5 more times—6 sts remain.

Fasten off and leave a yarn tail. Thread the yarn tail into the tapestry needle, then weave the yarn tail through the front loop of each remaining stitch and pull it tight to close. Weave in the yarn end.

## Arms (make 2)

**Rnd 1:** With Blossom, work 6 sc in a magic ring—6 sts.

**Rnd 2:** 2 sc in each st—12 sts.

**Rnd 3:** *Sc in the next 2 sts, 2 sc in the next st; repeat from * 3 more times—16 sts.

**Rnds 4–13:** Sc in each st.

Fasten off, leaving a long tail for sewing.

## Tentacles (make 8)

**Rnd 1:** With Blossom, work 4 sc in a magic ring—4 sts.

**Rnd 2:** 2 sc in each st—8 sts.

**Rnd 3:** Hdc in the next st, sc in the next 4 sts, hdc in the next st, 2 hdc in the next 2 sts—10 sts.

**Rnd 4:** Sc in the next st, sl st in the next 4 sts, sc in the next st, (hdc in the next st, 2 hdc in the next st) 2 times—12 sts.

**Rnd 5:** Sc in the next 6 sts, (hdc in the next 2 sts, 2 hdc in the next st) 2 times—14 sts.

**Rnd 6:** Hdc in the next st, sc in the next 5 sts, (hdc in the next 3 sts, 2 hdc in the next st) 2 times—16 sts.

**Rnd 7:** Sc in the next st, sl st in the next 4 sts, sc in the next st, (hdc in the next 4 sts, 2 hdc in the next st) 2 times—18 sts.

**Rnd 8:** Hdc in the next st, sc in the next 5 sts, (hdc in the next 5 sts, 2 hdc in the next st) 2 times—20 sts.

**Rnd 9:** Sc in the next st, sl st in the next 5 sts, sc in the next st, hdc in the next 13 sts.

**Rnd 10:** Hdc in the next st, sc in the next 6 sts, hdc in the next 4 sts, 2 hdc in the next st, (hdc in the next 3 sts, 2 hdc in the next st) 2 times—23 sts.

**Rnd 11:** Sc in the next 8 sts, hdc in the next 14 sts, 2 hdc in the next st—24 sts.

**Rnd 12:** Sc in each st.

Fasten off and weave in the yarn ends. Stuff the tentacles.

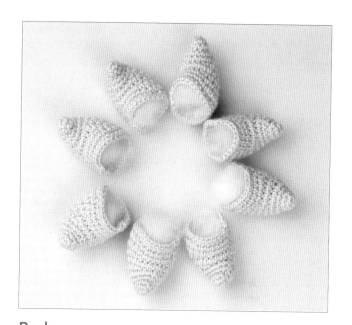

## Body

Mark the 6 central stitches at the top of each tentacle.

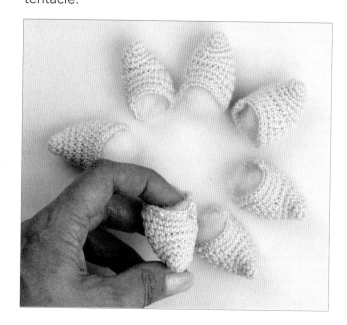

The first round of the body is worked over these 6 stitches on each tentacle to join them.

**Rnd 13:** With Blossom, work 6 sc in the marked sts of the first tentacle, *work 6 sc in the marked sts of the next tentacle; repeat from * 6 more times—48 sts.)

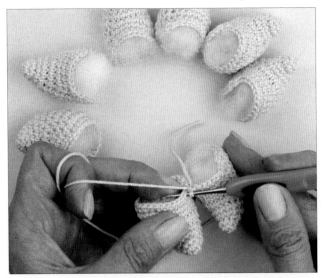

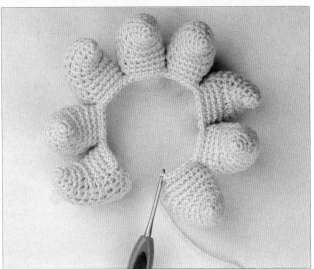

Join and continue crocheting in the round.

**Rnds 14–17:** Sc in each st.

**Rnd 18:** *Sc in the next 6 sts, sc2tog; repeat from * 5 more times—42 sts remain.

**Rnds 19–23:** Sc in each st.

**Rnd 24:** *Sc in the next 5 sts, sc2tog; repeat from * 5 more times—36 sts remain.

**Rnd 25:** Sc in each st.

**Rnd 26:** *Sc in the next 4 sts, sc2tog; repeat from * 5 more times—30 sts remain.

**Rnd 27:** Sc in each st.

Fasten off, leaving a long tail for sewing.

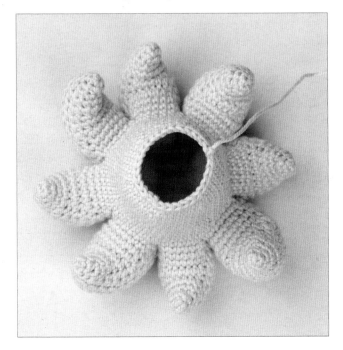

Turn the body so the tentacles are toward you. With your sewing needle, sew the 6 stitches between each tentacle together; 6 stitches on each tentacle should remain facing you.

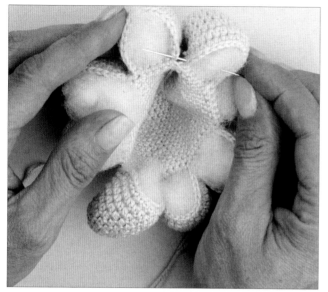

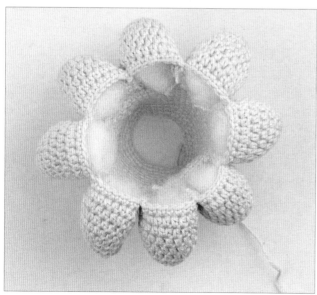

Pull up a loop of Blossom yarn in any remaining stitch of Rnd 12 of any tentacle.

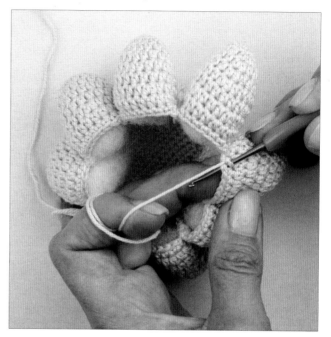

**Rnd 13:** Sc in each remaining st—48 sts.

**Rnd 14:** *Sc in the next 4 sts, sc2tog; repeat from * 7 more times—40 sts remain.

**Rnd 15:** *Sc in the next 3 sts, sc2tog; repeat from * 7 more times—32 sts remain.

**Rnd 16:** *Sc in the next 2 sts, sc2tog; repeat from * 7 more times—24 sts remain.

**Rnd 17:** *Sc in the next st, sc2tog; repeat from * 7 more times—16 sts remain.

**Rnd 18:** *Sc2tog; repeat from * 7 more times—8 sts remain.

Fasten off and leave a yarn tail. Thread the yarn tail into the tapestry needle, then weave the yarn tail through the front loop of each remaining stitch

and pull it tight to close. Weave in the yarn end. Stuff the body.

With Cotton Candy, embroider the spots on the lower part of the body.

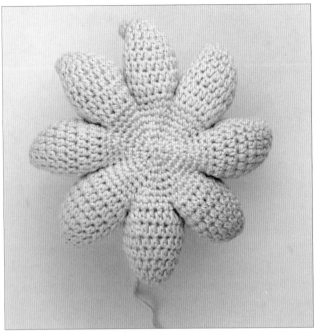

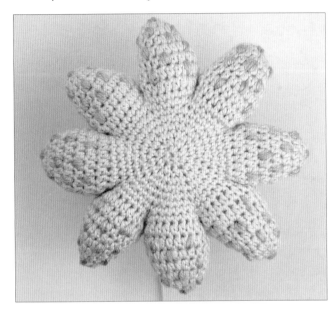

### Shirt

Foundation ch: With Black, ch 48, join with sl st making a ring, ch 1—48 sts.

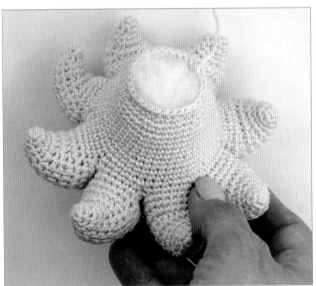

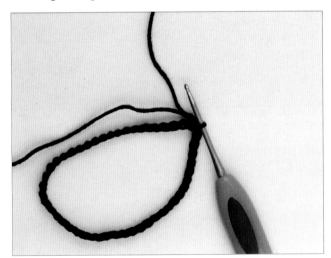

**Rnds 1–2:** Sc in each st.

**Rnd 3:** *Sc in the next 6 sts, sc2tog; repeat from * 5 more times—42 sts remain.

**Rnd 4:** Sc in each st.

Fasten off and weave in the yarn ends.

Choose where the front of the shirt will be. Mark the 10 center stitches of the front. Pull up a loop of Black yarn in the first of the 10 center stitches.

**Rows 5–6:** Sc in the next 10 sts, ch 1, turn—10 sts.

Continue with the strap.

**Rows 7–18:** Sc in the next 2 sts, ch 1, turn—2 sts.

**Row 19:** Sc in each st.

Fasten off, leaving a long tail for sewing.

Pull up a loop of Black in the 9th st of the 10 center stitches to work the 2nd strap.

**Rows 7–18:** Sc in the next 2 sts, ch 1, turn—2 sts.

**Row 19:** Sc in the next 2 sts.

Fasten off, leaving a long tail for sewing. Sew the straps to top edge of the back of the shirt.

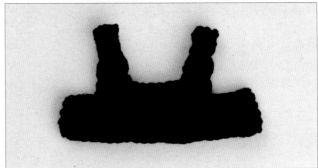

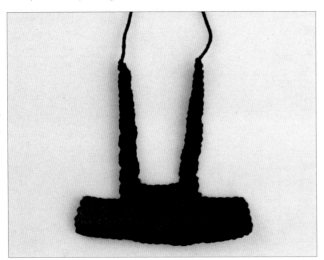

Pull up a loop of Cotton Candy in the center st at the bottom of the back of the shirt. Work 48 sc along the bottom edge. Fasten off.

Cut the shape of the skull out of white felt fabric and glue it to the center of the front of the shirt. With black sewing thread, embroider the details of the skull. With White yarn, embroider the crossed bones.

Pull up a loop of Cotton Candy in the center st at the upper of the back of the shirt. Work sc along the neckline edge. Fasten off.

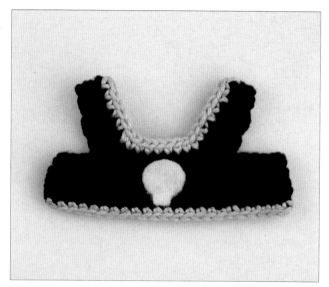

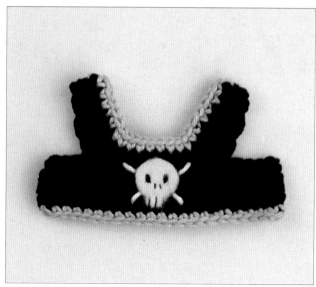

## Ears (make 2)

**Rnd 1:** With Blossom, work 6 sc in a magic ring— 6 sts.

**Rnd 2:** 2 sc in each st—12 sts.

**Rnd 3:** *Sc in the next st, 2 sc in the next st; repeat from * 5 more times—18 sts.

**Rnd 4:** *Sc in the next 2 sts, 2 sc in the next st; repeat from * 5 more times—24 sts.

**Rnds 5–8:** Sc in each st.

**Rnd 9:** *Sc in the next 2 sts, sc2tog; repeat from * 5 more times—18 sts.

**Rnd 10:** Sc in each st.

**Rnd 11:** *Sc in the next st, sc2tog; repeat from * 5 more times—12 sts.

**Rnds 12–14:** Sc in each st.

The ears don't need to be stuffed. Flatten the opening of the ear.

**Next row:** Working through both layers to close the opening, sc in next 5 sts, sl st in the last st.

Fasten off, leaving a long tail for sewing.

## Centers of the Ears (make 2)

Foundation ch: With Cotton Candy, ch 4. Stitches are worked around both sides of the foundation ch.

**Rnd 1:** Start in the 2nd ch from hook, sc in the next 2 sts, 5 dc in the next st, working along the bottom of the foundation ch, sc in the next 2 sts.

Fasten off, leaving a long tail for sewing.

Sew each center of the ear to its ear. Fold the bottom edge of the ears in half and secure with a few stitches.

## Time to Put It All Together!

Cut out the shapes of the eyes from the felt fabric, using the graphics below as a guide.

**Black part**

∅ 2.4 cm = 1 in

**White part**

∅ 1.5 cm = 0.6 in

Glue the black parts of the eyes between Rnds 7 and 13, and Rnds 24 and 30 of the head. Glue the white parts of the eyes on top of the black parts.

Using the sewing thread, finish securing the eyes to the head.

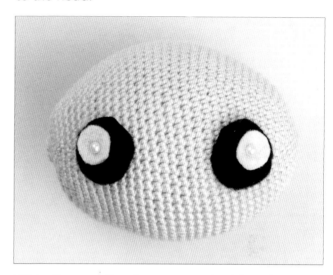

With Cotton Candy yarn, embroider the nose between Rnds 18 and 20, and the cheeks under the eyes. With White yarn, embroider the shine of the eyes, and with Black yarn embroider the mouth, eyebrows, and eyelashes.

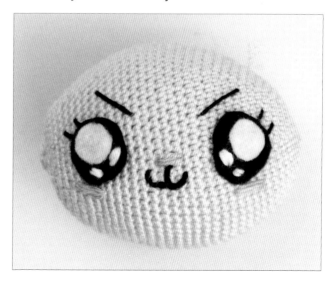

Sew the arms to the sides of the body between Rnds 20 and 25, with 16 stitches between them at the back.

Sew the head onto the body and sew the ears to the top of the head between Rnds 15 and 17.

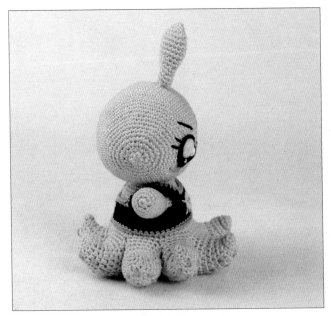

Place the shirt on the body.

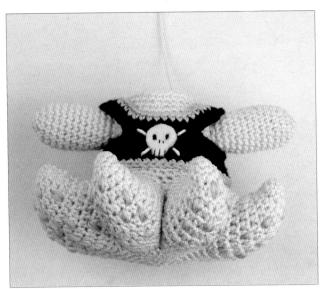

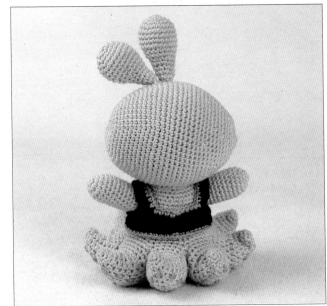

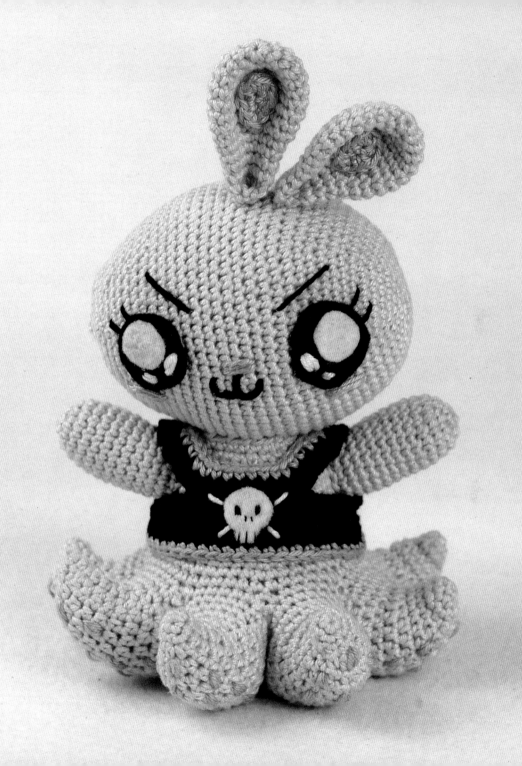

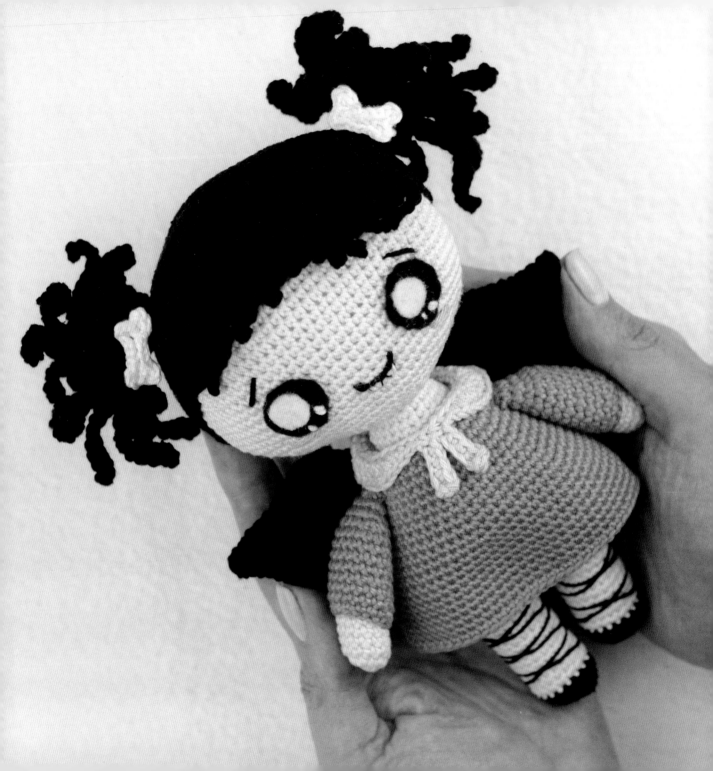

# VAMPiRE GiRL

## MATERIALS

Yarn and Colors® 100% mercerized cotton (sport weight yarn)

1.75oz (50g); 137yds (125m)

### Colors:

Blush (103) 137yds (125m)

White (001) (leftover)

Black (100) 82yds (75m)

Salmon (039) 55yds (50m)

Peach (042) (leftover)

Cotton Candy (037) (leftover)

- Size 2mm crochet hook
- Felt fabric (black and white)
- Fiberfill
- Tapestry needle
- Stitch marker
- Scissors
- Glue
- Black and white thread and sewing needle
- Pins

### Gauge:

7 sts and 7 rnds = 1in/2.54cm in sc

## Let's Begin!

### Head

**Rnd 1:** With Blush, work 6 sc in a magic ring—6 sts.

**Rnd 2:** 2 sc in each st—12 sts.

**Rnd 3:** *2 sc in the next 3 sts, sc in the next 3 sts; repeat from * once more—18 sts.

**Rnd 4:** (Sc in the next st, 2 sc in the next st) 3 times, sc in the next 3 sts, (sc in the next st, 2 sc in the next st) 3 times, sc in the next 3 sts—24 sts.

**Rnd 5:** (Sc in the next 2 sts, 2 sc in the next st) 3 times, sc in the next 3 sts, (sc in the next 2 sts, 2 sc in the next st) 3 times, sc in the next 3 sts—30 sts.

**Rnd 6:** (Sc in the next 3 sts, 2 sc in the next st) 3 times, sc in the next 3 sts, (sc in the next 3 sts, 2 sc in the next st) 3 times, sc in the next 3 sts—36 sts.

**Rnd 7:** (Sc in the next 4 sts, 2 sc in the next st) 3 times, sc in the next 3 sts, (sc in the next 4 sts, 2 sc in the next st) 3 times, sc in the next 3 sts—42 sts.

**Rnd 8:** (Sc in the next 5 sts, 2 sc in the next st) 3 times, sc in the next 3 sts, (sc in the next 5 sts, 2 sc in the next st) 3 times, sc in the next 3 sts—48 sts.

**Rnd 9:** Sc in the next 7 sts, 2 sc in the next st, (sc in the next 3 sts, 2 sc in the next st) 2 times, sc in the next 15 sts, 2 sc in the next st, (sc in the next 3 sts, 2 sc in the next st) 2 times, sc in the next 8 sts—54 sts.

**Rnd 10:** Sc in the next 8 sts, 2 sc in the next st, (sc in the next 4 sts, 2 sc in the next st) 2 times, sc in the next 16 sts, 2 sc in the next st, (sc in the next 4 sts, 2 sc in the next st) 2 times, sc in the next 8 sts—60 sts.

**Rnd 11:** Sc in the next 8 sts, 2 sc in the next st, (sc in the next 5 sts, 2 sc in the next st) 2 times, sc in the next 17 sts, 2 sc in the next st, (sc in the next 5 sts, 2 sc in the next st) 2 times, sc in the next 9 sts—66 sts.

**Rnd 12:** Sc in the next 9 sts, 2 sc in the next st, (sc in the next 6 sts, 2 sc in the next st) 2 times, sc in the next 18 sts, 2 sc in the next st, (sc in the next 6 sts, 2 sc in the next st) 2 times, sc in the next 9 sts—72 sts.

**Rnd 13:** Sc in the next 9 sts, 2 sc in the next st, (sc in the next 7 sts, 2 sc in the next st) 2 times, sc in the next 19 sts, 2 sc in the next st, (sc in the next 7 sts, 2 sc in the next st) 2 times, sc in the next 10 sts—78 sts.

**Rnds 14–28:** Sc in each st.

**Rnd 29:** Sc in the next 9 sts, sc2tog, (sc in the next 7 sts, sc2tog) 2 times, sc in the next 19 sts, sc2tog, (sc in the next 7 sts, sc2tog) 2 times, sc in the next 10 sts—72 sts remain.

**Rnd 30:** Sc in the next 9 sts, sc2tog, (sc in the next 6 sts, sc2tog) 2 times, sc in the next 18 sts, sc2tog, (sc in the next 6 sts, sc2tog) 2 times, sc in the next 9 sts—66 sts remain.

**Rnd 31:** Sc in the next 8 sts, sc2tog, (sc in the next 5 sts, sc2tog) 2 times, sc in the next 17 sts, sc2tog, (sc in the next 5 sts, sc2tog) 2 times, sc in the next 9 sts—60 sts remain.

**Rnd 32:** Sc in the next 8 sts, sc2tog, (sc in the next 4 sts, sc2tog) 2 times, sc in the next 16 sts, sc2tog, (sc in the next 4 sts, sc2tog) 2 times, sc in the next 8 sts—54 sts remain.

**Rnd 33:** Sc in the next 7 sts, sc2tog, (sc in the next 3 sts, sc2tog) 2 times, sc in the next 15 sts, sc2tog, (sc in the next 3 sts, sc2tog) 2 times, sc in the next 8 sts—48 sts remain.

**Rnd 34:** *Sc in the next 4 sts, sc2tog; repeat from * 7 more times—40 sts remain.

**Rnd 35:** *Sc in the next 3 sts, sc2tog; repeat from * 7 more times—32 sts remain.

**Rnd 36:** *Sc in the next 2 sts, sc2tog; repeat from * 7 more times—24 sts remain.

**Rnd 37:** *Sc in the next st, sc2tog; repeat from * 7 more times—16 sts remain.

Fasten off, leaving a long tail for sewing.

Stuff the head.

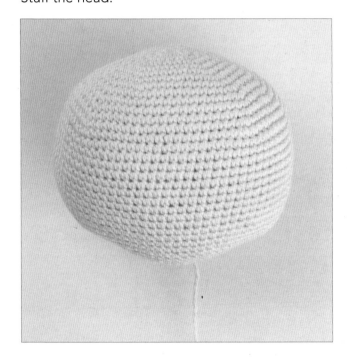

## Body

**Rnd 1:** With Blush, work 8 sc in a magic ring—8 sts.

**Rnd 2:** 2 sc in each st—16 sts.

**Rnds 3–10:** Sc in each st.

**Rnd 11:** *Sc in the next 3 sts, 2 sc in the next st; repeat from * 3 more times—20 sts.

**Rnd 12:** Sc in each st.

**Rnd 13:** *Sc in the next 4 sts, 2 sc in the next st; repeat from * 3 more times—24 sts.

**Rnd 14:** Sc in each st.

**Rnd 15:** *Sc in the next 3 sts, 2 sc in the next st; repeat from * 5 more times—30 sts.

**Rnd 16:** Sc in each st.

**Rnd 17:** *Sc in the next 4 sts, 2 sc in the next st; repeat from * 5 more times—36 sts.

**Rnd 18:** Sc in each st.

**Rnd 19:** *Sc in the next 5 sts, 2 sc in the next st; repeat from * 5 more times—42 sts.

**Rnd 20:** Sc in each st.

**Rnd 21:** *Sc in the next 6 sts, 2 sc in the next st; repeat from * 5 more times—48 sts.

**Rnds 22–30:** Sc in each st.

Divide the work in 2 parts of 24 stitches each. Continue working the first part, creating a smaller round for the first leg.

**Rnds 31–34:** Sc in each st—24 sts.

**Rnd 35:** *Sc in the next 2 sts, sc2tog; repeat from * 5 more times—18 sts remain.

**Rnds 36–45:** Sc in each st.

Change to Black.

**Rnds 46–47:** Sc in each st.

**Rnd 48:** *Sc in the next st, sc2tog; repeat from * 5 more times—12 sts remain.

**Rnd 49:** *Sc2tog; repeat from * 5 more times—6 sts remain.

Fasten off and leave a yarn tail. Thread the yarn tail into the tapestry needle, then weave the yarn tail through the front loop of each remaining stitch and pull it tight to close. Weave in the yarn end. Stuff the body and the first leg.

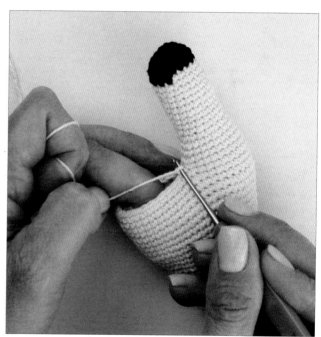

Pull up a loop of Blush in the next unworked st of Rnd 30, next to the first leg.

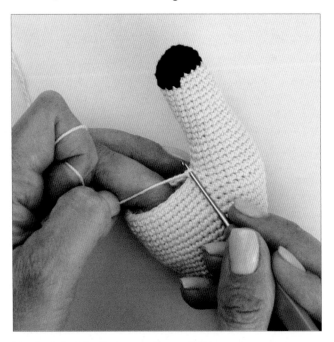

tail through the front loop of each remaining stitch and pull it tight to close. Thread a piece of Blush into the tapestry needle and close the gap between the two legs with a few stitches. Fasten off and weave the yarn ends.

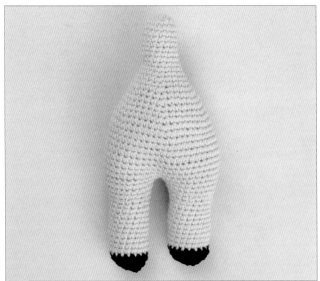

**Rnds 31–34:** Sc in each st—24 sts.

**Rnd 35:** *Sc in the next 2 sts, sc2tog; repeat from * 5 more times—18 sts remain.

**Rnds 36–45:** Sc in each st.

Change to Black.

**Rnds 46–47:** Sc in each st.

**Rnd 48:** *Sc in the next st, sc2tog; repeat from * 5 more times—12 sts remain.

Stuff the second leg.

**Rnd 49:** *Sc2tog; repeat from * 5 more times—6 sts remain.

Fasten off and leave a yarn tail. Thread the yarn tail into the tapestry needle, then weave the yarn

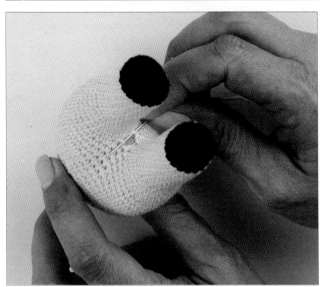

## Dress

**Rnd 1:** With Salmon, ch 30, join with a sl st to form a ring, making sure not to twist the ch, work sc in each ch—30 sts.

**Rnd 2:** *Sc in the next 4 sts, 2 sc in the next st; repeat from * 5 more times—36 sts.

**Rnd 3:** Sc in each st.

**Rnd 4:** *Sc in the next 5 sts, 2 sc in the next st; repeat from * 5 more times—42 sts.

**Rnd 5:** Sc in each st.

**Rnd 6:** *Sc in the next 6 sts, 2 sc in the next st; repeat from * 5 more times—48 sts.

**Rnd 7:** Sc in each st.

**Rnd 8:** *Sc in the next 7 sts, 2 sc in the next st; repeat from * 5 more times—54 sts.

**Rnd 9:** Sc in each st.

**Rnd 10:** *Sc in the next 8 sts, 2 sc in the next st; repeat from * 5 more times—60 sts.

**Rnd 11:** Sc in each st.

**Rnd 12:** *Sc in the next 9 sts, 2 sc in the next st; repeat from * 5 more times—66 sts.

**Rnds 13–21:** Sc in each st.

Fasten off and weave in the yarn ends.

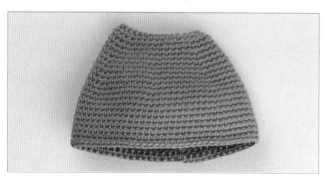

## Dress Collar

Pull up a loop of Peach in the back loop of any st of Rnd 1.

**Rnd 1:** Sc in each st, sl st to join, ch 1—30 sts.

**Rnd 2:** Sc in the next 3 sts, hdc in the next 3 sts, 2 dc in each of the next 5 sts, 2 hdc in the next st, sc in the next st, sl st in the next 2 sts, (ch 7, start in the 3rd ch from hook, hdc in the next 2 ch, sc in the next 2 ch, sl st in the last ch, sl st in the next st from Rnd 1) twice, sl st in the next st from Rnd 1, sc in the next st, 2 hdc in the next st, 2 dc in each of the next 5 sts, hdc in the next 3 sts, sc in the next 2 sts.

Fasten off and weave in the yarn ends.

## Arms (make 2)

**Rnd 1:** With Blush, work 6 sc in a magic ring—6 sts.

**Rnd 2:** 2 sc in each st—12 sts.

**Rnds 3–14:** Sc in each st.

Fasten off and weave in the yarn ends.

Stuff the arm.

## Sleeves (make 2)

**Rnd 1:** With Salmon, ch 16, join with a sl st to form a ring, making sure not to twist the ch, work sc in each ch—16 sts.

**Rnds 2–8:** Sc in each st.

**Rnd 9:** *Sc in the next 2 sts, sc2tog; repeat from * 3 more times—12 sts remain.

Put the arm inside the sleeve, matching the stitches as best as possible.

**Rnd 10:** Sc in each st of both layers to join the arm and sleeve—12 sts.

**Rnd 11:** Sc in each st.

**Rnd 12:** *Sc2tog; repeat from * 5 more times—6 sts remain.

Fasten off, leaving a long tail for sewing.

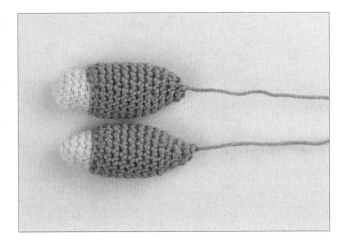

## Wig

**Rnd 1:** With Black, work 6 sc in a magic ring—6 sts.

**Rnd 2:** 2 sc in each st—12 sts.

**Rnd 3:** *2 sc in each of the next 3 sts, sc in the next 3 sts; repeat from * once more—18 sts.

**Rnd 4:** (Sc in the next st, 2 sc in the next st) 3 times, sc in the next 3 sts, (sc in the next st, 2 sc in the next st) 3 times, sc in the next 3 sts—24 sts.

**Rnd 5:** (Sc in the next 2 st, 2 sc in the next st) 3 times, sc in the next 3 sts, (sc in the next 2 sts, 2 sc in the next st) 3 times, sc in the next 3 sts—30 sts.

**Rnd 6:** (Sc in the next 3 sts, 2 sc in the next st) 3 times, sc in the next 3 sts, (sc in the next 3 sts, 2 sc in the next st) 3 times, sc in the next 3 sts—36 sts.

**Rnd 7:** (Sc in the next 4 sts, 2 sc in the next st) 3 times, sc in the next 3 sts, (sc in the next 4 sts, 2 sc in the next st) 3 times, sc in the next 3 sts—42 sts.

**Rnd 8:** (Sc in the next 5 sts, 2 sc in the next st) 3 times, sc in the next 3 sts, (sc in the next 5 sts, 2 sc in the next st) 3 times, sc in the next 3 sts—48 sts.

**Rnd 9:** Sc in the next 7 sts, 2 sc in the next st, (sc in the next 3 sts, 2 sc in the next st) 2 times, sc in the next 15 sts, 2 sc in the next st, (sc in the next 3 sts, 2 sc in the next st) 2 times, sc in the next 8 sts—54 sts.

**Rnd 10:** Sc in the next 8 sts, 2 sc in the next st, (sc in the next 4 sts, 2 sc in the next st) 2 times, sc in the next 16 sts, 2 sc in the next st, (sc in the next 4 sts, 2 sc in the next st) 2 times, sc in the next 8 sts—60 sts.

**Rnd 11:** Sc in the next 8 sts, 2 sc in the next st, (sc in the next 5 sts, 2 sc in the next st) 2 times, sc in the next 17 sts, 2 sc in the next st, (sc in the next 5 sts, 2 sc in the next st) 2 times, sc in the next 9 sts—66 sts.

**Rnd 12:** Sc in the next 9 sts, 2 sc in the next st, (sc in the next 6 sts, 2 sc in the next st) 2 times, sc in the next 18 sts, 2 sc in the next st, (sc in the next 6 sts, 2 sc in the next st) 2 times, sc in the next 9 sts—72 sts.

**Rnd 13:** Sc in the next 9 sts, 2 sc in the next st, (sc in the next 7 sts, 2 sc in the next st) 2 times, sc in the next 19 sts, 2 sc in the next st, (sc in the next 7 sts, 2 sc in the next st) 2 times, sc in the next 10 sts—78 sts.

**Rnds 14–23:** Sc in each st.

The next row is worked along the front edge of the wig only.

**Next row:** Ch 2, start in the 2nd ch from hook, sl st in the next ch, sl st in the last sc of Rnd 23, sc in the next st of Rnd 23,

(ch 4, start in the 2nd ch from hook, sl st in the next 3 ch, sl st in the same sc as the base of the ch, sc in the next st of Rnd 23) 2 times,

ch 6, start in the 2nd ch from hook, sl st in the next 5 ch, sl st in the same sc as the base of the ch, sc in the next st of Rnd 23,

ch 8, start in the 2nd ch from hook, sl st in the next 7 ch, sl st in the same sc as the base of the ch, sc in the next st of Rnd 23,

ch 6, start in the 2nd ch from hook, sl st in the next 5 ch, sl st in the same sc as the base of the ch, sc in the next st of Rnd 23,

ch 5, start in the 2nd ch from hook, sl st in the next 4 ch, sl st in the same sc as the base of the ch, sc in the next st of Rnd 23,

(ch 4, start in the 2nd ch from hook, sl st in the next 3 ch, sl st in the same sc as the base of the ch, sc in the next st of Rnd 23) 3 times,

(ch 2, start in the 2nd ch from hook, sl st in the next ch, sl st in the same sc as the base of the ch, sc in the next st of Rnd 23) 3 times,

(ch 4, start in the 2nd ch from hook, sl st in the next 3 ch, sl st in the same sc as the base of the ch, sc in the next st of Rnd 23) 3 times,

ch 5, start in the 2nd ch from hook, sl st in the next 4 ch, sl st in the same sc as the base of the ch, sc in the next st of Rnd 23,

ch 6, start in the 2nd ch from hook, sl st in the next 5 ch, sl st in the same sc as the base of the ch, sc in the next st of Rnd 23,

ch 8, start in the 2nd ch from hook, sl st in the next 7 ch, sl st in the same sc as the base of the ch, sc in the next st of Rnd 23,

ch 6, start in the 2nd ch from hook, sl st in the next 5 ch, sl st in the same sc as the base of the ch, sc in the next st of Rnd 23,

(ch 4, start in the 2nd ch from hook, sl st in the next 3 ch, sl st in the same sc as the base of the ch, sc in the next st of Rnd 23) 2 times,

ch 2, start in the 2nd ch from hook, sl st in the next ch, sl st in the same sc as the base of the ch, sc in the next st of Rnd 23.

Fasten off, leaving a long tail for sewing. Place the wig on the head at Rnd 10 on the front and Rnd 33 on the back. Sew the wig to the head.

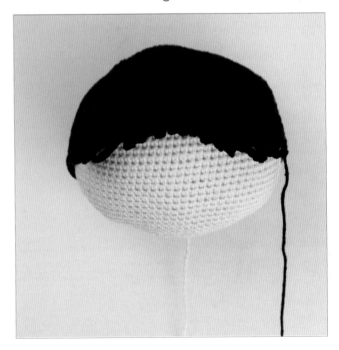

## Pigtails (make 2)

**Rnd 1:** With Black, work 6 sc in a magic ring—6 sts.

**Rnd 2:** 2 sc in each st—12 sts.

**Rnd 3:** *Sc in the next st, 2 sc in the next st; repeat from * 5 more times—18 sts.

**Rnd 4:** *Ch 16, start in the 2nd ch from hook, sc in the next 15 ch, sl st in the same sc as the base of the ch, sc in the next st of Rnd 3; repeat from * 17 more times.

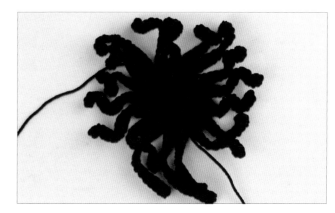

Fasten off and leave a yarn tail. Thread the yarn tail into the tapestry needle, then weave the yarn tail through the stitches of Rnd 3 and pull it tight to close.

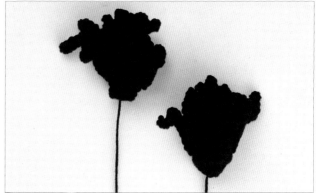

## Bones (make 2)

Foundation ch: With White, ch 8. Stitches are worked around both sides of the foundation ch.

**Rnd 1:** Start in the 2nd ch from hook, (sc, ch 2, sl st) in the same ch st, (sc, ch 2, sl st) in the next ch st, sl st in the next 3 ch sts, (sc, ch 2, sl st) in the next ch st, (sc, ch 2, sl st) in the next ch st, working along the bottom of the foundation ch, sl st in the next 3 sts, sl st in the 8th ch of the beginning to join. Fasten off, leaving a long tail for sewing.

## Wings (make 2)

**Rnd 1:** With Black, work 6 sc in a magic ring—6 sts.

**Rnd 2:** 2 sc in each st—12 sts.

**Rnd 3:** *Sc in the next 2 sts, 2 sc in the next st; repeat from * 3 more times—16 sts.

**Rnd 4:** *Sc in the next 3 sts, 2 sc in the next st; repeat from * 3 more times—20 sts.

**Rnd 5:** *Sc in the next 4 sts, 2 sc in the next st; repeat from * 3 more times—24 sts.

**Rnd 6:** *Sc in the next 5 sts, 2 sc in the next st; repeat from * 3 more times—28 sts.

**Rnd 7:** *Sc in the next 6 sts, 2 sc in the next st; repeat from * 3 more times—32 sts.

**Rnd 8:** *Sc in the next 7 sts, 2 sc in the next st; repeat from * 3 more times—36 sts.

**Rnd 9:** *Sc in the next 5 sts, 2 sc in the next st; repeat from * 5 more times—42 sts.

**Rnd 10:** *Sc in the next 6 sts, 2 sc in the next st; repeat from * 5 more times—48 sts.

The wings don't need to be stuffed. Flatten the opening of the wing.

**Next row:** Working through both layers to close the opening, 2 hdc in the next st, sc in the next 6 sts, (dc, ch 1, dc) in the next st, sc in the next 8 sts, (dc, ch 1, dc) in the next st, sc in the next 6 sts, 2 hdc in the next st.

Fasten off, leaving a long tail for sewing.

## Time to Put It All Together!

Cut out the shapes of the eyes from the felt fabric, using the graphics below as a guide.

**Black part**

Ø  2.0 cm = 0.8 in

**White part**

Ø  1.2 cm = 0.5 in

Glue the black parts of the eyes to the head between Rnds 21 and 27, with 8 stitches between them. Glue the white parts of the eyes on top of the black parts. Using the sewing thread, finish securing the eyes to the head.

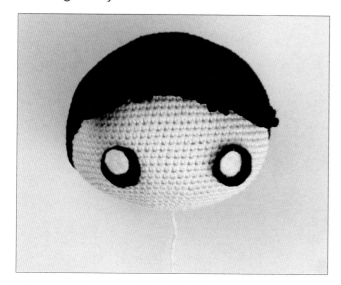

With Black yarn, embroider the mouth 5 stitches wide at Rnd 27 of the head and centered between the eyes. Embroider the fangs with White yarn and black sewing thread. With Cotton Candy, embroider the cheeks below the eyes. With White

yarn, embroider the shine of the eyes, and with Black yarn embroider the eyebrows.

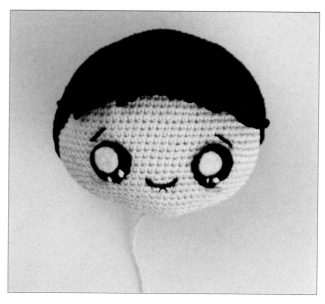

Sew the pigtails to each side of the wig at Rnd 17. Sew the bones onto the pigtails.

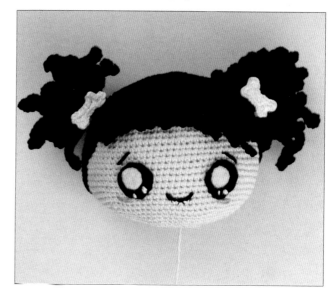

With Black yarn, add the straps of the shoes. Place the dress on the body.

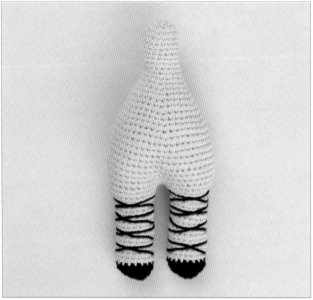

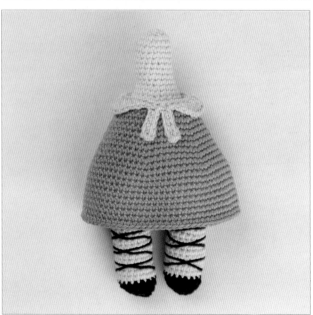

Sew the arms to the sides of the body at Rnd 4. Attach the head to the body. Use your finger to poke a hole in the filling so that you can pull the neck through the opening of the head, leaving 1 or 2 rounds of the neck visible. Sew the head onto the neck.

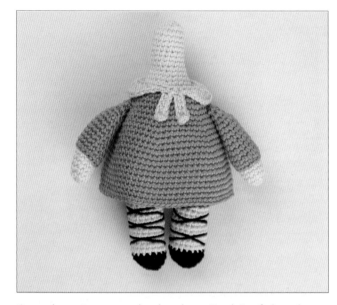

Sew the wings on the back at Rnd 6 of the dress, with 3 stitches between then.

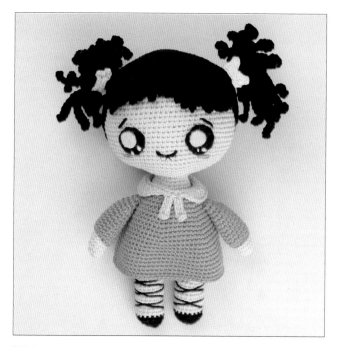
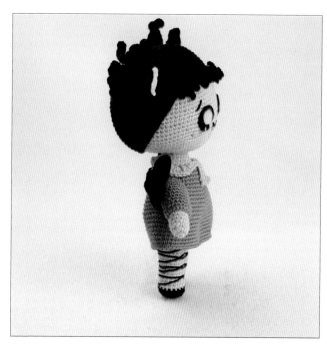
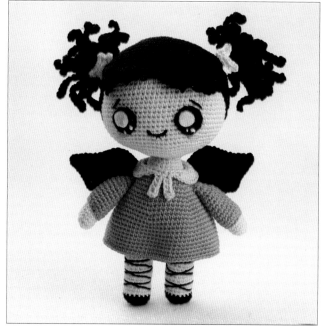
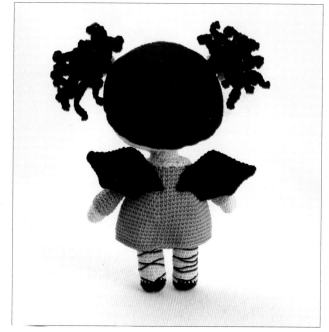

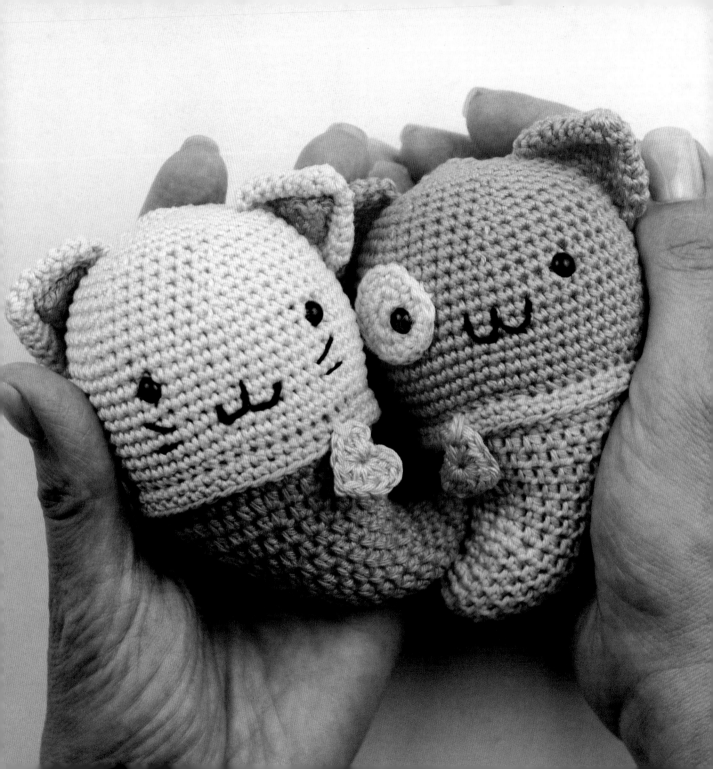

# GHOST KITTIES

## MATERIALS

Yarn and Colors® 100% mercerized cotton (sport weight yarn)

1.75oz (50g); 137yds (125m)

### Colors:

Peach (042) 82yds (75m)

Salmon (039) 82yds (75m)

Mustard (015) 28yds (25.5m)

Cotton Candy (037) 28yds (25.5m)

Black (100) (leftover)

- Size 2mm crochet hook
- Fiberfill
- 4 black safety eyes, ¼in (6mm) diameter
- Tapestry needle
- Stitch marker
- Scissors
- Black and white thread and sewing needle
- Pins

### Gauge:

7 sts and 7 rnds = 1in/2.54cm in sc

## Let's Begin!

### Eye Color Patch

**Rnd 1:** With Salmon, work 6 sc in a magic ring—6 sts.

**Rnd 2:** 2 sc in each st—12 sts.

**Rnd 3:** *Sc in the next st, 2 sc in the next st; repeat from * 5 more times—18 sts.

Fasten off, leaving a long tail for sewing.

### Body and Head

**Rnd 1:** With Salmon or Peach, work 4 sc in a magic ring—4 sts.

**Rnd 2:** 2 sc in each st—8 sts.

**Rnd 3:** Hdc in the next st, sc in the next 4 sts, hdc in the next st, 2 hdc in the next 2 sts—10 sts.

**Rnd 4:** Sc in the next st, sl st in the next 4 sts, sc in the next st, (hdc in the next st, 2 hdc in the next st) 2 times—12 sts.

**Rnd 5:** Sc in the next 6 sts, (hdc in the next 2 sts, 2 hdc in the next st) 2 times—14 sts.

**Rnd 6:** Hdc in the next st, sc in the next 5 sts, (hdc in the next 3 sts, 2 hdc in the next st) 2 times—16 sts.

**Rnd 7:** Sc in the next st, sl st in the next 4 sts, sc in the next st, (hdc in the next 4 sts, 2 hdc in the next st) 2 times—18 sts.

**Rnd 8:** Hdc in the next st, sc in the next 5 sts, (hdc in the next 5 sts, 2 hdc in the next st) 2 times—20 sts.

**Rnd 9:** Sc in the next st, sl st in the next 5 sts, sc in the next st, hdc in the next 13 sts.

**Rnd 10:** Hdc in the next st, sc in the next 6 sts, hdc in the next 4 sts, 2 hdc in the next st, (hdc in the next 3 sts, 2 hdc in the next st) 2 times—23 sts.

**Rnd 11:** Sc in the next 8 sts, hdc in the next 14 sts, 2 hdc in the next st—24 sts.

**Rnd 12:** Sc in the next st, sl st in the next 6 sts, sc in the next st, (hdc in the next 7 sts, 2 hdc in the next st) 2 times—26 sts.

**Rnd 13:** Sc in the next 8 sts, (hdc in the next 8 sts, 2 hdc in the next st) 2 times—28 sts.

**Rnd 14:** Hdc in the next st, sc in the next 6 sts, hdc in the next st, (hdc in the next 9 sts, 2 hdc in the next st) 2 times—30 sts.

**Rnd 15:** Sc in the next st, sl st in the next 7 sts, sc in the next st, (hdc in the next 6 sts, 2 hdc in the next st) 3 times—33 sts.

**Rnd 16:** Hdc in the next st, sc in the next 8 sts, (hdc in the next 7 sts, 2 hdc in the next st) 3 times—36 sts.

**Rnd 17:** *Sc in the next 5 sts, 2 sc in the next st; repeat from * 5 more times—42 sts.

**Rnd 18:** Sc in each st.

Fasten off and weave in the yarn ends.

Choose which side you want your kitten's tail to be on and place a marker for the back.

Pull up a loop of Mustard in the center st of the back of Rnd 18.

**Rnd 19:** With Mustard, *sc in the next 6 sts, 2 sc in the next st; repeat from * 5 more times—48 sts.

Change to Peach or Salmon.

**Rnd 20:** BL sc in each st.

**Rnd 21:** *Sc in the next 7 sts, 2 sc in the next st; repeat from * 5 more times—54 sts.

**Rnds 22–29:** Sc in each st.

**Rnd 30:** *Sc in the next 7 sts, sc2tog; repeat from * 5 more times—48 sts remain.

**Rnd 31:** Sc in each st.

**Rnd 32:** *Sc in the next 6 sts, sc2tog; repeat from * 5 more times—42 sts remain.

**Rnd 33:** Sc in each st.

**Rnd 34:** *Sc in the next 5 sts, sc2tog; repeat from * 5 more times—36 sts remain.

**Rnd 35:** Sc in each st.

**Rnd 36:** *Sc in the next 4 sts, sc2tog; repeat from * 5 more times—30 sts remain.

**Rnd 37:** Sc in each st.

Leave the work on hold to make the face.

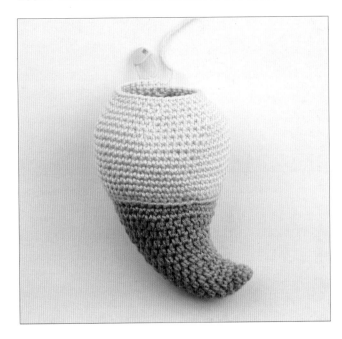

Place or embroider the eyes between Rnds 26 and 27 of the head, 11 sts apart. If you are making the version with the eye color patch, sew it to the head between Rnds 24 and 30 before adding the eyes.

With Black, embroider the whiskers and the mouth.

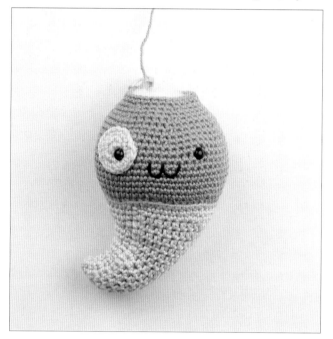

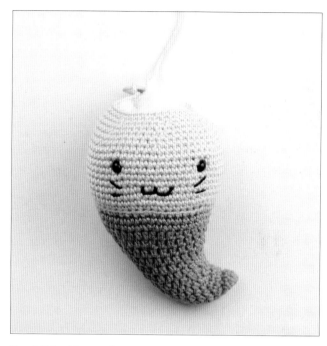

**Rnd 38:** *Sc in the next 3 sts, sc2tog; repeat from * 5 more times—24 sts remain.

**Rnd 39:** *Sc in the next 2 sts, sc2tog; repeat from * 5 more times—18 sts remain.

Stuff the body and the head.

**Rnd 40:** *Sc in the next st, sc2tog; repeat from * 5 more times—12 sts remain.

**Rnd 41:** *Sc2tog; repeat from * 5 more times— 6 sts remain.

Fasten off and leave a yarn tail. Thread the yarn tail into the tapestry needle, then weave the yarn tail through the front loop of each remaining stitch and pull it tight to close. Weave in the yarn end.

## Collar

Pull up a loop of Mustard in any st of Rnd 19.

**Rnd 1:** BL sc in each st—48 sts.

**Rnd 2:** Sc in each st.

Fasten off and weave in the yarn ends.

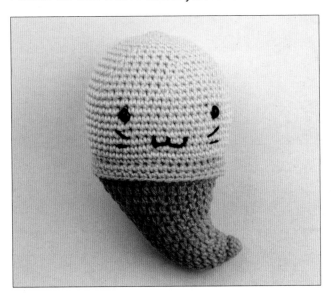

## Ears (make 2)

**Rnd 1:** With Peach or Salmon, work 6 sc in a magic ring—6 sts.

**Rnd 2:** *Sc in the next st, 2 sc in the next st; repeat from * 2 more times—9 sts.

**Rnd 3:** *Sc in the next 2 sts, 2 sc in the next st; repeat from * 2 more times—12 sts.

**Rnd 4:** *Sc in the next 2 sts, 2 sc in the next st; repeat from * 3 more times—16 sts.

**Rnd 5:** *Sc in the next 3 sts, 2 sc in the next st; repeat from * 3 more times—20 sts.

**Rnd 6:** *Sc in the next 4 sts, 2 sc in the next st; repeat from * 3 more times—24 sts.

**Rnd 7:** Sc in each st.

The ears don't need to be stuffed. Flatten the opening of the ear.

**Next row:** Working through both layers to close the opening, sc in next 11 sts, sl st in the last st.

Fasten off, leaving a long tail for sewing.

## Centers of the Ears (make 2)

These are for the kitten with a Salmon tail and Peach head.

**Row 1:** With Salmon, work 1 sc in a magic ring, ch 1, turn—1 st.

**Row 2:** 2 sc, ch 1, turn—2 sts.

**Row 3:** Sc in the 1st st, 2 sc in the last st, ch 1, turn—3 sts.

**Row 4:** 2 sc in the 1st st, sc in the next st, 2 sc in the last st—4 sts.

Fasten off, leaving a long tail for sewing. Sew each center of the ear to its ear.

## Little Heart

**Rnd 1:** With Cotton Candy, work ch 2, 2 dc, 2 hdc, 1 dc, 2 hdc, 2 dc, ch 2, sl st in a magic ring—9 sts.

Adjust the stitches around the ring to form a heart.

Fasten off and weave in the yarn ends.

## Time to Put It All Together!

Sew the ears to the head between Rnds 28 and 37.

Sew the heart to the collar.

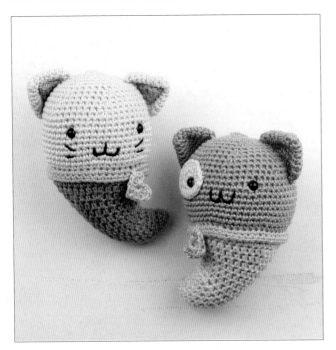

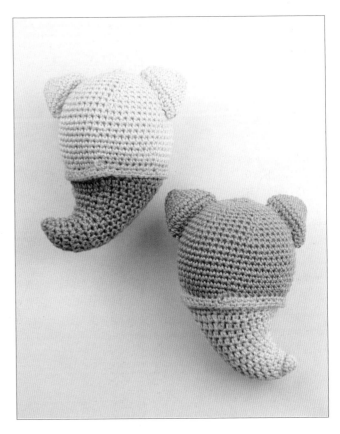